T0080397

EN GUERRE: FRENCH ILLUSTRATORS AND WORLD WAR I

KNOCK-OUT !!!

NEIL HARRIS AND TERI J. EDELSTEIN

EN GUERRE

FRENCH ILLUSTRATORS AND WORLD WAR I

THE UNIVERSITY OF CHICAGO LIBRARY

2014

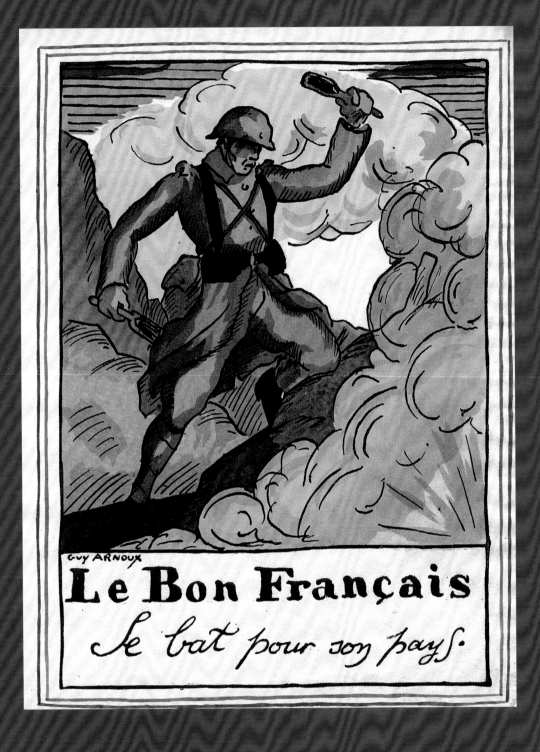

GUY ARNOUX

Le Bon Français

se bat pour son pays.

CONTENTS

FOREWORD AND ACKNOWLEDGMENTS

THE CENTENNIAL OF THE OUTBREAK of World War I is an occasion for historical commemoration. It is also an opportunity for critical reflection on the war's complex and interrelated diplomatic, political, and technological transformations. Many of the decisive scenes of the Great War were enacted in the military theaters of the battlefield, but the impact of mobilization brought equally significant social change to the home front. *En Guerre: French Illustrators and World War I* explores one of the most important of these cultural theaters of the war, the contest to influence public opinion and shape loyalties in one of the principal Allied powers. Drawing on their expertise and connoisseurship in graphic arts, book illustration, and visual culture, Neil Harris and Teri J. Edelstein examine a group of gifted French artists whose work vividly expressed the camaraderie, horror, valor, and absurdities of the war. Alternately promoting and critiquing the official narratives of the conflict, these French illustrators left an eloquent record of the ironies of the great international struggle and the uncertain rewards of victory.

The University of Chicago Library is deeply grateful to Neil Harris, Preston and Sterling Morton Professor of History and Art History Emeritus, the University of Chicago, and Dr. Edelstein for proposing this project and bringing to it their discriminating taste and deep knowledge of the materials. Approaching the topic with unflagging energy and enthusiasm, they sought out the finest exemplars to represent each theme and artist. We are glad to acknowledge their work in shaping an exhibition that is both historically perceptive and visually compelling.

The development of the exhibition and the publication would not have been possible without the engagement and support of a group of generous donors. It is a pleasure to acknowledge the funds provided to this project by the Smart Family Foundation, Inc.; the University of Chicago Library Society; the France Chicago Center of the University of Chicago; the Gladys Krieble Delmas Foundation; Martha Fleischman; the Institut Français in Paris and the Cultural Service at the Consulate of France in Chicago; an anonymous donor; and research support from the Preston and Sterling Morton Professorship at the University of Chicago.

The illustrated books and printed materials in the exhibition and publication are drawn from the holdings of the Special Collections Research Center of the University of Chicago Library. For additional materials made available on loan and for permission to reproduce images of these items, the Library gratefully acknowledges the private collection of Professor Harris and Dr. Edelstein; Richard Cheek; the Ryerson and Burnham Libraries, the Art Institute of Chicago, Jack Perry Brown, Director, and Mary Woolever, Archivist; the Anne S. K. Brown Military Collection, Brown University Library, Peter Harrington, Curator; the Rare Book and Manuscript Library, Kislak Center for Special Collections, Rare Books & Manuscripts, University of Pennsylvania, David McKnight, Director, Lynne Farrington, Curator of Printed Books, and Elton-John Torres, Administrative and Reprographic Services Coordinator.

The images of additional materials not included in the exhibition but reproduced in this publication were generously furnished by several other research libraries and museums. For permission to publish these images, the University of Chicago Library expresses appreciation to the Spencer Museum of

Art, the University of Kansas; the Graphic Arts Collection, Princeton University Library; Library and Archives Canada; the Research Library, Western Reserve Historical Society; the Musée de l'Image, Ville d'Epinal; and the Musée du Jouet, Ville de Poissy.

The staff of the University of Chicago Library was essential to every aspect of the creation of the exhibition and the design and production of the publication. Alice Schreyer, Assistant University Librarian for Humanities, Social Sciences, and Special Collections, and Curator of Rare Books, engaged in the initial planning for the exhibition and contributed curatorial and bibliographic expertise. Patti Gibbons, Head of Collection Management and Preservation in Special Collections, was responsible for arranging exhibition loans, coordinating production of the publication and editing of its images, soliciting additional images and copyright permissions, and coordinating with the University of Chicago Press. Joseph Scott, Exhibition Designer in Special Collections, created the design of the exhibition, produced the exhibition gallery installation, and coordinated communications and web information. Exhibition Assistant Alice Bucknell edited digital images. Catherine Uecker, Rare Books Librarian in Special Collections, provided bibliographic support. Mike Kenny of the Library's Preservation Department was responsible for exhibition and publication photography, and Aude Gabory of Preservation provided translations.

This publication was designed and produced by Joan Sommers and Amanda Freymann of Glue + Paper Workshop, Chicago. Alexandra Bonfante-Warren was responsible for copy editing and editorial assistance. Additional support was provided by the staff of the University of Chicago Press.

Daniel Meyer
Director, Special Collections Research Center
University of Chicago Library

WE ECHO THE GRATITUDE to all those mentioned by Daniel Meyer in his Foreword and we wish to add our own thanks to all of the funders who so generously supported this endeavor. Without their significant donations, this publication would not exist. We also wish to thank all those who so generously shared their collections with us.

We must be repetitious and specifically thank the staff of Special Collections of the University of Chicago. Countless people assisted in material ways. Our thanks to Judith Nadler, Alice Schreyer, Daniel Meyer, and Joseph Scott, in addition to everyone else who participated. But Patti Gibbons deserves a most special mention. Her endless dedication and her expertise were beyond extraordinary.

Our research and the realization of the exhibition were assisted by many colleagues. This list is not inclusive but represents our gratitude to all those who assisted in some way: Joseph Berton, Dan Bertsche, Thomas Breban, Jack Perry Brown, Blanche Buffet, Doran Cart, Richard Cheek, Kenneth Clarke, Dominique Coulombe, Elizabeth Davenport, Joan and Robert Feitler, Martha Fleischman, Laurance Geannopulos, Christine Giviskos, Gloria Groom, Peter Harrington, Janice Katz, Michel Lagarde, Nicholas Lilly, Joseph Loundy, Alan Marshall, Matthew Naylor, Michèle Noret, Graham Paul, John Pollack, Emmanuel Pollaud-Dulian, Denis Quenelle, Susan Rossen, Patrice Rozie, Martine Sadion, Michael Sittenfeld, Stephen Stigler, Marilyn Symmes, Michael Twyman, Jackie Vossler, Michael Weintraub, Stephen Young, and Julie Zeftel.

The creation of the publication benefited from the expertise of Glue + Paper Workshop and we thank them.

Finally, we wish to thank all of the talented illustrators featured in this volume. We are pleased to celebrate their achievements and make them known to a wider audience.

This commemoration reminds us again of the terrible cost of human conflict.

Neil Harris
Teri J. Edelstein

Neil Harris

ILLUSTRATING THE GREAT WAR

BY EARLY 1917 THE GREAT WAR was two and one half years old. In France, while defeat had been avoided at huge cost, victory was still not in clear sight. Grief, exhaustion, cynicism, patriotism, bitterness, and, after April, exhilaration at the American entry, alternated with one another. Painters, sculptors, and architects, like everyone else, had been mobilized; some had been killed, others wounded, many remained at the front. Art journalists were also affected. The editor of the *Gazette des beaux-arts*, Emile Bertaux, died unexpectedly, aged forty-seven, in January 1917, of influenza, weakened, said his eulogist, by thirty months of military service.[1] It was in the *Gazette*, the same month of Bertaux's death, that the French historian, journalist, and art critic Hilaire Noël Sébastien Clément-Janin began an ambitious project. Placing painters and sculptors to one side, his three-part survey of French print makers sought to demonstrate just how artists, etchers, engravers, lithographers, publishers, and illustrators had responded to the conflict.

Clément-Janin confronted a huge subject. He estimated that the number of different prints about the war was already approaching ten thousand (omitting book illustrations, which were not part of the survey), a body of work "frightening to the unfortunate critic who finds himself thrown into this ocean of paper."[2] Happily for his purposes, he reported, a Parisian couple, the Leblancs (Henri and Louise), living on the avenue Malakoff, had devoted themselves to collecting these materials from the very start of the war.[3] The walls of their large apartment, their bookshelves, and their vitrines were filled or covered with posters, prints, books, airplane models, and battlefield relics.[4] They offered Clément-Janin the opportunity to catalogue the visual materials, and he responded by proposing both an organization and a commentary.[5]

Clément-Janin divided his subject into three large parts. First, the "actualists," the "journalists of the pencil," well-known and prolific figures like Jean-Louis Forain, painter, lithographer, and etcher; Abel Faivre, illustrator, humorist, caricaturist, and, above all, poster maker; and Henri-Gabriel Ibels, associated with the Nabis and influenced by Henri de Toulouse-Lautrec. Their ranks also included Hermann-Paul, Jean Veber, Théophile Steinlen, Henry de Groux, Pierre-Georges Jeanniot, and dozens of others. Frank editorialists, they made use, as Clément-Janin put it, of "irony, invective, sarcasm, and most terrible of all, truth," in their art. They worked in many media—woodblock, etching, engraving, drypoint, and lithography—but all exhibited one primary characteristic: *esprit*. *Esprit* was "the French virtue par excellence, or, to be more precise, the Latin virtue," Clément-Janin wrote, clearly under the spell of wartime patriotism. This mysterious essence resists easy definition, but its presence seemed obvious to him. Like many others he enlisted aesthetic and humanist traditions in the interest of French nationalism, and appreciated the fact that most of these artists demonized their German enemies unmercifully.

After his first essay had appeared, months later, Clément-Janin examined a second group of artists he labeled "documentarians."[6] These, just as admirable as the first set, depicted what they had seen without adding their own views or, Clément-Janin admitted prudently, without "adding too much." Sketch albums were part of this array, including those by Bernard Naudin, Charles Fouqueray, M. G. Scott, and dozens of others. There was also the work of André Devambez, Gabriel Belot, Albert Robida, and landscapists, portraitists, and allegorists, all meriting respectful attention. In the course of his analysis Clément-Janin listed a lengthy series of artists and titles.

And finally, in the last essay, published soon thereafter, he presented the "image makers," a cluster of artists who, if not entirely new in their methods, were yet doing something novel, reviving and reinventing older print-making traditions.[7] They did not quite fit into any fixed category, and according to Clément-Janin their ranks included Lucien Laforge, Pierre Abadie-Landel, Hermann-Paul, Guy Arnoux, and Eduardo García Benito. Clément-Janin concluded with some comments on the poster makers.

The categories were porous: artists renowned for their battlefield accounts or their depictions of atrocities were treated in the section on posters. Image and print makers were sometimes discussed within the "actualists." There was almost no attention paid to book illustrators, as such. Some names appeared in more than one section. And, nearly a century later, many of the judgments Clément-Janin offered seem dubious or overstated.

Nonetheless, his effort to classify was serious and comprehensive and it demonstrates that the makers of the books and images forming the focus of this exhibition and its catalogue are culled from a much larger cohort. Many of the most productive and prominent artists discussed by Clément-Janin—Faivre, Steinlen, Forain—are not included. The artists featured here are largely drawn from the "image makers" whom Clément-Janin treated in his third essay: Laforge, Abadie, Arnoux. The exhibition also incorporates others whom he does not name, along with the neglected group of book illustrators.

This eclectic band boasts few well-known (at least in this country) artists. They tended to be young, with much of their careers ahead of them, and most of them employed color. The pigments, often applied by hand using pochoir, a stencil process, or successive woodblocks, were what made this work so appealing, especially to children, to those depressed by the painful rigors of war, to those seeking to recall, even momentarily, the halcyon elegance of pre-war fashion. Not all the illustrators and print makers featured in the *En Guerre* exhibition relied on color. Jean-Emile Laboureur, for one, did not. But most of them did. With just a handful of exceptions like Laboureur and George Barbier, these artists were not working in a refined style; their images are often crude and vigorous rather than subtle and refined. Their work was meant to carry emotional weight, to call attention to itself, and to tap into a fount of memory and nostalgia. This was a mythical rather than a realistic war. The turn to tradition, and the decreased enthusiasm for modernist styles such as Cubism, would also influence far greater artists of the day, including Pablo Picasso, André Lhote, and Joan Miró.

The tone of the wartime art can be jolting. Consider Laforge, for example, and his *Conte de fées* (fig. 1). The print is striking but ultimately perplexing. In six panels, recalling (or anticipating) the *bande dessinée*, or comic-strip art, just emerging in France, stenciled in brilliant inks and calligraphed in handsome cursive letters, Laforge's broadside repackages the story of World War I as a fairy tale. Five lovely girls play happily in a beautiful garden, minding their own business. Suddenly little France, Belgium, and Britain are menaced by a grimacing and apparently demented German ogre, his head encased in a pickelhaube, the spiked helmet so closely associated with the Prussian military. The invader goes after the children, one by one, but they resist. Belgium, the first to endure his attentions, escapes his grasp; France, the "most beautiful of all," pushes him into the English Channel; and England, blockading his ports, starves him to death. Now at their mercy the ogre is decapitated, and "peace returned for all time." With a

happier ending than many fairy tales, this *Conte* was printed, probably in a limited edition of several hundred (no edition size is indicated), by Lutetia in Paris, a prolific publisher of patriotic broadsides and portfolios, singled out for commendation by Clément-Janin.

Too large to fit in a quarto-size portfolio, too small and fragile to serve as a wall poster, *Conte de fées* is just one among thousands of such images created during the war by this cadre of energetic illustrators. Their uses remain unclear. Presumably reserved for indoor deployment, they might have been framed and hung as demonstrations of loyalty, or kept in large albums, to be passed around at dinner parties, posted by storekeepers in their shops or by officials in their offices, or perhaps actually read to children. Or something else entirely. It is difficult to determine just how they were consumed or where they were handled. Sometimes freely distributed, more often sold, many were avidly sought by collectors, and rising prices followed, Clément-Janin informs us.

Laforge's involvement raises further questions. He seems an unlikely proponent of the war effort. Born in 1889, the centenary of the Revolution, Laforge was a man of the Left, a Dreyfusard, and a supporter of anarchism; his pacifist sympathies led him twice to feign insanity when mobilized for army duty.[8] A brief internment and a hospital stay followed. Hopes of becoming a successful painter were frustrated by a lack of client interest, but he was able to place his cartoons and caricatures in a number of sympathetic journals like *L'humanité*, *Le journal du peuple*, and, a bit later, *Le canard enchaîné*. Laforge, a vigorous polemicist and outspoken progressive, seems to have been best suited to political journalism. Just before the war he had illustrated a couple of children's books, *Les mille et une nuits* and *Les infortunes d'Ogier le danois*. Others would follow after 1918. Their simply drawn and sharply satirical illustrations, colored with stencils, would bring him considerable attention, but most of it came long after his death in 1952. Rediscovered in recent days, several of Laforge's books have been reprinted as classics of children's illustration.[9]

– conte de fées –

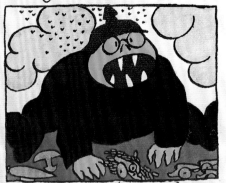

il y avait une fois des petites filles qui vivaient chez elles bien tranquilles sans rien demander à personne.

mais à côté l'ogre teutonus les menaçait sans cesse en grondant : chiffon de papier, kultur, domination !

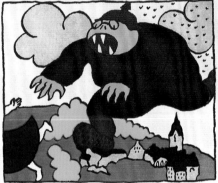

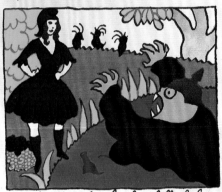

un jour, devenu fou, il se jeta sur la plus petite, la belgique, pour l'écraser mais elle lui glissa dans les mains.

puis il entra chez la plus belle, la france pour lui voler ses vins et ses fleurs – mais il tomba dans la marne.

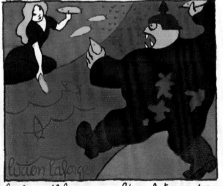

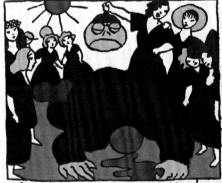

furieux, il lança sur l'angleterre des oiseaux et des poissons en forme de cigare qu'elle lui mangea : il mourut de faim.

alors les petites filles entourèrent l'ogre et lui coupèrent la tête. et la paix revint pour toujours.

se trouve à la librairie lutetia 66 bᵈ raspail paris

FIG. 1
Lucien Laforge. *Conte de fées*. Paris: Librairie Lutetia, [n.d.]

Still, Laforge's wartime fable does not appear to have been intended for the very young. As Clément-Janin noted, heroism was clearly not Laforge's specialty; he invoked neither booming cannon, nor ranks of cavalry riding into battle. Instead, he took a dark, sardonic view of war and the military, leavened by a pervasive comic sense that was "molièresque," Clément-Janin contended. With his vivid caricatures and exaggerated colors, Laforge seems, at some points, to have been close to the Fauves, the group of early twentieth-century French painters led by Henri Matisse and André Derain.[10] It is even possible to imagine that the simple fable of the little girls was meant as an ironic commentary on the grotesque and ferocious propaganda being issued by the authorities and—more to the point—broadly accepted by the public. Perhaps only the reductionist savagery that so many fairy tales feature was an appropriate tone to take.

Most of Laforge's other wartime illustrations focus on the underside of the war years, away from the actual battlefield. Thus, his postcard series, *La pochette de la marraine*, captured a week in the life of a soldier, seven days on leave with his *marraine*—his "godmother," that is, his pen pal. The French government and private charities had encouraged a system of pen pals to raise troop morale. Its benefits (and abuses) provoked wide and often critical coverage, with some of the *marraines* accused of prostitution. An amused Laforge produced one postcard for each day of the week and granted his soldier a lively social life. The return to the front left behind a devastated female companion. Curiously, Laforge selected an African combatant from one of the French colonies as his protagonist. Again, whether this was meant to satirize the *marraines de guerre*, French morals, racism, or the war itself, is unclear. Laforge's politics were far from racist.[11] As in the *Conte de fées*, his intentions are not easy to read.

Still more playful is another series Laforge did for Lutetia, six large-scale, pochoir-colored plates entitled *La guerre en dentelles* (fig. 2).[12] Here, romance was paramount: a cupid, sometimes several, appears in every plate. Among his subjects are dalliances

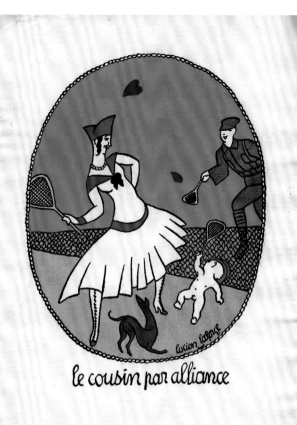

FIG. 2
Lucien Laforge. "Le cousin par alliance." *La guerre en dentelles.* Paris: Librairie Lutetia, 1916

between soldiers and their lovers, a tennis match between Marianne and her British ally, and a dark cellar where prostitutes are reading, primping, and taking refreshments from an African attendant. Whether the theme is Love Conquers All or something else is not absolutely clear, but the perspective Laforge offered, despite its patriotic colors and military references, hardly constitutes an endorsement of the aims of the war. Instead, the simply drawn, brightly colored plates project a sly, even subversive set of observations on the way life goes on, war or no war.

Other Laforge wartime commentaries are less ambiguous, like the heroic Montenegrin warrior in the *Hymnes alliés*. But even here there is a mysterious element in the background. Is it a ship's hull, or a shark fin? This set of twelve stenciled prints, in an edition of one thousand, included contributions by Abadie, Hermann-Paul, Robert Bonfils, and Jean Leprince. Laforge's piece stands out among them, with its radiant pigments and uncomplicated shapes, but in other works he concentrated more naturally on the softer sides of military life. Another series of pochoir prints for Lutetia, six in all, blends the comic and the tragic. Here again is a soldier with his *marraine*, as well as troops entertaining themselves with a dramatic revue and cooking on the battlefield, Red Cross nurses in a military hospital, and the capture of a spy. Mischief, some of it sinister, remains present. A colorful dog runs through several of the prints, although not all of them, and his (or her) colors change.

Laforge had some counterparts. Pierre Abadie was a Breton painter who in the 1920s and '30s would be active in the Seiz Breur (Seven Brothers) movement, a group of artists and artisans intent on recovering and sustaining the folk traditions of Brittany. During the war he created *L'alphabet de l'armée*, a portfolio of six pochoir prints for Le Nouvel Essor, along with *Les joies du poilu*, another set of six also for Le Nouvel Essor (fig. 3). These were similar in spirit to Laforge's series, brightly colored and deliberately primitive in their drawing

and composition. They were also droll, amiable, sardonic, and nonchalant rather than bellicose in character, the *Joies* featuring a military odd couple fishing, swimming, drinking, and picnicking together.

Laforge's cynicism went beyond the somewhat ribald and lighthearted mood of Abadie's images and may have been best expressed in black and white, through the illustrations to Lucien Descaves's *Ronge-maille vainqueur*. Descaves was another man of the Left, an old opponent of the army, dismissed from it by reason of his satirical 1889 novel, *Sous-offs*.[13] Descaves and Laforge were natural partners for *Ronge-maille*. Prepared in 1917, the book was banned by French censors and only published several years after the armistice. The story is told by the title rat, the sole victor of World War I. "Years when the harvest is red, are for us years of abundance," explains Ronge-maille, bearing the name La Fontaine had given him three centuries earlier. "The corpse of a human, on whatever side of the trenches, always tastes good.... We always have the last word."[14] The armistice welcomed by so many humans brought only famine to the rats. Other authors, notably Pierre Chaine in his *Mémoires d'un rat*, also turned to rodents as witnesses to war, and in this case, heroes of war. Chaine's comic take was reprinted several times, and inspired the work of several illustrators, none more inventive than Henry Coudour, whose pochoir images made the story into something like a prequel for the animated film *Ratatouille* (2007). In a publication meant for children, unlike Laforge's effort, Coudour and Chaine converted their rat protagonists into appealing allies.

Laforge, on the other hand, used his simple drawings and stark black-and-white contrasts to dissent from the *bourrage de crâne*, the mental fever of conflict, the delirious mind-set that afflicted so many and that the propaganda machines of the warring powers fueled so effectively. But even he was, at least occasionally, susceptible to the temptation to sustain the sacred cause, at least while the war was on. And if a Laforge could be enlisted, so could almost anyone else.

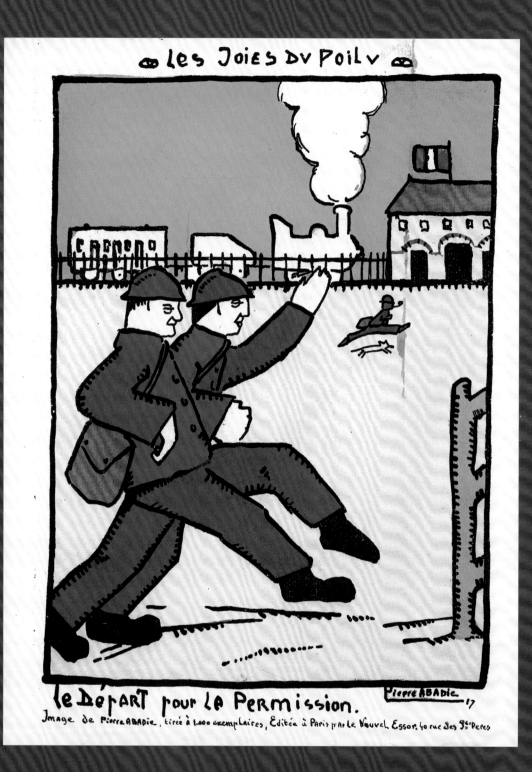

FIG. 3
Pierre Abadie[-Landel].
"Le départ pour la
permission." *Les joies du
poilu*. Paris: Le Nouvel
Essor, 1917

ONE HUNDRED YEARS LATER, the numbers remain staggering. Close to fifty million men mobilized across Europe; more than thirty-five million military casualties, including at least eight million dead; individual battlefield days claiming tens of thousands of lives. France alone lost almost 1.4 million men, with the totals even higher in Germany and Russia. The Great War bitterly—and very quickly—earned its title, although civilians would suffer far more in the wars that followed.

The scale of the conflict and the enveloping mobilization meant that no aspect of life would remain untouched. To sustain the huge costs and maintain acceptable levels of public support, every instrument of persuasion became exploitable. "Total" war required commitment to a sense of mission in every combatant state. And this in turn meant production of an unending flood of messages aimed at every sector of the population, messages of justification, inspiration, and vilification; messages that were visual and textual; and messages that were formulated to excite sentiments of solidarity and sympathy for the cause and hatred or contempt for the enemy. Their creators were the figures who had engaged Clément-Janin.

And despite his efforts, they remain far less studied than the poets, painters, and sculptors, many of whom shared the horrors of the front lines. These last included Henri Gaudier-Brzeska, who was killed in 1915 at Neuville-Saint-Vaast, and Raymond Duchamp-Villon, brother to Marcel Duchamp, wounded near Champagne, who died of typhoid fever. The poet Guillaume Apollinaire, friend of Picasso, victim of a head wound and influenza, died only days before the armistice of November 1918. Fernand Léger was gassed at Verdun, Roger de La Fresnaye at Tours; Georges Braque and Marcel Gromaire were wounded, while Derain, Maurice de Vlaminck, Lhote, Jean Metzinger, Francis Picabia, Albert Gleizes, Jacques Villon, André Dunoyer de Segonzac, Ossip Zadkine, Moïse Kisling,

and František Kupka all served at the front.[15] Their lives and their works would attract considerable attention in subsequent years.

The print makers and illustrators also suffered. François-Louis Schmied, a Swiss-born wood engraver and perhaps France's greatest book deviser of the interwar years, lost an eye in combat; Gus (Gustave Blanchot) Bofa was seriously wounded; Joseph Hémard, just beginning his career as an illustrator, was taken prisoner and spent more than four years in German detention; Chas (Charles) Laborde was gassed. Laboureur, Marcel Jeanjean, Louis Icart, Jean Droit, Lucien Boucher, Charles Fouqueray, Charles Martin, Umberto Brunelleschi, Pierre Brissaud, Mathurin Méheut, André-Edouard Marty, all illustrators and graphic artists, served in the military.[16]

That many of them felt the need to record the military experience itself, to transmit a sense of the unfathomable misfortunes of life that were generated, is to be expected. These graphic commentaries often center on the iconic figure of the ordinary French soldier, the hirsute, unkempt *poilu*, as well as the horrors of battle, the destruction of historic cities, the despair of Belgian refugees. The sketchbooks and renderings, much noted by contemporary critics, occupy only a modest part of this exhibition, absorbed as it is by book illustrators, broadside makers, and the creators of color prints.

A number of book artists did draw upon their experiences in prisoner-of-war camps, and could perhaps be included in the image-making category Clément-Janin devised.[17] Boucher's *Images de la vie des prisonniers de guerre*, recording life in the prison camp of Merseburg in Saxony (one of three hundred German camps), its text by his fellow prisoner Mario Meunier, a Greek scholar and secretary to Auguste Rodin, was perhaps the most elegantly presented— and most expensive—of these efforts (fig. 4). Its publisher, Marcel Seheur, was also a prisoner. The limited edition of just 175 copies contains two dozen hand-colored woodcuts, deliberately naive in character, transmitting the daily ordeals endured by thousands of French captives. These are not images of

FIG. 4

Mario Meunier. "Le cafard."
*Images de la vie des prisonniers
de guerre.* Illus. by E. L[ucien]
Boucher. Paris: Marcel Seheur,
[1920]

men in combat, but of the routines of eating, bathing, marching, and fighting boredom, all within the confines of a prison camp. Boucher, in his midtwenties when the war began, had studied ceramic painting and done caricatures for *Le rire* and *Fantasio*. *Prisonniers* was published in 1920, when the passions of war had begun to be succeeded by other emotions. It betrays little indignation about the enemy, favoring instead a sympathetic portrayal of those enduring the constraints and indignities of captivity.[18]

Hémard's memoir, which appeared in 1919, after the armistice, was a much less expensive production, printed on cheap paper, in an unnumbered edition, and priced at six francs, or something close to ten of today's dollars. Like Boucher, Hémard concentrated on documenting mundane matters—prisoners exercising, a Christmas Eve concert, a sports event. His narrative also reflects a well-developed sense of humor; the last vignette contrasts the prisoner arriving at camp, carrying nothing, and his departure, bent under piles of luggage. The color lithography of several illustrations only vaguely anticipated the brilliant pochoirs that adorn Hémard's many books of the 1920s.

Another memorable set of artist commentaries on life at the front—or just behind it—was provided both during and after the war, by the much-traveled and supremely urbane Laboureur, who had spent a good deal of time in Canada, Germany, the United States, and the United Kingdom.[19] Laboureur had studied at the Sorbonne and had come to know Toulouse-Lautrec during his years in Paris. He would become a highly acclaimed book illustrator and print maker in the 1920s and '30s. During the war he served as an interpreter for the British army in Belgium and northern France, and later at an American naval base in the south of France. Some of Laboureur's work appeared in *L'élan*, the short-lived periodical founded by Amédée Ozenfant in 1915 to demonstrate the patriotic potential of avant-garde artistry.[20] Laboureur emphatically demonstrated the wartime relevance of modernism. A series of print portfolios—among them, *Images de l'arrière: Petites images de la guerre sur le front britannique* and *Dans les Flandres britanniques*—featured

the distinctively angular, cubist-like figures that would become Laboureur's signature, at least for a while (fig. 5). A master of etching and woodblock alike, Laboureur would also commemorate Woodrow Wilson's triumphant visit to France after the armistice with his *Types de l'armée américaine en France*, a set of miniature head shots aimed at catching the racial and ethnic diversity of the American military forces.

Like Boucher, Laboureur did not attempt to demonize the enemy, but sought instead to document the ironies of military service and transmit some sense of the "exotic" dress and customs of France's allies, especially the Scots. The plaid kilts worn by the Scottish soldiers fascinated French artists, who invariably placed them alongside pictures of the "exotically" clad troops from Africa and Asia who had shouldered much of the burden of fighting the Germans. Many of the artists simply sought typicality, as Raoul Dufy did in *Les alliés: Petit panorama des uniformes*, a patriotic and simply drawn tribute to comrades in arms. The French infantryman Dufy drew was supposedly modeled on his friend Apollinaire, but the others are generalized images, basically faceless. This version was one of Dufy's several wartime efforts at invoking conventional French visual narrative to stimulate patriotism, and fit Clément-Janin's notion that the function of this kind of work was allegorical, not documentary (fig. 6). Such pictures, he went on, aspire to moral truth, to prevailing ideas, rather than reality.[21] Laboureur was more absorbed by individual stories. After the war ended he went on to portray encounters between the British forces and their allies.

The reporting of Boucher, Hémard, and Laboureur, although it was supplemented by that of others, did not typify the larger illustrator effort. For one thing, these three artists maintained a rather remote and even whimsical posture toward the events they were describing, concentrating on neither heroism nor sentimentality and refusing to caricature the enemy. On the whole, they stood aloof from the broader propaganda campaign, perhaps because they had actually been soldiers or even imprisoned. For another, their

TA ΕΘΝΗ ΠΟΥ ΣΥΜΜΑΧΟΥΝΤΑΙ ΓΙΑ ΝΑ ΝΙΚΗΣΟΥΝ
ΤΟ ΔΙΚΑΙΟ ΚΑΙ Η ΛΕΥΘΕΡΙΑ

Les Nations Alliées pour le triomphe du droit et de la liberté

FIG. 6
Raoul Dufy. *Les nations alliées . . .* Paris: Librairie Lutetia, [n.d.]

artistry took somewhat traditional expression in books or portfolios aimed at typical collectors. And finally, they were building on highly personal experiences, unlike colleagues like Laforge, who had managed, for reasons of personal principle, to avoid military service.

As Laforge showed, service at the front was not a prerequisite for contributing to the wider graphic effort. Nor was reportage as such the principal mission for this group of artists. It was, instead, a broader commentary, meant, for the most part, to bolster morale, arouse indignation, ridicule the enemy, glorify heroic traditions, add some needed humor, and satisfy the need for diversion during the long agonies of war. They devised thousands of books, prints, posters, postcards, placards, magazine issues, pamphlets, advertisements, certificates, announcements, toys, and games referencing the conflict. This consumerist orientation disposed their creators to formulate an art that was accessible, drawing on well-established currents of storytelling that had both religious and military origins. They were, in effect, recipients of a special stylistic occasion, one that placed them in the center of a vital, if temporary artistic shift of taste.

This shift has been explored in some detail by Kenneth Silver's important book, *Esprit de corps*.[22] Silver argues that the military crisis underwrote, even encouraged what had been a submerged attitude of hostility toward many aspects of aesthetic modernism and the avant-garde, identified, by its critics, with the malign influence of Germany and Austria-Hungary in the years just preceding the war. While hardly new, such sentiments swelled dramatically in the first months of conflict, preparing the way for a massive stylistic shift among major artists like Braque, Matisse, Picasso, Juan Gris, and Gino Severini. Such hostility was echoed in unexpected places. Inexpensive magazines like *Fantasio* and *La baïonnette* satirized the enemy by dressing its women in Secession-style garments recalling the era of Gustav Klimt and Josef Hoffmann in Vienna.

The shift was far from universal. A number of artists retained their modernist tastes, some even exaggerating their preference for Cubism and abstraction. But French artists were encouraged by critics to return to their sources, draw on their country's glorious past, and repudiate the unhealthy Central European influences—philosophical, musical, commercial, and industrial, as well as graphic—that, critics claimed, had sapped vitality from the nation. Attacks were launched not only on Cubism, but on designers found guilty of associating with the pernicious influence of *le style munichois*, or any other manifestation of Teutonic creativity.

Silver concentrates upon "serious" artists of major reputation, but the stylistic turn he has defined is in effect an endorsement of vernacular illustration, and, most notably, the *images d'Epinal*, the tradition helping to inspire Laforge and Abadie. These hand-colored prints, originally produced in the eponymous town in the northeastern province of Lorraine, featured woodcuts and, later, lithographs with political, military, religious, and domestic themes (fig. 7).[23] At the end of the eighteenth century the Pellerin firm took over production of these images, secular and religious alike, for more than fifty years, and then, after a hiatus, returned to manage their creation.[24] Unsophisticated, brightly colored, simple in technique and organization, Epinal-like prints, and, just as strongly, colored prints produced elsewhere in France, would constitute a significant influence throughout the war years. They were invoked and elaborated on by Lhote and Dufy, among others. France was not alone in this kind of revival: Russian poster artists during World War I drew on their own woodcut *lubok* heritage, active and continuous for hundreds of years.[25]

Painters working solely from such inspiration would face constraints. Silver points out that "an artist of serious intent could not go on turning out folkloric prints ad infinitum," and that this was "one very limited artistic response to war."[26] But popular illustrators and graphic artists drew on national

SIRE, CE LINCEUL VAUT BIEN LA CROIX !!

A la bataille d'Ulm, Napoléon, en parcourant la première ligne, criait *en avant!* et faisait signe aux soldats d'avancer; de temps en temps son cheval disparaissait au milieu de la fumée du canon. Durant cette terrible charge, il se trouva près d'un grenadier grièvement blessé. Ce brave criait comme les autres, *en avant! en avant!* Napoléon s'approche de lui, et lui jetant son manteau, lui dit : « Tâche de me le rapporter, je te donnerai en échange la croix que tu viens de gagner. » Le grenadier, qui se sentait mortellement blessé, répondit à l'Empereur : « Sire, le linceul que je viens de recevoir vaut bien la croix, » et il expira enveloppé dans le manteau impérial. Le combat terminé, l'Empereur fit relever le grenadier, qui était un soldat de l'armée d'Egypte, et ordonna qu'il fût enterré dans son manteau.

Propriété de l'Éditeur. (Dépôt.)

DE LA FABRIQUE DE PELLERIN, IMPRIMEUR-LIBRAIRE, A EPINAL.

traditions and produced simply drawn colored images in large number. Much of their work was, by definition, ephemeral, but, for a time at least, these artists were widely recognized, their names synonymous with specific stylistic features. The Great War provided an opportunity to work variations on multiple patriotic themes, project some satirical commentary, and satisfy, with their limited editions, serious collectors and casual purchasers simultaneously.

ONE ARENA THAT WIDENED considerably as a result of the war was a market that had already been growing for decades: the children's book. Children figured heavily in the convulsive propaganda campaigns—as victims of war, in northern France and

FIG. 7

[François Georgin]. *Sire, ce linceul vaut bien la croix!!* Epinal: Pellerin & Cie, 1837, reissued, 1912

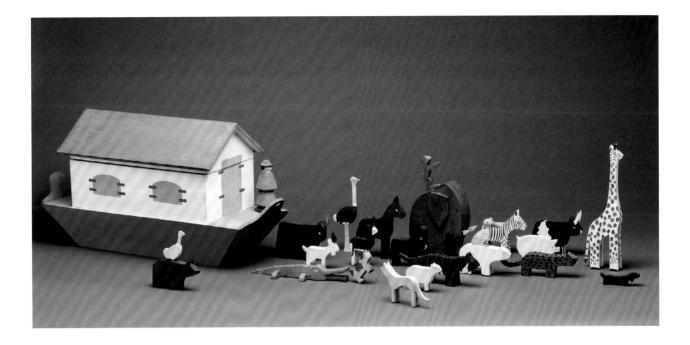

Belgium; as the future inheritors of victory (or defeat); as innocent but heroic symbols of courage and ingenuity; as faithful imitators of their elders in accepting wartime sacrifices. There were even programs in French schools to get children to draw and paint their impressions of war.[27] In Paris this was urged as a therapeutic practice. Posters and postcards alike used the features of children to make their generally obvious points, and recent scholarship has devoted itself to analyzing both the wartime experiences of children and the motifs sounded by the stories and images adapted for them.[28] This proliferation followed decades of growth in the children's market for books generally. A standardized educational system, rising literacy rates, and cheap printing had all underwritten a publishing explosion, which included the creation of heavily illustrated magazines filled with colorful images and exhilarating tales, all designed for young tastes and meant for family reading.[29]

Compulsory education spelled profits for several major houses specializing in children's materials. Fayard, founded in 1857, was among the most active publishers of children's journals, producers of a seemingly unending series of periodicals aimed at the lucrative audiences they had discovered. The

titles suggest the subject material and the targets: *Le bon vivant, La jeunesse illustrée, La vie pour rire*—in essence, early comic-strip papers. The Fayard empire, and other publishing houses, recruited a number of budding illustrators to work for them.[30]

Among them was André Hellé, who would be so dynamic a force during the war. Hellé, who was born in Paris during the year of Prussian victory, 1871, had begun exhibiting in various salons by 1905, but was also soon designing children's rooms, theater sets, and, most significantly, wooden toys.[31] He first gained broader attention in 1911 when he published, with the firm of Alfred Tolmer, *Drôles de bêtes*, a pochoir-illustrated bestiary with a series of archaically shaped, brightly colored, and impeccably appealing animals wandering through its pages.[32] The book was part of a larger marketing campaign with a major Paris department store, Au Printemps. Hellé also launched L'arche de Noé (Noah's ark), a line of toys and furniture (fig. 8). Their angular contours, playful colors, and simplified shapes caught the admiring attention of artists and critics, including the avant-garde Apollinaire, and can be seen as anticipating the work of Russian constructivists and Bauhaus designers, appearing just a few years later.

FIG. 8

André Hellé. "L'arche de
Noé." [S.l.: s.n.], 1911

FIG. 9

André Hellé. *Alphabet
de la Grande Guerre
1914-1916.* Paris: Berger-
Levrault, [1916]

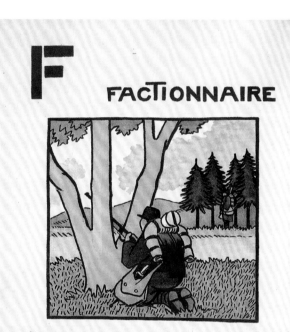

L'œil aux aguets, dissimulé de son mieux, le factionnaire regarde
et écoute. C'est de l'attention qu'il apporte à son rôle que dépend
le sort des troupes qui sont derrière lui, qu'il doit avertir de l'approche
des ennemis.

Hellé's wooden toys were particularly significant, as the French were attempting to win back a market that had been taken over by German manufacturers, centered in Nuremberg, during the nineteenth century. Various artists sought to reassert French supremacy in toy manufacturing, including Robida, Benjamin Rabier, Caran d'Ache (the pseudonym of Emmanuel Poiré), Marius Rossillon (better known as O'Galop, the designer of Michelin's Bibendum), Georges Lepape, and Hellé's partner, Charles Emile Carlègle. They were not notably successful as merchandisers, although during the 1910s and '20s a series of avant-garde artists in various countries would develop and promote their own toys and games.[33] Hellé followed *Drôles de bêtes* the following year with another folio-size book entitled *Grosses bêtes & petites bêtes*, also bearing his firm's seal, a Noah's ark. But Hellé's most celebrated prewar accomplishment was probably the commission he received for the costumes, scenery, and libretto of Claude Debussy's ballet *La boîte à joujoux*.[34] Hellé completed the work in 1913, but the war delayed the premiere until 1919.

The Debussy piece, featuring a doomed romance and a betrayed lover, is set entirely among dolls and other toys. Despite its prewar gestation, it decisively anticipated themes that would soon be widely promoted. Children and toys became, for Hellé and other artists, surrogates for the adults caught up in the violence of the war, and, some have suggested, symbols of the helplessness that millions felt during those years.[35] In another, smaller-size text, a blend of patriotism and merchandising, Hellé illustrated snippets and brief stories by a rather diverse group of French writers. *French Toys*, published in 1915, featured entwined French and American flags and pleaded, as it opened, "Help us children of a free nation for obtaining the triumph of French toys."[36]

Hellé, too old for military service but apparently involved in camouflage work in Paris, then went on to what might have been his most overtly belligerent wartime piece, *Alphabet de la Grande Guerre 1914-1916* (fig. 9), although some of his illustrations

for *La baïonnette* shared its aggressiveness. In the late nineteenth and early twentieth centuries ABCs were being distributed by leading publishers in several formats and styles. Some of these primers were humorous, ironic, playful, and sardonic, occasionally incorporating the military themes that little boys so relished. But Hellé centered his text on one conflict, and this was unusual. Published by Berger-Levrault, the longtime producers of stenciled children's books, then headquartered in Paris and Nancy but formerly of Strasbourg, the *Alphabet* featured soldiers, weapons, and military exercises, each letter receiving a typical Hellé rendering, simple and colorful. The format was clear and repeated on every page; the protagonists more than vaguely resembled some of the dolls Hellé had designed earlier. Patriotism informed even the endpapers, which consisted of the flags of the allied nations. The illustrations showed no scenes of combat mayhem, nor was there much of the frequently caricatured enemy, but some later critics found its implicit endorsement of the war effort and cheerful exploration of devastating weapons to be an exploitation of its child readers, and, in retrospect, given Hellé's own sympathies and talents, disappointing and disengaged.[37]

Far more somber—and more critical—was Hellé's other major wartime contribution. Its title suggests its emotional range: *Le livre des heures héroïques et douloureuses des années 1914, 1915, 1916, 1917, 1918.* This was another pochoir-illustrated publication from Berger-Levrault. It appeared just after the war, the publishing house proudly listing the recovered city of Strasbourg, along with Paris and Nancy, on its title page. Meant, unlike the *Alphabet*, primarily for adults, the book contains approximately 140 stenciled panels, one running across the top of each page. Below them, with specific dates attached, run extracts of official pronouncements, speeches, telegrams, and communiqués, issued, for the most part, by the French government and its ministers. Moving inexorably from week to week, like the war, the *Livre des heures* never departs from its design formula, the insets capturing particularly poignant moments. Scholars have

analyzed in detail Hellé's selection of events, probing the relationship between image and text, and at least one concluding that Hellé's pacifist sympathies are evidenced by the choices he made and the patterns he established. Indeed, the book ends with a vignette of children standing amidst a set of ruins. Whether likened to the diversions of a contemporary comic book or the devotions of a medieval book of hours, as its title suggests, the *Livre*'s cumulative impact projects sorrow and disillusionment. The official extracts that serve as its running text, the words of generals, prime ministers, and heads of state, only emphasize the pain and futility of the war all the more.[38]

THE CALCULATED SIMPLICITY of Hellé's illustrations is echoed in a number of other books, some of them clearly meant primarily for children and most of them embracing the superpatriotism of the war effort. Several are pictorially audacious if emphatically militaristic. The work of Charlotte Schaller certainly fits this character. Swiss-born, married to a Frenchman, and living in Paris, Schaller had exhibited as a painter at various salons in the years before the war. She also contributed several illustrations to *La baïonnette*, the virulently anti-German periodical intended for broad consumption and attracting the talents of dozens of France's most prolific illustrators. Schaller did two children's books, the first, *En guerre!* (1914), in pochoir and the second, *Histoire d'un brave petit soldat* (1915), lithographed, both published by the ever-present Berger-Levrault. The story line of *En guerre!* is simple. Boby and his sisters mobilize their soldiers and toys, follow the war news, write their father, who has been called to the front, rejoice in victories, comfort the wounded, burn up an intrusive German toy soldier (along with a German grammar), and conclude the book singing the "Marseillaise" and dreaming of victory. Red, blue, and yellow are the dominant colors, while black is reserved

for the heavy Prussian boots that Schaller deploys on one memorable, if frightening, page.

Schaller's second book, larger in format but more crudely printed, follows the adventures of a collection of toy soldiers, one in particular, mimicking the larger mobilization of French armed forces against the villainous enemy. There are battles, wounds, hospital stays, dreams and nightmares, dismembered enemy troops, and loving treatment tendered to the damaged but virtuous toy-soldier hero. "Keep dreaming of victory," the book ends, reminding its readers that if one soldier falls, ten will take his place. Strong primary colors, an elementary narrative, and dramatic layouts combine to engage a youngster's attention and envelop him (it seems designed more for boys than for girls) in its embrace of patriotic righteousness. Still, the girls are given a supportive role as nurses, a theme that quite a few other illustrators developed as well.

Scores of children's books about the war appeared in France and in Francophone Belgium during these years, many of them quite traditional in story and design, with young heroes and heroines experiencing—reacting to, participating in—the great effort. In small and large formats alike, they provided variations on established themes. Well-known artists like Rabier, a master of animal illustration, made major contributions. Rabier, also a toy maker and a pioneer of film animation and comic strips who after the war would create the logo for the celebrated cheese product La vache qui rit, produced *Flambeau, chien de guerre*, published by a leading children's book firm, Tallandier. Joseph Porphyre Pinchon, often considered the father of the French *bande dessinée*, enlisted his hugely popular heroine, the young and naive Breton housemaid Bécassine, in the war effort.[39] Indeed, Pinchon himself was mobilized into the army, and had to turn over some of his work to another artist.

And there was "L'oncle Hansi," Jean-Jacques Waltz, the champion of Alsatian identity and a veteran foe of its German annexation. Under his alter ego, Hansi pursued his satirical assaults on the enemy and his picturesquely sentimental vision of Alsace, in several war-related publications. Hansi so irritated the Germans that, just before the war, he was charged with high treason, put on trial, and sentenced to imprisonment. A timely escape across the frontier allowed him to serve in the French army and to continue his work. These artists and others like them served an established market with established characters and distinctive, if recognizable styles.

Few of these artists approached the vitality of Hellé's and Schaller's illustrations, but one who did was Val-Rau in *Spahis et tirailleurs* (fig. 10). Little is known about her beyond an occasional painting, but Berger-Levrault produced a work that in many ways outdoes almost any other children's book printed at the time.[40] Its fantastic pink and purple palette, rendered, like the text itself, in stencils, highlights the contributions of Algerian and Senegalese troops, placing them within rhythmic compositions that seem to anticipate the revolution in children's-book illustrations that would come to France in the 1920s and '30s.[41] The imported fighters, a favored subject for many propagandists, apparently stimulated the artist's riot of warm tones, evoking the "exotic" flavors of France's African colonies. Its striking originality has few parallels within the children's-book genre.

Another children's book that stands out was the work of a somewhat obscure French painter and illustrator, Henri Gazan. It appeared in an edition of five hundred published by Gaston Boutitie, a house responsible for a number of artists' books. *Marie-Anne et son oncle Sam* was dedicated, in French and English, "To all those who have lent a friendly aid to the children of France in her hour of need," and came out just after the war ended, in 1919. In forty-one dazzling hand-colored panels, the book describes the plight, again in both languages, of a little girl fallen into the ocean, menaced by sharks, crying for help. Hearing her shrieks a brave man ("Oncle Sam") leaps into the water, kills the menacing sharks, and successfully fights off a whole series of monsters, a "coalition of hatred" (fig. 11). He rescues the girl, and in the morning sunshine they both move "towards the radiant shore where dwell Friendship and Life."

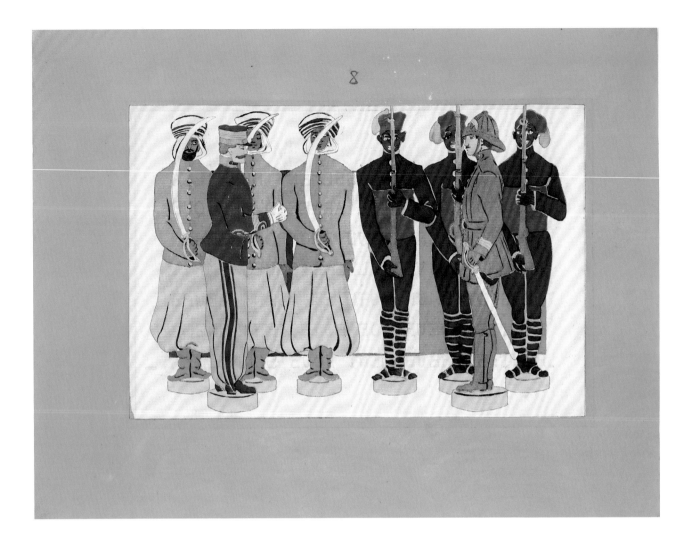

FIG. 10
Val-Rau. *Spahis et tirailleurs: Pour Odile Kastler en l'année de guerre 1916.* Paris: Berger-Levrault, 1916

Unabashedly sentimental, filled with gratitude for the American alliance, and adopting the techniques of the comic strip, *Marie-Anne et son oncle Sam* is redeemed by its pulsing energy and intense palette, not quite as striking as Val-Rau's but sparkling just the same.

Another imaginative illustrator of children's books was André Foy, whose work was featured in a number of illustrated magazines, especially *La baïonnette*. Foy collaborated on several wartime books, one of them, with the poet André Alexandre, *La veillée des p'tits soldats de plomb*. His striking color images may suggest to some the cartoonist Winsor McCay, who created *Little Nemo in Slumberland* (1905).

It should be acknowledged that most of the children's books produced during or just after the war years were illustrated in fairly traditional ways, employing the kinds of sensible, sentimental, or

FIG. 11
H[enri] Gazan. *Marie-Anne
et son oncle Sam.* Paris:
G[aston] Boutitie, 1919

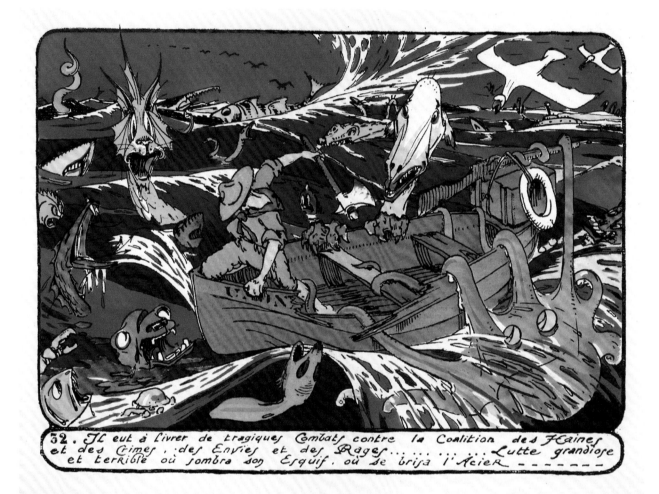

heroic representations that had characterized the genre for decades. Almost all were fully complicit with the Germanophobia convulsing the nation. Berger-Levrault continued to be the source of much anti-German imagery, such as Simone Bouglé's *Bébés s'en vont en guerre!* Bouglé's rosy images of children playing at being nurses and soldiers must have been appealing to children and explored many of the same patriotic themes that Hellé, Schaller, and Val-Rau exploited, but without the visual verve. Bouglé would go on to illustrate many textbooks.

Marcel Jeanjean did not lampoon the enemy, his publications coming after the war had ended. Jeanjean, who began his military career in the infantry but quickly moved on to the air force, chronicled life as a military pilot in *Sous les cocardes*, his first book, lively and entertaining. But his most interesting work for children would come only in the 1920s and '30s. Any account of significant illustrators producing important children's books must include the Belgian artist Jeanne Hovine, whose *Journal d'une poupée belge, 1914-1918* featured the survival of a toy bear in German-occupied Belgium.[42]

THE GROWING APPEAL of comic-strip magazines accounts for some of the talent transferred to children's books, but at least as significant for the larger war effort was the migration of fashion designers from the world of elegant women's frocks and adornments to the patriotic cause. While the production of colored prints, portfolios, and books highlighting fashion was not new in 1914—indeed had more than a century of tradition behind it—the *grand luxe* versions issued by fashion publishers like Lucien Vogel or spotlighting the work of the couturier Paul Poiret certainly were recent accomplishments. Perhaps the most notable was the 1912 founding by Vogel of the *Gazette du bon ton*, the same year that two other lavish, pochoir-illustrated journals, *Modes et manières d'aujourd'hui* and the *Journal des dames et des modes,* appeared. They followed close on the heels of 1908's album *Les robes de Paul Poiret,* with drawings by Paul Iribe, and the 1911 appearance of *Les choses de Paul Poiret*, illustrated by Georges Lepape (fig. 12).[43] Poiret had worked for the great houses of Worth and Doucet, and his gifts for merchandising, his sympathy with modern art, and his design talents helped confirm him as one of the leading couturiers in Paris just before the war, aided as well by publicity afforded his luxuriant and well-publicized lifestyle.[44] Commissions for and purchases from Matisse, Picasso, Dunoyer de Segonzac,

Dufy, and Constantin Brancusi cemented Poiret's reputation as an adventurous art collector.

But it is the impact of the Poiret portfolios that concerns us here. Iribe and Lepape helped transform the world of costume illustration with their daring incorporation of paintings, outdoor settings, and debonair social activities.[45] The minimalist character of the hand-colored plates (and exquisite advertisements) filling the new journals, many of them influenced by Japanese woodblock conventions, others by the sensational reverberations of the Ballets russes then performing in Paris, fit both the legacy of Art Nouveau and the growing taste for modernism being served up by French artists. Opulent, urbane, seductive, and theatrical, the designs helped the "Beau Brummels of the Brush" serving fashion's needs to enter a world of self-conscious celebrity.[46]

After 1914 this energy, exuberance, and artistry was soon transferred to the service of wartime goals. Although most fashion journals basically stopped printing soon after military activities began, they did produce some special issues with wartime themes. More to the point, the artists working for Poiret, Vogel, and the other fashion editors and publishers flooded the minds and eyes of Parisians with patriotically themed images. In 1915, despite the fact that it had suspended publication for the duration of the war, the *Gazette du bon ton* put out a special issue featuring six designs by Etienne Drian, a young but experienced illustrator. Each image depicted a modishly dressed French woman linked to a patriotic theme. In "La Marseillaise" the model is listening to a phonograph, playing, no doubt, the national anthem; a second, "Bouquet tricolore," shows another woman arranging a vase of flowers in patriotic colors; "Avenue du bois" depicts more somberly dressed women standing amidst empty chairs, referring perhaps to the men absent at the front (fig. 13); and "En suivant les opérations" presents an elegantly attired young woman closely studying a map of military operations—these again in red, white, and blue. By contrast, the German women—large, frumpish, grotesquely dressed—became targets for artists like Fabien Fabiano, working

in journals such as *Fantasio* and *La baïonnette*.[47]
Teutonic tastes (and appetites) were meant to con-
trast with those of the lithe Parisiennes, who seemed
instinctively to know how to dress (or undress).

Lepape epitomized the disruption of the fashion
illustrators in his plate for this last wartime issue of the
Gazette du bon ton, in the summer of 1915. "L'ouragan"
(the hurricane) presents an elaborately dressed model,
her billowing frock in the national *tricolore*, hat flying
near her head, blown amidst the hurricane of wartime
explosions that form a mass of dark clouds behind
her. Below, the bomb bursts of naval battles at sea
carry out the theme. Lepape would develop a varia-
tion on this subject in a 1917 pochoir, "Vive la France,"
that became the cover for the English edition of *Vogue*

FIG. 12

Georges Lepape. *Les
choses de Paul Poiret, vues
par Georges Lepape*. Paris:
Maquet, 1911

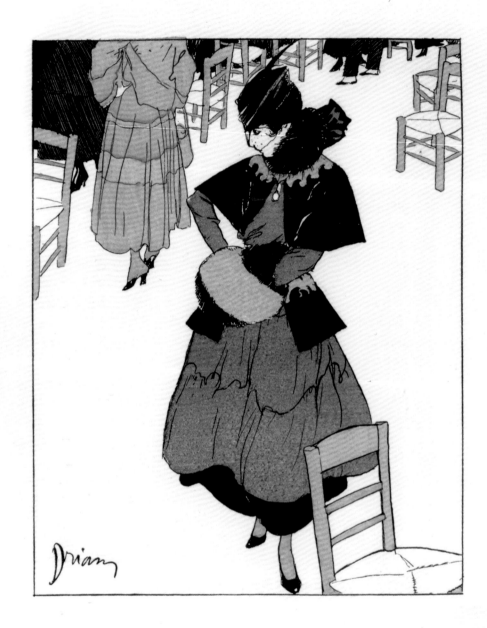

AVENUE DU BOIS

FIG. 13
Etienne Drian. "Avenue
du bois." *Gazette du bon
ton: Arts, modes & frivolités.*
Paris: Lucien Vogel, Année
2, Eté 1915

magazine in November 1917. Probably his most powerful series of wartime images came after the war had ended, in a memorable issue of *Modes et manières*, produced in 1921. Here Lepape, accompanying a dozen poems by Henry Jacques, presented a narrative of the conflict, mixing together pathos, pantomime, and pride. His beautifully dressed women move from the exhilaration of mobilization, through wartime dances and visits from soldiers on leave, to victory, in twelve finely stenciled plates (fig. 14). The cover of the special issue simply lists, beneath the patriotically adorned heroine, the tragic and ultimately triumphant years, one after another, from 1914 to 1919.

There was no reason, of course, for these artists to stay tethered to the pages of the *Gazette du bon ton* or *Modes et manières* in order to create their variations on military messages. Thus, Barbier, recently discovered by Vogel and soon to be celebrated for his theatrical costumes and illustrated books, juxtaposed soldiers returned from the battlefield with fashionable ladies in the pochoir plates and printed silk covers of *La guirlande des mois*. This five-volume series began appearing annually in 1917. That year Barbier depicted an elegantly drawn soldier hurling a hand grenade in battle. Barbier was never known for his images of virile men, and his androgynous, usually languid, but sometimes merely dazed soldiers often resemble women dressed in uniform. The small-format plates, produced under the limitations of wartime conditions, even included, in 1919, a rather impassive rendition of a zeppelin air raid. Barbier's pochoir engraving for Meynial, "Les alliés à Versailles," published several years later, as part of the album *Le bonheur du jour* (fig. 15), provides an epicene counterpoint to Dufy's vigorous panorama of 1914. During the war Barbier furnished illustrations for *La baïonnette* and *La vie parisiènne* and in 1915 drew, for the latter, a double image entitled "Images d'Epinal," summoning up the uniforms and amorous dalliances of earlier days to encourage contemporary soldiers. Cupid firing an exploding cannon adorns the frontispiece of the *Guirlande* for 1917, collapsing the erotic with the martial in what would soon become a recognizable trope.[48]

FIG. 14

Georges Lepape. "La victoire." *Modes et manières d'aujourd'hui.* [Paris: Pierre Corrard, 1921]

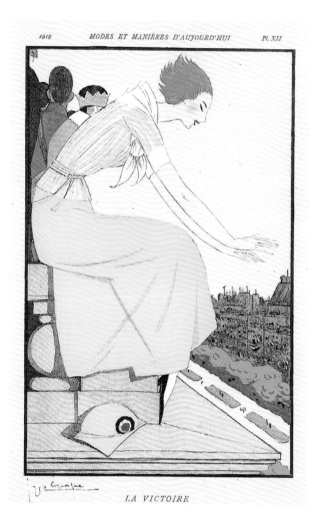

LA VICTOIRE

Les alliés à Versailles.

FIG. 15

George Barbier. "Les alliés à Versailles." *Le bonheur du jour, ou, les grâces à la mode.* Paris: Chez Meynial, 1924

Despite the fact that Clément-Janin acknowledged almost none of the fashion virtuosos in his lengthy survey, they constituted a formidable array, whose enlistment in the war effort testified to the continuing power of Paris as the center of sophistication. Iribe, who had contributed to launching the era with his Poiret portfolio (and had also designed some elegant furniture), became an especially vigorous, some might say ferocious, creator of images in the pages of *La baïonnette* and for *Le mot*, the magazine he helped start in late 1914.[49] With Jean Cocteau writing some of its stirring editorials, *Le mot*, somewhat exceptionally, championed modernism and patriotism simultaneously, featuring artists like Gleizes and La Fresnaye, and reproducing work by Dufy. Dufy contributed several Epinal-inspired drawings to the magazine, notably "La fin de la Grande Guerre," in March 1915. In the 1930s Iribe's

aggressive nationalism would eventuate in a brand of right-wing politics, both chauvinistic and xenophobic, but within the fervid wartime maelstrom of anti-German hatred and contempt, Iribe's dramatic caricatures, however artistically distinctive, were ideologically unexceptional.[50]

LEPAPE, BARBIER, MARTY, Brissaud, Brunelleschi, Gerda Wegener, and others who would become luminaries in the Moderne craze of the 1920s joined colleagues from the humor magazines and children's literature of their day to fill the pages of *La baïonnette,* the weekly journal meant to appeal to the troops in the field as well as to those behind the front lines. Each issue pursued its own theme. In addition to an arresting front cover, it featured caricatures and cartoons, both in color and black and white, highlighting the latest war news, ridiculing the enemy and doubters at home, and generally striving to console and lift the morale of the population. Almost every established commercial artist contributed, particularly the fashion designers. But several among them made such special contributions to the war literature that they merit a separate discussion.

One was Robert Bonfils, a budding book illustrator whose work had begun appearing in 1912. At that time, Bonfils had yet to contribute to any of the fashion journals, but he knew most of the major figures, for he had studied at Fernand Cormon's atelier. Some of Bonfils's predecessors there included Toulouse-Lautrec, Emile Bernard, Vincent van Gogh, and Matisse—along with Brissaud, Marty, Martin, and Lepape. Bonfils was also a decorator. While flourishes and arabesques adorn his illustrated books, further commissions involved wallpapers, porcelains, and tapestries. This decorative exuberance would be further displayed in a series of astonishing postcards. French artists produced many such sets during the war, but the floral imagery Bonfils deployed to celebrate the allies is arresting and

imaginative; few other postcards achieve this level of originality.[51]

The circumstances that led to Bonfils's collaboration with Descaves in *La manière française* are unclear. Descaves, as noted earlier, worked with Laforge in a trenchant critique of the war effort in 1917, published only after the war's end. But in 1916, for Lutetia, he wrote an inspirational introduction to a group of Bonfils's plates. These pochoir-colored, free-flowing, highly romantic images (in addition to some ornamental tailpieces) touch upon many aspects of the war experience—at sea and on the battlefield, the devoted *marraines,* the war loans, the air skirmishes, the creation of the Croix de Guerre—and are accompanied by brief quotations from songs, proclamations, pronouncements, and dispatches. Thus, one plate, "Adolphe Pégoud," features the French aviator's plane in aerial combat, along with an official citation attesting to his bravery and heroic death in battle (fig. 16). Unlike the pairings in Hellé's *Livre des heures,* text and image reinforce one another and are unabashedly optimistic and triumphant. With red, white, and blue ties meticulously attached to its cover and sporting Bonfils-designed endpapers with *Vive la France* running through them, the portfolio was limited to 320 copies. The firm of Charpentier did the pochoir coloring.

In his introduction, Descaves spoke of the need to recover the purity of an earlier day. "We have too many artists. We don't have enough artisans," he declared, paying tribute to the tradition of Epinal print makers and their greatest nineteenth-century craftsman, François Georgin. Georgin and Epinal had enjoyed a rediscovery not so many years earlier by Alfred Jarry and his Symbolist collaborators, their woodcuts reproduced in new, short-lived journals like *Ymagier,* issued in the 1890s.[52] *La manière française* was too elegant to fit comfortably within this stylistic tradition, but its more sophisticated rendition was just as patriotic, harnessing on its cover a helmeted, spear-carrying horsewoman to symbolize an aroused nation, mobilized on behalf of *l'union sacrée.*

ADOLPHE PÉGOUD.

« Le 5 février 1915 a attaqué à bonne distance un monoplan et en provoqua la chute. Presque immédiatement après, il put attaquer deux biplans successivement, provoqua la chute du premier et força le second à l'atterrissage. »

A été tué dans un glorieux combat, le 31 août 1915.

(*Citation à l'ordre du jour de l'armée*).

FIG. 16

Robert Bonfils. "Adolphe Pégoud." *La manière française*. Paris: Librairie Lutetia, [1916]

As with Laforge's print series and other portfolios, it is difficult to reconstruct the audiences or determine how the prints were displayed. We don't know if patriotism or art enthusiasm was the basis for patronage. Relatively few copies of *La manière française* survive today, four copies in American libraries. This prevailing scarcity does not apply to another of the period's fashion artists, Guy Arnoux. Arnoux began publishing illustrated books about the same time as Bonfils. He had served with the cavalry between 1907 and 1909, and became a contributor to a number of fashion magazines, among them the *Gazette du bon ton* and the *Gazette du bon genre*. Once the war began he was posted to the infantry (much to his chagrin, given his love of horses), wounded, and stricken with pulmonary disease. Recovering, he began a connection with the publishing house of Devambez, although simultaneously he started service with the French navy. Arnoux's military adventures did not prevent his creation of a number of patriotic brochures and portfolios, some in unnumbered editions, ranging from folio-size prints and posters to very small-scale images and book covers, like his design for Lucien Boyer's *La chanson des poilus*.

Arnoux's themes were unabashedly nationalistic, and drew heavily on French military traditions, particularly the swashbuckling era of the seventeenth and eighteenth centuries. "Guy Arnoux is our Georgin," wrote Clément-Janin, referring to the celebrated Epinal engraver. One of Arnoux's characteristic techniques was linking traditions of French military glory going back to Carolingian times, with contemporary experiences. Working with historic flags, uniforms, and weapons, Arnoux created several portfolios of hand-colored plates. *Quelques drapeaux françois*, published by Devambez, was an especially impressive example (fig. 17). The sheets of the ten pochoir images each measure 18½ by 12½ inches (47 x 31.8 cm). They were supplemented by *Tambours et trompettes* and the somewhat smaller *Quatre canons françois*, both published, again, by Devambez. Arnoux also produced more modest publications extolling the virtues of civilian war behavior—thrift, purchasing

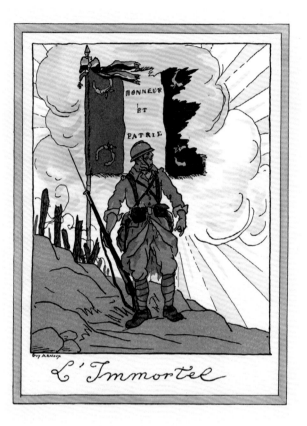

FIG. 17

Guy Arnoux. "L'immortel."
Quelques drapeaux françois.
Paris: Devambez, [n.d.]

bonds, conserving food—and aimed several publications directly at English-speaking readers. The trilogy of *Carnet d'un permissionnaire*, *Le bon Anglais*, and *Nos frères d'Amérique* typifies this effort, while the five prints for *Le bon Français* even more directly cement the linkage between old-fashioned hand-coloring and old-fashioned patriotism. In the 1920s he became the French navy's official painter.[53]

Although he concentrated his energies on French historic traditions, Arnoux's involvement with propaganda efforts could be quite domestic and homely, as in his illustrations for *Histoire du petit chaperon rouge*, a somewhat heavy-handed adaptation of "Little Red Riding Hood" that includes her encounter with a Prussian-helmeted wolf. Arnoux's transition from fashion illustrator to war propagandist was as effortless as his later passage to book illustrator and commercial artist.

Colorful, artfully composed, often beautifully printed, and intensely patriotic, Arnoux's work, however fashionable and historically grounded, is somewhat facile when placed alongside the art of one of his colleagues on the *Gazette du bon ton*, Charles Martin. Just a few years older than Arnoux, Martin, another student at the Atelier Cormon, had begun to exhibit as a painter in the Salon d'automne, but soon turned to illustration. He became a prolific contributor to both the *Gazette du bon ton* and *Modes et manières,* as well as to *La vie parisienne*, *Le rire*, and *Le sourire*. A convert to Cubism, a commitment he would repudiate in later years, Martin had begun work for Vogel in 1914 on what would become one of the most luxurious portfolios of the postwar period, *Sports et divertissements*. This collaboration with the composer Erik Satie would eventually be published by Jules Meynial. Martin's departure for the army and Vogel's bankruptcy interrupted the project. Afterward, Martin radically revised his high-society designs.

But Martin's service in the trenches was transformational. For months there, according to his biographer, the critic Marcel Valotaire, he led a soldier's life of intellectual idleness, facing no needs beyond drinking, eating, sleeping, and finding shelter. Fashion and elegance were far away, but one day he received a package containing all that was necessary to make sketches. He set to work, and after exhibiting some of them in a show of artist-soldiers, brought them to Vogel.[54] The unpretentious pen drawings, eventually published by Meynial, would become one of the most original artist books of the war. *Sous les pots de fleurs* (under the flowerpots), black-and-white renditions of trench warfare, was introduced by the omnipresent Pierre Mac Orlan, the nom de plume of Pierre Dumarchey, a novelist, critic, newspaper correspondent, and friend of many artists and writers. *Sous les pots* is darker in spirit than any of Martin's prewar work, its title, famously, a *contrepèterie*, the French term for a spoonerism, which reverses the first letters of words in a phrase. The title can thus be read as *sous les flots de peur* (beneath the waves of fear), and such is indeed the overwhelming sensation projected by these brooding images. The title also puns on the military slang for "helmet," that is, "flowerpot."[55] Ironically, one of Martin's more sumptuous prewar pieces was a catalogue of hats, *La mode en mil neuf cent douze*, done, as the title indicates, in 1912.

The focus of the sixteen highly geometricized plates in *Sous les pots* is life in the front lines, which Martin was experiencing on a daily basis, the grim fluctuations of boredom, anxiety, fear, and loneliness that were the lot of the *poilu* (fig. 18). Suggestive rather than meticulously detailed, austere, and intimidating, the plates remain powerful today. Some of their flavor, along with the colorful fashion of Paris high life before the guns of August had sounded, can be found in another book by Martin, the illustrations accompanying the wartime evocations of the novelist and journalist Marcel Astruc. The portrayal appeared in 1921 as *Mon cheval mes amis et mon amie*, a cheaply printed but limited edition of five hundred, smaller in format than *Sous les pots*. Martin himself later called the book a "side issue," for he was still struggling with the need for stylistic consistency. Valotaire noted that the illustrations represented at one and the same time direct observations of the war and the lingering influence of Cubism. It remains a forceful demonstration

FIG. 18

Charles Martin. "La relève." *Sous les pots de fleurs.* Paris: Jules Meynial, 1917

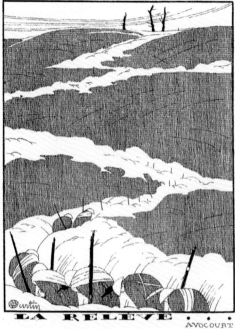

of how one fashion artist's sensibility could be transformed by the war.[56] Martin would return to the colorful elegance of the *Gazette du bon ton* after the war, working for that journal and others, and going on to create, along with his newly designed *Sports et divertissements*, several ingenious promotional brochures, one for the printing firm of Draeger, "Soignez la gloire de votre firme," and another, "Monseigneur le vin," for the Etablissements Nicolas.

Martin was barely fifty when he died in 1934. But during the brief time he had left after the war, he would be identified with the etchings he did for deluxe, limited-edition books, extravagant productions that, to some extent, had been anticipated and prepared for by the *Gazette du bon ton*. Two *demi-luxe* books (limited editions of more than one thousand), published in Belgium in the late 1920s and early '30s, not long before his death, indicate the hold World War I still had on Martin. The books illustrate two widely circulating texts by the French novelist and intellectual André Maurois, subjects also for Laboureur.[57] But these semicomic portraits of the British troops in Belgium and northern France, high-spirited and eminently suited to Maurois's ironic vignettes, were miles away from the deep sorrow and shock of Martin's wartime creations.

The odyssey of one last fashion designer, Eduardo García Benito, deserves separate treatment here. Born in Valladolid, Spain, Benito came to Paris as a teenager and began his studies at the Ecole des Beaux-Arts in 1912. As a foreign national he was not mobilized, but the wartime crisis offered many opportunities and he exploited them fully. One involved illustrating a children's book about Reims Cathedral, the target of massive German bombardment early and late in the war. It quickly became a dominant symbol of Teutonic barbarism.[58] Inexpensively produced on cheap paper, Robert Burnand's *Reims: La cathédrale*, published by Berger-Levrault in 1918, was done in lively, even garish colors. The narrative device—a wounded soldier's dream, abetted by the cathedral's iconic angel—allowed Benito to move through a lengthy visual history of the martyred building that included Clovis, Joan of

LA GRANDE GUERRE

A LA SANTÉ DU ROI

FIG. 19

Eduardo García Benito. "A
la santé du roi." *La Grande
Guerre*. Paris: Tolmer,
[n.d.]. 2ᵉ série, no. 42

Arc, and Napoleon.[59] Henriette Damart, a painter and children's-book illustrator, created another pochoir history of Reims, *Josette et Jehan de Reims*, which, like Benito's book, echoes, in its colors and simplicity, the pared-down artistic legacy that so many other illustrators were invoking.

Just as archaizing were the broadsides Benito produced over the course of the war—several of them for the American alliance and the American Red Cross—and the illustrations he made for *La Grande Guerre*, a serial published by Tolmer, the house that had served Hellé so well (fig. 19). *La Grande Guerre* features more than fifty stenciled plates by Benito, depicting scenes of battle on the war's various fronts. Many of his prints pay direct homage to French vernacular traditions. Others, more angular but also stenciled, hint at Benito's celebrity in the world of fashion and the immense success he would enjoy in later years doing covers for Condé Nast's *Vogue* and *Vanity Fair*, along with designing opulent advertising portfolios.

THE *GAZETTE DU BON TON* and *Modes et manières* alumni who moved so easily into wartime illustration formed part of a larger group that had been energized by the expanding world of French humor magazines. The 1890s were an especially formative decade for this genre, with *Le rire* commencing in 1894, *Le pêle-mêle* coming one year later, and *Le sourire* boasting its first issue in 1899.[60] *L'assiette au beurre* joined the group in 1901, for at least the next decade. But there were dozens of other comic periodicals on the market, created over the previous few decades and employing French *bande-dessinée* artists, along with illustrators and print makers. Political positions varied, but many of them feature cartoons, caricatures, and sketches by the leading artists and illustrators of the day, from Gris, Steinlen, Kees van Dongen, and Félix Vallotton to Rabier, Toulouse-Lautrec, Martin, Hermann-Paul, and Leonetto Cappiello. Frequently mordant, mocking, and

ironic, magazine art was easily transferable to war-time journalism, either in new publications like *La baïonnette*, *Le crapouillet*, and *Le canard enchaîné*, or in separately published books and portfolios.[61] Artists like Wegener, Bofa, Jeanjean, Gazan, Foy, Henri Monier, Jules Depaquit, Zyg Brunner, and Marcel Capy supplied a stream of sarcastic, some-times acid images, going after the enemy and its despised leaders, or taking on French grumblers, pol-iticians, pessimists, and incompetents. Some are gentler than others, of course, and the caricatures could, in certain hands, be quite positive and morale-building, or at least broadly sympathetic. But the overall tone is lacerating and critical.

Hermann-Paul fit within this broad category of commentators. Born in 1864 in Paris, the son of a well-known physician, he was simultaneously a painter, lithographer, and poster artist. His targets, during the late nineteenth and early twentieth centu-ries, were numerous: monarchists, bureaucrats, cler-gymen, army officers, colonialists, accusers of Alfred Dreyfus, and defenders of the status quo. Hermann-Paul worked for a series of French news maga-zines, including *Le rire*, *L'assiette au beurre*, and *Le Figaro*; his direct, easily recognizable style, which featured bold masses of black and severe but simple representations of people and landscapes, suited the woodcut medium that he first took up during the war, replacing lithography, his earlier favorite.[62]

Hermann-Paul's first major account of the con-flict came with *Les 4 saisons de la kultur*, six plates published in 1915 and focused on the barbarism of the enemy troops, who were shown drunkenly pil-laging, raping, and hanging the unfortunate victims in their way (fig. 20).[63] Their ferocity demonstrates Hermann-Paul's endorsement of the national cause, somewhat unexpected, given his strong left-wing political sympathies and skepticism during the prewar years. Unlike Laforge, Hermann-Paul unam-biguously supported the war. He was also extremely productive. Estimates have him producing at least four hundred images for the newspaper *La victoire*, as well as dozens of separate woodcuts, both colored and black

and white, along with a series of folios.[64] Hermann-Paul attacked not only the Germans but the nouveaux riches war profiteers, incompetent generals, and venal politicians.

Perhaps his most ambitious foray into wartime woodcuts came with the *Calendrier de la guerre*, pub-lished by Lutetia. Although the plan was to encompass at least three years of monthly images, only two of the three sets were published. The literary scholar John Anzalone has suggested that the devastating battle-field losses and soldier mutinies made a celebratory third series impossible. Far more restrained than *Les 4 saisons*, the two published years were also, as Anzalone has noted, very different.[65] The first year features events and situations, including mobilization, the destruction of Reims, battles, and submarine war-fare. Simply drawn, the subjects were each keyed to a specific month, and are often poignant in character: couples embracing as the war began, a child abandoned at sea with sunken boats around her, Reims Cathedral in ruins. The second year was devoted exclusively to valiant figures, mainly generals and admirals, shown in heroic poses against backgrounds contextualiz-ing their identity and contributions. Some of these personages, like General Robert Nivelle and General Nicolas Nicolaievitch of Russia, had become contro-versial by the time the calendars were actually distrib-uted. The celebratory tone was a strange reversal for an artist who had been so strongly antiestablishment for much of his career. A relatively large edition of 1,060 examples for the *Calendrier* suggests Lutetia's hopes for sales, perhaps reflecting ambitions stoked by Hermann-Paul's broad reputation. Nonetheless, few sets survive intact today, and the ironies associated with the disasters of war dominate any appreciation of Hermann-Paul's calendar.

The considerable power of simple, hand-colored images, with their reassuring assertion of histori-cal lineage, is demonstrated again and again in the work featured in this exhibition. These images do not entirely block out occasional assertions of more modern trends. The efforts of Iribe and *Le mot* have already been mentioned, and some artists, like

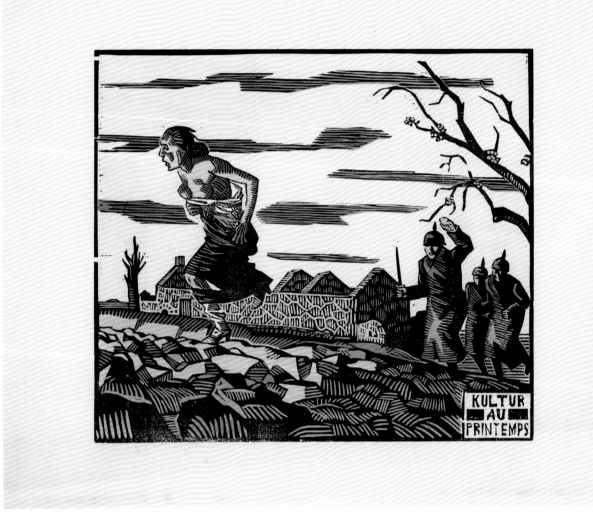

FIG. 20

Hermann-Paul. "Kultur au printemps." Plate 4. *Les 4 saisons de la kultur.* Paris: Dorbon-aîné, 1915

Léger, carried forward their personal stylistic commitments during the war. This can be seen vividly in Léger's designs for Blaise Cendrars's *J'ai tué*, five woodcuts, one of them enhanced by pochoir. It was Léger's first illustrated book. Cendrars, a Swiss-born poet and novelist who became a naturalized French citizen during the war, had been closely involved with several Parisian artists and writers, including Apollinaire, Marc Chagall, Amedeo Modigliani, and Sonia Delaunay. Joining the army, Cendrars fought on the front line, and in September 1915 was seriously wounded in Champagne, losing his right arm as a result. *J'ai tué* came out of his battlefield experiences, an emotional prose poem filled with arresting images. Though both Cendrars and Léger distanced

themselves from Cubism in later years, Léger's designs exemplify his attachment to abstraction. At least one of the images contains, along with stenciled letters, what appears to be a severed arm, a clear reference to Cendrars's injury.

As Kenneth Silver points out, other artists at the front, like André Mare, found Cubism an effective device for presenting the war's total distortion of ordinary life. But the prevailing note in popular imagery remains the comforting, familiar, and neoprimitive images transcending the separate categories of children's books and magazine satire that helped spawn so much French wartime art. The enormously popular and most prolific contributor of children's images to the war effort, Francisque Poulbot, who produced at least one hundred wartime postcards, as well as sheet-music covers, book illustrations, menus, placards, and posters, was adored for his sentimental presentation of winsome tykes.[66]

Religious imagery continued to exert a powerful appeal, as can be seen in Lhote's brightly stenciled portrait of Sainte Geneviève, patron saint of Paris, who nearly fifteen hundred years earlier had saved the city from Attila and the Huns. This quintessential manipulation of medieval visual traditions by a master of modernism portrays the saint, with the Eiffel tower and the Seine flowing in the background, confronting a heavily scaled and coiled serpent topped by the head and helmet of the enemy. The spirit of France, draped in the tricolor, floats above her. And then there was Léon Lebègue's work for *La passion de notre frère le poilu*, published in 1918. Lebègue's opening pages consist of a triptych, a central image with a flap on either side. Pulling apart the two side panels, each bearing an angel, reveals the unshaven French soldier, the archetypal *poilu*, kneeling before God the Father, the Son, and the Holy Mother, along with the heavenly hosts. Lebègue, more than fifty years old when the war began, was still another well-established designer who had worked extensively for magazines, including *La plume*, *Gil Blas*, and *Le rire*. The tone of Lebègue's book is pious and somber, splashing colloquial references onto a sacred landscape.

Music was a favorite subject for many of the wartime illustrators, one that offered opportunities to acknowledge, and to endorse, the heroism of France's military partners. Tolmer published the colorfully decorated *Les musiques de la guerre*, which features the national anthems of seven allied powers (including Japan and Serbia). The artist, Swiss-born Paulet Thévenaz, produced fourteen stirring paste-on bandeaux, all of them stenciled. Each nation sports two of these horizontal panels, one devoted to peacetime activities, the other showing it at war.

The rousing *Hymnes alliés*, with contributions from a group of artists, has already been mentioned, as has Hellé's work. *En seconde ligne*, also by Hellé, juxtaposes eighteen military trumpet calls with stenciled vignettes, each depicting a specific summons. More atypical is Louis Lefèvre's *Rondes glorieuses*, two series of ten plates each, linking bars of music and words with cartoonlike and somewhat irreverent images. Intended for "the children of our brave soldiers," they contrast ordinary *poilus* and daily incidents with the words and music of well-known songs that run below them. Hundreds of elaborate sheet-music covers also gave illustrators the chance to depict military heroes or milk maudlin scenes for popular consumption.

ILLUSTRATING THE WAR did not end after November 11, 1918. There were memoirs to be published; popular histories, novels, and poetry to be issued; and texts of atonement, regret, and denunciation to be absorbed. Within this last category came Paul Vaillant-Couturier's *Jean sans pain*, an antiwar fable published in 1921, featuring the art of Charles Alexandre Picart le Doux, a painter and poet.[67] Vaillant-Couturier's vigorous and direct denunciation of war is matched by the intense, simply drawn images Picart le Doux employed, in a book that was inexpensively produced and priced. It evolved into something of a cult classic, particularly on the

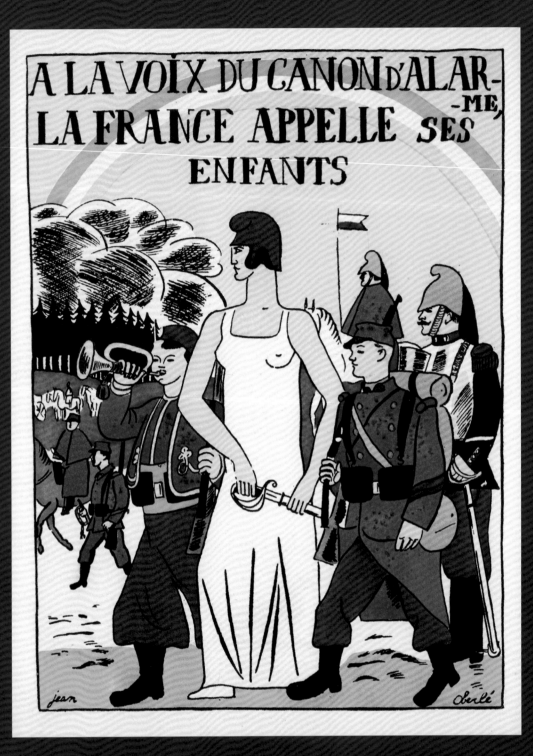

FIG. 21
Joseph Delteil. "A la voix
du canon d'alarme." *Les
poilus: Epopée*. Illus. by
Jean Oberlé. Paris: Aux
Editions du Loup, 1926

Left, and Vaillant-Couturier became editor in chief of the Communist newspaper *L'humanité* in the 1920s. And the artist Dunoyer de Segonzac used his wartime experience to produce etchings for a series of novels about the war, published in the 1920s.[68]

Laboureur and Martin also continued to elaborate on wartime themes in their work. War novels were reprinted, war correspondents published their dispatches (Hémard illustrated one of these collections), and there were retrospective publications of wartime sketches by artists like Laborde.[69] Affection for the *poilu* remained deep and passionate; Jean Oberlé drew on popular imagery when illustrating Joseph Delteil's *Les poilus* in 1926 (fig. 21).[70] Campaigns for the relief of the wounded and in aid of veterans also enlisted the help of illustrators like Brissaud, who, years later, were still supplying cover art for concert benefits. The war's effect lingered even in books having multiple subjects, as in Boucher's hand-colored woodcuts for *La vieille valse* by Pierre Matras.[71] Hermann-Paul produced a war-inflected *La danse macabre* that appeared in 1919.[72]

As might be expected, books for children retained the martial spirit. "All of children's literature breathed a military tone for years to come," comments Jean-Paul Gourévitch.[73] The children's magazine *Mon journal* opened a subscription in 1920 to erect a monument to child heroes of the war, and artists like Hansi, Job, and Gustave Fraipont glorified the conflict long after the armistice.

Some other artists seemed to complete (as well as begin) their graphic careers with their war work, but most of the artist-illustrators who had been so deeply involved in military themes thrived in the 1920s and after, although they moved on to very different subjects or returned to older preoccupations.

For ten or twelve years following the armistice, French publishers, binders, illustrators, typographers, and bibliophiles enjoyed a golden age, as fabled volumes and portfolios found their way to eager consumers.[74] Prosperity, in the luxury trades at least, transformed the wartime austerities facing artists and printers into a quickly vanishing memory. Fashion portfolios multiplied and graphic artists flourished as *livres d'artistes* by Matisse, Picasso, Braque, Dufy, Léger, and Chagall were joined by thousands of *demi-luxe* illustrated books. Stimulated in part by the arrival of Russian emigré artists, the children's-book industry also prospered.[75] Cubism returned as an option, and Surrealism soon established a strong voice. The power of vernacular art traditions remained a force.[76]

Within a short time, war themes grew distant for many of the popular artists, or went underground with the Surrealists. Indeed, the defeated enemy was far more active than the victor in directly eliciting the horrors of those years: Käthe Kollwitz, George Grosz, Max Beckmann, Erich Heckel, Ludwig Meidner, Ernst Ludwig Kirchner, Otto Dix, Ernst Barlach, and Karl Schmidt-Rottluff, among others, produced searing print portfolios, paintings, sculpture, and books reflecting the effects of the conflict. They were joined by some British and Belgian artists, but not by many French colleagues. The patriotic energies supporting the ferocious French effort seemed self-consuming. Once the war was over, these artists turned elsewhere, though endless ceremonies, photographs, political invocations, and visits to the ruined cities of northern France and Belgium certainly kept the psychological wounds open. [77]

This catalogue and exhibition, then, form a snapshot of a singular moment that captured the energies of French artists and illustrators as they served a supreme national crisis. They were able to draw upon old legacies and recent practices alike in their quest to assert art's relevance to patriotism, and its capacity to console as well as to encourage, to instruct as well as to revile. All the more reason, then, to acknowledge, on the centenary of The War To End All wars, this collective response and its deployment of hallowed imagery in the interest of the sacred cause.

NOTES

1 Charles Diehl, "Emile Bertaux," *Gazette des beaux-arts*, 13 (1917), pp. 1-8.

2 [Hilaire Noël Sébastien] Clément-Janin, "Les estampes et la guerre," *Gazette des beaux-arts*, 13 (1917), pp. 75-76.

3 Louise and Henri Leblanc gave their enormous holdings—pamphlets, maps, articles, posters, sheet music, novels, and manifestos—to the French State before the war had ended. A 397-page catalogue was published in 1917 and can be found online at http://archive.org/ under the Louise and Henri Leblanc Collection, University of Ottawa.

4 A photograph of the apartment is reproduced in Daniel J. Sherman, "Objects of Memory: History and Narrative in French War Museums," *French Historical Studies*, 19 (Spring 1995), p. 55. The Leblanc collection is now incorporated in the Bibliothèque de documentation internationale contemporaine. For more on the Leblancs, see Stefan Goebel, "Exhibitions," in Jay Winter and Jean-Louis Robert, eds., *Capital Cities at War: Paris, London, Berlin 1914-1919* (Cambridge, U.K., and New York: Cambridge University Press, 2007), vol. 2, pp. 163-64.

5 The three essays appeared in *Gazette des beaux-arts*, 13 (1917), pp. 75-94, 361-83, and 483-508. Along with a brief but aggressively patriotic introduction, they were published in book form as *Les estampes, images et affiches de la guerre* (Paris: Gazette des beaux-arts, 1919). The sections were subdivided somewhat differently, and the new introduction and appendix noted additional work. I have cited the original essays because the *Gazette* is more accessible in its periodical form in American libraries and also reflects the assessments of Clément-Janin while the war was on. The book is indexed and contains a separate list of illustrations.

6 *Gazette des beaux-arts*, 13 (1917), pp. 361-83.

7 Ibid., pp. 483-508.

8 For more information on Laforge and a bibliography, see François San Millan, *Lucien Laforge à l'index* (Paris: La Nouvelle Araignée, 2008); and Marcus Osterwalder, *Dictionnaire des illustrateurs 1905-1965* (Neuchâtel: Ides et Calendes, 2001), p. 964. Images of Laforge's work can be found on-line at magalerieparis.wordpress.com.

9 Notably *Abcdefghij…* (Paris: La Mercurie, 2010); *Les métamorphoses d'Aladin ou comment il fût passé au caviar* (Paris: Michalon, 2006); and *Les contes des fées de Charles Perrault. Illustrés par Lucien Laforge* (Paris: Albin Michel, 2008).

10 Clément-Janin, p. 488.

11 He may simply have liked the tonal contrast. His illustrations for *Le kama-soutra* (Penjab [Paris]: Les Amis Bibliophiles, 1924), juxtaposed amorous dark- and light-skinned models.

12 The only recorded copy in the United States is in the library of the Western Reserve Historical Society, Cleveland.

13 For more on French traditions of militarism, verbal and visual, see the arresting and occasionally absurd materials in Lucien Seroux, *Anthologie de la connerie militariste d'expression française*, 4 vols. (Toulouse: AAEL, 2003-8).

14 Lucien Descaves, *Ronge-maille vainqueur* (Paris: Ollendorff, 1920), pp. 2-3.

15 Richard Cork, *A Bitter Truth: Avant-garde Art and the Great War* (New Haven: Yale University Press, 1994), is the broadest survey of international artists' responses.

16 As early as 1916 systematic efforts were being made to chart artists' deaths. See Paul Ginisty, *Les artistes morts pour la patrie* (Paris: Félix Alcan, 1916). Ernest Peixotto, an American artist who served with the American Expeditionary Forces, described the contributions of artists in "Special Service for Artists in War Time," *Scribner's*, 62 (July 1917), pp. 1-10. Peixotto accompanied his essay with reproductions of drawings by French war artists.

17 Among them, though not included in this exhibition, was Jacques Touchet, *Croquis d'un prisonnier de guerre* (Paris: A. Marty, 1918).

18 In his preface to the book, the novelist Pierre Mac Orlan wrote movingly of the three prisoners, Boucher, Meunier, and Seheur, as representing the "French soul" in all its gaiety, transcending their somber surroundings. Seheur would go on to publish other books by Boucher in the 1920s.

19 For more, see Sylvain Laboureur, *Catalogue complète de l'oeuvre de Jean-Emile Laboureur*, 4 vols. (Neuchâtel: Ides et Calendes, 1969-91). For a commentary in English on Laboureur, see Gordon N. Ray, "The Art Deco Book in France," in Dorothy L. Vander Meulen, ed., *Studies in Bibliography*, 55 (2002), pp. 67-85.

20 For more on the debate over the relationship between Cubism and patriotism, see Elizabeth Louise Kahn, *The Neglected Majority: "Les camoufleurs," Art History, and World War I* (Lanham, Md.: University Press of America, 1984).

21 See the comments of Kenneth Silver in "Jean Cocteau and the Image d'Epinal," in Arthur King Peters, ed., *Jean Cocteau and the French Scene* (New York: Abbeville, 1984), p. 94.

22 Kenneth Silver, *Esprit de corps: The Art of the Parisian Avant-Garde and the First World War, 1914-1925* (Princeton: Princeton University Press, 1989).

23 For more on Epinal and its connection with twentieth-century artists, see *Epinal tricolore: L'imagerie Raoul Dufy, 1914-1918* (Epinal: Musée Départemental de l'Art Ancien et Contemporain, 2011). See also Jay Winter, *Sites of Memory*, *Sites of Mourning: The Great War in European Cultural History* (Cambridge, U.K., and New York: Cambridge University Press, 1995), pp. 122-31, for a discussion of Pellerin's history, political bias, and extensive influence. Several essayists in *Epinal tricolore* note that Epinal prints are often conflated with popular woodcut traditions of the nineteenth century. See Malou Schneider and Dominique Lerch, eds. *Des mondes de papier: L'imagerie populaire de Wissembourg* (Strasbourg: Musées de la ville de Strasbourg, 2010), particularly the essay by Jean-Hubert Martin, "Le réveil de la couleur entre imagerie de Wissembourg et art moderne," pp. 13-21. And for other print makers, see Jean Adhémar, *Stampe popolari francesi* (Milan: Electa, [1967]), pp. 165-91.

24 Jay Winter quotes an estimate that more than seventeen million examples of *imagerie d'Epinal* had appeared before 1870. Winter, *Sites of Memory*, p. 123. By the second half of the nineteenth century, many of the Pellerin firm's competitors had gone out of business, helping to account for Epinal's dominance as a production center. Pellerin reissued many of its early nineteenth-century prints as lithographs, and these somewhat simplified versions fed artist interest in the years just before and during the war itself. See *French Popular Imagery: Five Centuries of Prints* (London: Hayward Gallery, 1974).

25 See Stephen M. Norris, *A War of Images: Russian Popular Prints, Wartime Culture, and National Identity, 1812-1945* (De Kalb: Northern Illinois University Press, 2006), chap. 7.

26 Silver, *Esprit de corps*, pp. 41-42.

27 See Manon Pignot, *La guerre des crayons: Quand les petits Parisiens dessinaient la Grande Guerre* (Paris: Parigramme, 2004). See also Frederick Hadley, "Dessiner pendant la guerre: L'encadrement des enfants," in Manon Pignot et al., *Les enfants dans la Grande Guerre* (Péronne, Somme: L'Historial de la Grande Guerre, 2003). This well-illustrated catalogue accompanied an exhibition and contains several essays analyzing the impact of the war on children.

28 For a special take on the immense production of postcards, see Marie-Monique Huss, "Pronatalism and the Popular Ideology of the Child in Wartime France: The Evidence of the Picture Postcard," in Richard Wall and Jay Winter, eds., *The Upheaval of War: Family, Work and Welfare in Europe, 1914-1918* (Cambridge, U.K., and New York: Cambridge University Press, 1988), pp. 329-67.

29 See Pascal Ory, "De la presse enfantine à la bande dessinée," Henri-Jean Martin et al., *Histoire de l'édition française* (Paris: Promodis, 1986), vol. 4, pp. 468-79; Alain Fourment, *Histoire de la presse des jeunes et des journaux d'enfants 1768-1988* (Paris: Editions Eole, 1987); and Laurence Olivier-Messonnier, *Guerre et littérature de jeunesse (1913-1919): Analyse des dérives patriotiques dans les périodiques pour enfants* (Paris: L'Harmattan, [2012]). This last text provides the most sustained examination of children's magazines and the war.

30 Olivier-Messonnier, *Guerre et littérature*, p. 13, estimates that at least forty periodicals for children were established between 1914 and 1933.

31 For Hellé's toys see, among others, *Toys of the Avant-garde* (Málaga: Museo Picasso, 2010), pp. 80-81; the blog for the Association des amis d'André Hellé, which is linked on magalerieaparis.wordpress.com. Ma Galerie à Paris has done various articles on French illustrators of this period. Also see Jean-Hugues Malineau, *Images drolatiques d'André Hellé: Le petit monde d'André Hellé* (Paris: Michel Lagarde, 2012).

32 Alfred Tolmer and his firm were significant forces in the world of French children's illustration and fine advertising. See *Exposition Tolmer: 60 ans de création graphique dans l'Ile Saint-Louis* (Paris: Bibliothèque Forney, 1986). *Drôles de bêtes* has been recently reprinted (Paris: Editions MeMo, 2011), one of a series of classic French children's books that have attracted new interest.

33 For more on designer toys, see, as well as *Toys of the Avant-garde,* Juliet Kinchin and Aidan O'Connor, *Century of the Child: Growing by Design 1900-2000* (New York: Museum of Modern Art, 2012).

34 For more on this, see Glenn Watkins, *Proof through the Night: Music and the Great War* (Berkeley: University of California Press, 2003), chap. 6.

35 As did animals. See Stéphane Audoin-Rouzeau et al., *La guerre des animaux* (Péronne, Somme: L'Historial de la Grande Guerre, 2007).

36 In one expression of interest, the Art Institute of Chicago held a monthlong exhibition of French toys, beginning April 15th, 1918. The accompanying pamphlet, introduced by a Harriet Monroe poem, "Young France and Young America," featured twenty-three French toy makers (with their addresses), giving work to some whose lives were disrupted by the war. See *The French Toy: Exhibition of French Toys* (Chicago: Gunsaulus Hall, Art Institute of Chicago, 1918).

37 See the comments in Olivier Piffault et al., *Babar, Harry Potter et Cie.: Livres d'enfants d'hier et d'aujourd'hui* (Paris: Bibliothèque Nationale de France, 2009), pp. 448-52. Hellé also published *L'alphabet de la grande paix, 1918-19* (Paris: La Renaissance du Livre, 1919), but whether this was before or after *Le livre des heures héroïques* is unclear.

38 Hellé also demonstrated greater sensitivity to the disasters of war in his *Histoire de Quillembois soldat* (Paris: Berger-Levrault, 1919).

39 For more on Bécassine, see Olivier-Messonnier, *Guerre et littérature*, pp. 27-87.

40 Val-Rau (Valentine Rau) was a friend of the actor and playwright Jean Schlumberger, who may have introduced her to Jacques Copeau's celebrated and innovative Théâtre du vieux colombier in Paris, for which she apparently designed costumes in the years just before and during World War I. See *The Egoist*, 1 (March 16, 1914), p. 114, for a brief comment on both her costumes and her paintings.

41 For a short overview, see Laura Noesser, "Le livre pour enfants," in Henri-Jean Martin et al., *Histoire de l'édition française*, vol. 4, pp. 457-67.

42 Hovine [Jeanne and Laure], *Journal d'une poupée belge, 1914-1918* (Brussels: C. Dangotte, 1918).

43 For more on these publications and the fashion journals, see Mary E. Davis, *Classic Chic: Music, Fashion, and Modernism* (Berkeley: University of California Press, 2008), esp. pp. 44-61.

44 For more on Poiret, see Nancy Troy, *Couture Culture: A Study in Modern Art and Fashion* (Cambridge, Mass.: MIT Press, 2003). A recent bilingual catalogue for an exhibition at the Musée international de la parfumerie, Grasse, *Paul Poiret: Couturier-parfumeur* (Paris: Somogy, 2013), is also very helpful.

45 For more on Lepape, see Claude Lepape and Thierry Defert, *From the Ballets Russes to Vogue: The Art of Georges Lepape* (New York: Vendome Press, 1984).

46 "Beau Brummels of the Brush," *Vogue*, June 13, 1914, p. 35.

47 The comic illustrators Maurice Radiguet and Marcel Arnac published a satire on German women and fashion, *Mode in Germany: Ligue contre le mauvais goût anglo-français* (Paris: Ollendorff, [1915]). In this series of drawings even pets and makeup are not safe. *La baïonnette* was filled with unflattering portrayals of Germans attempting to ape French fashion, or to design their own.

48 For more on Barbier, see Ray, "The Art Deco Book in France," pp. 35-46; Barbara Martorelli, ed., *George Barbier: La nascita del déco* (Venice: Marsilio, Musei civici veneziani, 2008); and Unno Hiroshi, *Fashion Illustration and Graphic Design: George Barbier: Master of Art Deco* (Tokyo: Pie Books, 2011).

49 For more on *Le mot*, see Silver, *Esprit de corps*, pp. 43-51.

50 For more on Iribe, see Raymond Bachollet et al., *Paul Iribe* Paris: Denoël, 1982); and Silver, *Esprit de corps*, passim.

51 It is estimated that some twenty thousand different illustrated postcards were produced in France during the war, by more than seventy publishers. Printings of one hundred thousand copies or more were apparently not rare. See Huss, "Pronatalism in Wartime France," pp. 332, 359.

52 For more on this, see Stephen H. Goddard, *Ubu's Almanac: Alfred Jarry and the Graphic Arts* (Lawrence, Kans.: Spencer Museum of Art, 1997). Some commentators (including Clément-Janin) mythologized Georgin and may well have magnified his influence beyond existing influence. See Martine Sadion, "François Georgin: 'Maître' de Raoul Dufy," *Epinal tricolore*, pp. 43-53.

53 Arnoux continues to have a following, admirers of his repeated efforts to project French patriotism. See the website www.guyarnoux.fr.

54 Marcel Valotaire, *Charles Martin*. Les artistes du livre (Paris: Henry Babou, 1928), pp. 17-18.

55 See the commentary in David J. Porter and John Anzalone, "Clouds in the Sky: The *Sports et Divertissements* of Erik Satie and Charles Martin," *Bulletin du bibliophile* (2001, no. 2), pp. 343-72.

56 Valotaire. *Charles Martin*, pp. 21-22.

57 These were, respectively, *Les silences du Colonel Bramble* (Brussels: Editions du Nord, 1929) and *Les discours du Docteur O'Grady* (Brussels: Editions du Nord, 1932).

58 The Germans insisted that the cathedral was being used for military operations, with observers working atop the towers. For cartoons satirizing the French hiding behind art masterpieces, see Jean-Paul Auclert, *La Grande Guerre*

des crayons: Les noirs dessins de la propagande en 1914-18 (Paris: Robert Laffont, 1981).

59 Benito's illustrations were described as "amazing" by Barr Ferree, "War Books of the Cathedrals," *Architectural Record*, 44 (November 1918), pp. 476, one of many contemporaneous reviews of the literature describing the devastation at Reims, Senlis, Soissons, and elsewhere in the northern départements of France.

60 For the explosion of illustrated journals at this time see Martine Thomas et al., *Le dessin de presse a l'époque impressioniste, 1863-1908* ([Paris]: Democratic Books, 2008).

61 For more on *Le canard enchaîné*, see Allen Douglas, *War, Memory, and the Politics of Humor: The Canard Enchaîné and World War I* (Berkeley: University of California Press, 2002).

62 For more, see Raymond Geiger, *Hermann Paul*. Les artistes du livre (Paris: Henry Babou, 1929).

63 Hermann-Paul, *Les 4 saisons de la kultur* (Paris: Dorbon-aîné, 1915).

64 Interestingly, the views of the French politician Gustave Hervé, whose newspaper *La victoire* Hermann-Paul worked for, took a parallel course, from extreme antimilitarism to a form of national socialism and right-wing nationalism.

65 John Anzalone, "Hermann-Paul et la guerre sur bois," *Bulletin du bibliophile* (2009, no. 1), pp. 142-62.

66 Well documented in Jean-Pierre Doche, *Poulbot et le livre* (Paris: L'Apart, 2011).

67 For more on *Jean sans pain*, see Margaret R. Higonnet, "Picturing Trauma in the Great War," in Elizabeth Goodenough and Andrea Immel, *Under Fire: Childhood in the Shadow of War* (Detroit: Wayne State University Press, 2008), pp. 115-28. In this same collection, see also Eric J. Johnson, "Under Ideological Fire: Illustrated Wartime Propaganda for Children," pp. 59-75.

68 Notably several books published by Roland Dorgelès. See *La guerre de 1914-18 par quelques artistes* (Paris: Musée des arts décoratifs, 1940). I thank Olivier Zunz for bringing this catalogue to my attention.

69 The cover and illustrations by Hémard were for Pierre Mac Orlan, *La fin: Souvenirs d'un correspondant aux armées en Allemagne* (Paris: L'Edition Française Illustrée, 1919). Laborde's work was gathered and published much later. See Guy Laborde, *Ecole de patience: La guerre vue par Chas Laborde* (Monaco: A la Voile Latine, 1951). Nicolas Beaupré et al., *Xavier Josso: Un artiste combattant dans la Grande Guerre* (Paris: Somogy, 2013), documenting an exhibition at the Musée de la Grande Guerre du pays de Meaux, features the many drawings, prints, and letters of this artist-soldier.

70 Most notably its stenciled frontispiece. See Joseph Delteil, *Les poilus: Epopée* (Paris: Editions du Loup, 1926).

71 Pierre Matras, *La vieille valse* (Paris: Marcel Seheur, 1920).

72 Hermann-Paul, *La danse macabre* (Paris: Léon Pichon, 1919).

73 Jean-Paul Gourévitch. *Images d'enfance: Quatre siècles d'illustration du livre pour enfants* ([Paris]: Editions Alternatives, 1994), p. 71.

74 The best description in English of this extravagant era of book making can be found in Ray, "The Art Deco Book in France." See also Antoine Coron, "Livres de luxe," in Martin et al. *Histoire de l'édition française*, pp. 408-37.

75 See Alban Cerisier and Jacques Desse, *De la jeunesse chez Gallimard: 90 ans de livres pour enfants. Un catalogue* (Paris: Gallimard, 2008).

76 The idealization of French peasant traditions played a large role. See Romy Golan, *Modernity & Nostalgia: Art and Politics in France between the Wars* (New Haven: Yale University Press, 1995), chaps. 1-2. For variations on popular art traditions, see, for example, the lithographic illustrations by Lucien Boucher for Pierre Mac Orlan, *Les boutiques* (Paris: Marcel Seheur, 1925), and Mac Orlan, *Les boutiques de la foire* (Paris: Marcel Seheur, 1926).

77 For more, see Daniel J. Sherman, *The Construction of Memory in Interwar France* (Chicago: University of Chicago Press, 1999).

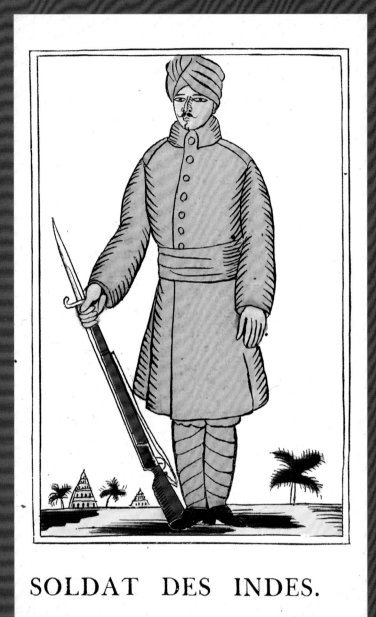

SOLDAT DES INDES.

Teri J. Edelstein

CATALOGUE

THE ALLIES

T**HE THREAT OF WAR**, shifting alliances, and accompanying intrigues had been roiling Europe for decades before the assassination of Archduke Franz Ferdinand of Austria, on June 28, 1914, thrust the Triple Entente into combat with the Central Powers: Germany and the Austro-Hungarian and Ottoman empires. Invaded countries and others now joined the French Republic and the British and Russian empires to create the Allies. French illustrators used a number of techniques to show unity in diversity: visualizing national anthems, introducing foreigners in their various uniforms, gathering together colorful flags, picturing soldiers from many countries fighting for the cause. Assorted publications defined the group differently. The portfolio *Hymnes alliés* featured twelve allies, unusually adding China.

CHASSEUR A PIED.

SOLDAT ÉCOSSAIS.

COSAQUE DU DON.

SOLDAT ANGLAIS.

TIRAILLEUR SÉNÉGALAIS

DRAGON ANGLAIS·

ARTILLERIE DE 75.

1

Raoul Dufy. *Les alliés: Petit panorama des uniformes.* Paris: Iribe & Cie, [1915]

As an artist of the French avant-garde, Dufy is frequently classified as a Fauve. During the Great War, however, he adopted a purposefully simplified style, evoking the brightly colored popular "Epinal" prints, frequently nationalistic, inexpensively produced, and widely distributed in the nineteenth century. In a style even more naive than his sources, Dufy produced posters and pamphlets for the French Press Commission. In this work, he represents the Allies as of 1915. According to legend, the French artilleryman is a portrait of Dufy's friend Guillaume Apollinaire, a member of the Thirty-eighth Regiment. The poet and playwright was seriously wounded in 1916.

2

Robert Bonfils. *Le bouquet des alliés.* [S.l.: s.n.], 1915

Some postcards were clearly intended to be collectibles. This set by Robert Bonfils is one of the most ingenious, mimicking the six sheets plus cover of full-size portfolios. The theme is the familiar one of the Allies. Each is depicted as a flower: England as a thistle, France as a rose, Russia as a mum. Worms, beetles, frogs, flies, and snakes wearing the pickelhaube threaten their beauty but bug and butterfly soldiers defend their blooms. Bonfils has solved the problem of uniting these disparate countries in the most imaginative way, combining them in a bouquet of blooms, their diversity only enhancing the harmony of the whole.

LA BRABANÇONNE

HYMNE BELGE

3

Les musiques de la guerre. Illus. by Paulet Thévenaz. Paris: Chez Tolmer & Cie., 1915

The lighthearted cover of *Les musiques de la guerre*, featuring three children—Russian, French, and Scottish—singing and playing instruments, does not prepare us for the images within. The music of the war exemplifies a popular theme of unity in diversity: the anthems of the Allies. Heading one page is a narrow horizontal illustration of the country at peace, facing it are the degradations of war, above the words and music. Contented Belgians reside in the sunny countryside. Opposite, starving, they huddle on the deck of a ship in stormy seas heading for refuge in Ireland. On another opening, ecstatic citizens of France sing the "Marseillaise" at the founding of the Republic. Facing, Marianne leads the troops in battle.

4

Paul Ancrenaz. "Le choeur des Boches." *La baïonnette*, 20 juillet 1916. Paris: L'Edition Française Illustrèe

The pages of *La baïonnette* are filled with the work of talented artists whose names as illustrators are not known today. The radically simplified forms, strong outlines, and use of intense colors of Paul Ancrenaz suggest the work of Lucien Laforge. The editors of the magazine noted Ancrenaz's originality and accorded him the honor of the back page. "The Optimist," a portrait of David Lloyd George, was not only the two-page centerfold in one issue, it was the cover for an issue of *Le coup de baïonnette*, a selection of issues regularly published at four francs. The broad passages of color and the circular forms with dotted edges in many of Pierre Legrain's illustrations remind us of his later fame as one of the greatest bookbinding designers of the Deco era.

5

Pierre [-Emile] Legrain. "L'optimiste." *La baïonnette*, 30 septembre 1915. Paris: L'Edition Française Illustrée

6

"God Save the King." Illus. by Gérard Cochet. *Les hymnes alliés.* Paris: Le Nouvel Essor, [1917]

Finding common ground among the disparate Allies during the war was a goal often met by allusion to or even by reproducing national anthems. This portfolio displays the differing styles of each artist representing a country. Gérard Cochet followed a common French misunderstanding by clothing his English soldier in a Scottish kilt. Whether the French admired, or envied, the sight of men in skirts or whether they chose to subtly mock their historic enemies, now their staunchest allies, is unknown.

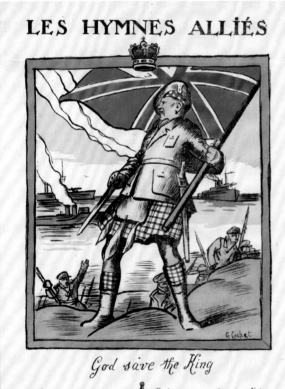

7

"Hymne monténégrin." Illus. by Lucien Laforge. *Les hymnes alliés.* Paris: Le Nouvel Essor, [1917]

The deployment of such portfolios as *Les hymnes alliés* is undetermined, but if anyone did affix the depictions of the twelve Allies plus the cover sheet to a wall the most eye-catching would certainly have been this one. Lucien Laforge created an almost abstract composition of unmodulated blocks of brilliant red, blue, and orange with a green triangular accent on the horizon. The staunch Montenegrin stands on a rocky outcropping on the edge of the Adriatic Sea, perhaps at the port of Bar. He looks toward the horizon where we might see a French ship outrunning the blockade to bring much-needed supplies.

8

"Hymne américain." Illus. by Hermann-Paul.
Les hymnes alliés. Paris: Le Nouvel Essor, [1917]

The United States formally entered World War I on April
6, 1917. Hermann-Paul's contribution to the series cel-
ebrates the land of the free and the home of brave. In
a circle of support, a contemporary American doughboy,
with the industrial might of the United States behind
him, joins hands with an eighteenth-century French sol-
dier, behind him the French ships that came to the aid of
the fledgling republic. Under the stars and stripes at the
center of the composition the Statue of Liberty repre-
sents the goals of the struggle and the historic friendship
between France and the United States.

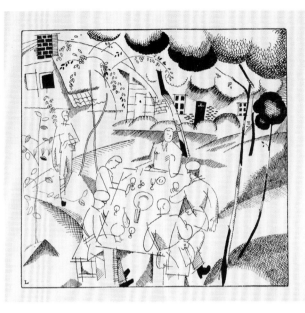

9

Xavier Marcel Boulestin. *Dans les Flandres
britanniques.* Illus. by Jean-Emile Laboureur.
Paris: Dorbon-aîné, 1916

In *Dans les Flandres britanniques,* Laboureur's illustrations
reflect his time with the British Expeditionary Forces in
Belgium acting as an interpreter for the army. Perhaps
because he was not directly involved with the fight-
ing, the book portrays the soldiers at leisure attending
an impromptu theatrical performance, viewing boxing
matches, flirting with pretty girls. However, in this rep-
resentation of an outdoor scene, the shapes of the trees
recall the smoke of battle. Laboureur's simple abstracted
figures and almost cubist landscapes reveal his involve-
ment with contemporary avant-garde art.

LES HYMNES ALLIÉS

★ HYMNE AMERICAIN ★
LA BANNIÈRE ÉTOILÉE FLOTTE SUR LE
PAYS DE LA LIBERTÉ ET LE FOYER DES BRAVES

Image de Hermann-Paul, tirée à 1 000 exemplaires, éditée à PARIS, par le NOUVEL ESSOR, 84, rue des S.-Pères

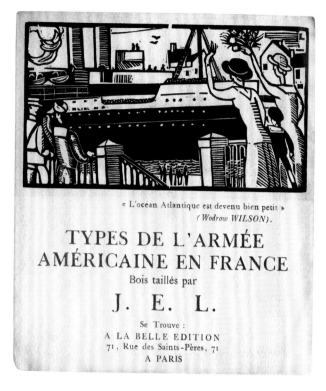

10

A.S.C. [Army Service Corps]. *Types de l'armée américaine en France.* Illus. by Jean-Emile Laboureur. Paris: A La Belle Edition, 1918

Created on the occasion of President Wilson's visit to the Paris Peace Conference, the cover of Laboureur's book depicts women and children waving welcome as the American forces arrive in France. One woman flourishes a large bouquet as the ship steams into port. The other illustrations, printed in black on a ground of either green or yellow, present faces of the Americans, beginning with the General, and including every branch of the military. An African American dockworker comes before the pilot, and bringing up the rear is the secretary who helps manage them all. The strong lines and minimal details of the portrait vignettes, done in woodcut, make this one of Laboureur's most distinctive wartime works.

11

Roger Boutet de Monvel. *Le bon Anglais.* Illus. by Guy Arnoux. Paris: Chez Devambez, 1914

12

Roger Boutet de Monvel. *Carnet d'un permissionnaire.* Illus. by Guy Arnoux. Paris: Chez Devambez, 1917

Le Brancardier

Le Communiqué.

L'heureux Filleul.

Paris.

13

Roger Boutet de Monvel. *Nos frères d'Amérique.* Illus. by Guy Arnoux. Paris: Chez Devambez, [1918]

In addition to numerous portfolios and large-format books on the war, Guy Arnoux created a series of small, almost postcard-size books featuring the French or their allies. The spare and strong illustrations portray a typology of the troops fighting for the noble cause, although they seldom stray beyond stereotype. In *Le bon Anglais* we see the Irish making merry, an English major relaxing against a bar, and the Black Watch in their plaid trousers and kilts. Even the staunch soldiers from the USA and France take note of their compatriots dressed in skirts in *Nos frères d'Amérique* (Our American brothers).

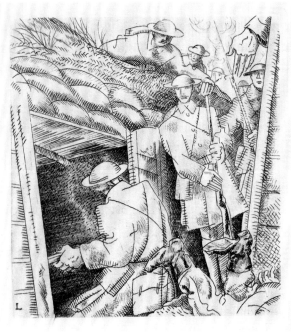

14

14

André Maurois. *Les discours du Docteur O'Grady*. Illus. by Jean-Emile Laboureur. Paris: Société d'Edition, 1929

Having worked with the British Expeditionary Forces himself, like André Maurois, the author, J.-E. Laboureur, proved a perfect illustrator of Maurois's garrulous post-war tale of the comic adventures of Doctor O'Grady during the conflict. Laboureur worked in different styles for his various books on the war. This volume is his most realistic and detailed. In one of the rare illustrations in which the war itself enters the narrative, the choice of the etching medium allowed Laboureur to contrast the dark recesses of the trenches with the daylight on the battlefield—although the light also contains the awkwardly splayed legs and an arm of dead compatriots at the edge of the composition.

15

André Maurois. Cover. *Les silences du Colonel Bramble*. Illus. by Charles Martin. Brussels: Aux Editions du Nord, 1929

Published just as the war ended in 1918, *Les silences du Colonel Bramble* quickly became immensely popular, inspiring many illustrated editions for years to come. Using his experiences as a translator and liaison officer to the British forces, André Maurois's slightly comic tale captured the public imagination in many Allied countries. For the victors, the horrors of the war seem to have quickly receded. Although Charles Martin reprised many visual elements from *Sous les pots de fleurs*, these men fight the war with a smile and a cheerful heart.

15

16

André Maurois. Cover. *Les discours du Docteur O'Grady*. Illus. by Charles Martin. Brussels: Aux Editions du Nord, 1932

Inspired by his extraordinary publishing success, André Maurois followed Colonel Bramble's adventures with the exploits of Doctor O'Grady. Again, many editions

ANDRÉ MAUROIS

LES DISCOURS DU DOCTEUR ·O'GRADY·

16

illustrated by different artists followed. New editions of both books continued to be produced for at least fifty years, attesting to their enduring popularity. Charles Martin illustrated both in companion volumes issued in 1929 and 1932. Although the novels take place during the war, the wreath of victory already decorates the cover.

Paul Iribe. "La danse macabre." *La baïonnette*, 13 avril
1916. Paris: L'Edition Française Illustrée

ENEMIES

O NE WAY OF UNITING EVERYONE in the country was to make the foes of France vivid to soldiers and citizens alike. The Central Powers were mocked, vilified, and satirized. The Germans received most of the attention—the pointed pickelhaube helmet became a common symbol for them. Franz Josef, emperor of Austria and king of Hungary, is represented as being in his dotage in *La baïonnette*'s "Impérial gaga." And, the Ottoman Empire allowed illustrators to include a touch of the exotic.

Tancrède Synave. "Impérial gaga." *La baïonnette*, 5 août 1915. Paris: L'Edition Française Illustrée

SEM [Georges Goursat]. "Têtes de Turcs." *La baïonnette*, 15 juillet 1915. Paris: L'Edition Française Illustrée

17

La baïonnette: Enemies

Published weekly from July 8, 1915, until April 22, 1920, for an initial price of twenty centimes, the satirical magazine *La baïonnette* conveyed its take on the war visually, with no photographs and very little text. In its initial appearances, *La baïonnette* exemplified the expression

"Keep your friends close and your enemies closer." The first issue was entitled "Le kaiser rouge," and all the numbers that immediately followed were devoted to a satiric examination of the enemy, an ongoing preoccupation. A sample of titles will demonstrate: "Le clownprinz," "Têtes de Turcs," "Bouillon de kultur."

SEM [Georges Goursat]. "Pacifistes." *La baïonnette*, 3 août 1916. Paris: L'Edition Française Illustrée

A[dolphe Léon] Willettte. "Leurs espions." *La baïonnette*, 19 août 1915. Paris: L'Edition Française Illustrée

18

La baïonnette: The Enemy Within

An enormous number and variety of French artists contributed to *La baïonnette*'s pages, primarily those who specialized in illustration. Each sixteen-page issue focused on a particular theme, beginning with an arresting cover. Although cheaply printed in black and white with some process color, *La baïonnette* forcefully transmitted its messages: how the war affected each French citizen, the evil of the enemy, the details of the conflict. The enemy in one's midst was not spared: the civilians who eschewed patriotism and commitment, spies (evidently servants were especially suspect—the cover features an evil nursemaid), pessimists, and pacifists all came under the point of the bayonet.

[Lucien-Henri] Weiluc. "Les pessimistes." *La baïonnette*, 23 septembre 1915. Paris: L'Edition Française Illustrée

19

Paul Iribe. *La baïonnette*. Paris: L'Edition
Française Illustrée

Paul Iribe was unquestionably the most powerful contrib-
utor to *La baïonnette*, represented by covers and numer-
ous illustrations. The centerfold of each issue featured
a two-page graphic, and Iribe contributed a dispropor-
tionate share of these. A protagonist from his 1908 *Les
robes de Paul Poiret* wandered into one but the searing
power of his creations belied Iribe's association with
fashion. One special number, "La danse macabre" (April
13, 1916), devoted exclusively to images by Iribe, was reis-
sued in a luxury edition of 380 copies. "Les fossoyeurs
de la mer," depicting the "pirate" U-boats, demonstrates
his stark, commanding compositions, his exploitation of
large visual masses, and his palette of few colors.

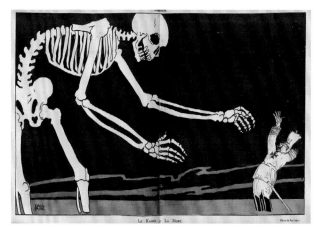

"Le kaiser et la mort." *La baïonnette*, 4 novembre 1915

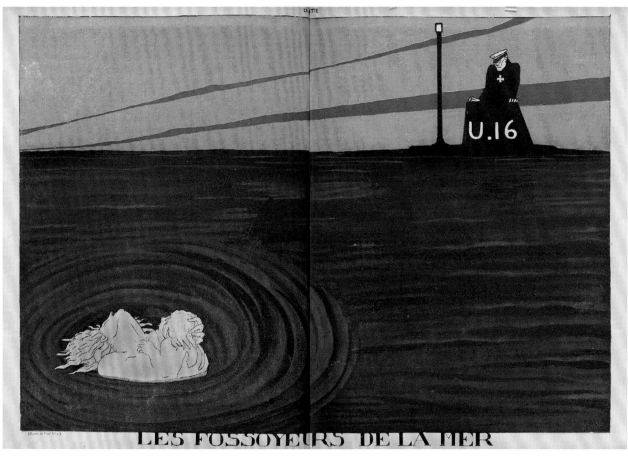

"Les fossoyeurs de la mer." *La baïonnette*, 22 juin 1916

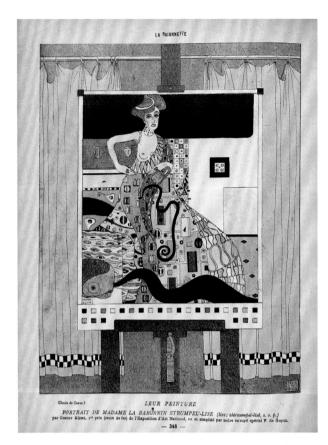

Félix de Goyon. "Leur peinture: Portrait de Madame la Baronnin Strumpel'-Lise par Gustav Klimt." *La baïonnette*, 31 mai 1917. Paris: L'Edition Française Illustrée

20

La baïonnette: German Art

French artists are often accorded prominence in discussions of the development of radical artistic styles but during the war abstraction and other cutting-edge modes were often placed in the enemy camp and excoriated. More than once the pages of *La baïonnette* ridiculed the "culture" of the enemy. An issue entitled "Other Atrocities" linked avant-garde art with such abominations as the book *Psychoboche* (*Boche* is disparaging slang for a German) and the hideous fashions depicted by Iribe in the centerfold. The caption to "Leur art" (Their art) exclaims, "German Art! Er! Everything is like a pig!" In this case, that observation extends to the physiques of the viewers.

Fernand Palmieri. "Leur art." *La baïonnette*, 31 mai 1917. Paris: L'Edition Française Illustrée

21

Joseph Hémard. *Chez les Fritz, notes et croquis de captivité.* Paris: L'Edition Française Illustrée, 1919

Hémard documented his years as a prisoner of war from October 1914 until December 22, 1918. The keen observation of human nature, the humor, and the dynamic shorthand that are so prevalent in his later career are already much in evidence. He classified his fellow prisoners: the differences between Russians from Moscow and those from the Caucasus, the variety of sports and activities that occupied the men, the many different poses the spectators could assume, the diversity of his compatriots, who included, to name a few, Arabs, Senegalese, Serbs, Italians, and Japanese—a true gathering of the Allies.

22

Lucien Laforge. *Conte de fées*. Paris: Librairie Lutetia, [n.d.]

Lucien Laforge frequently worked in a simplified, almost crude, style. Here using the format of a comic book, and chiefly primary colors, he recapitulated the story of World War I as a fairy tale. *Conte de fées* is a broadside, stenciled and calligraphed. Five lovely girls are playing happily in a garden when a gigantic hideous ogre, wearing the spiked helmet (pickelhaube) often used as shorthand to signify the enemy, accosts beautiful France, Belgium, and Britain. He tramples cities in his assault. All the children resist and, eventually, he is defeated and decapitated. "Peace returned for all time."

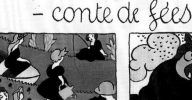

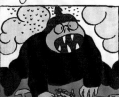

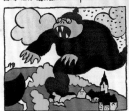

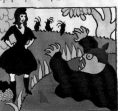

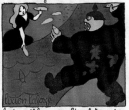

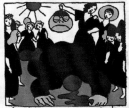

23

23

Mario Meunier. Frontispiece. *Images de la vie des prisonniers de guerre.* Illus. by E. L[ucien] Boucher. Paris: Marcel Seheur, [1920]

The lively action and cheerful colors in the frontispiece of Boucher's record of his tenure in a German prisoner-of-war camp give no inkling of the subject and tone of the images that reside within. In his preface Mac Orlan aptly calls them beautiful images both melancholic and sardonic. They capture the unending boredom and depression of imprisonment with purposefully simple compositions. Even the muted colors echo the inmates' despair and Meunier's brief evocative texts read like prose poems. What this image does share with the interior illustrations is the combination of large blocks of color, oblique angles, and abstracted forms that clearly owe something to Japanese prints and avant-garde practice.

24

Mario Meunier. "A ceux qui sont restés." *Images de la vie des prisonniers de guerre.* Illus. by E. L[ucien] Boucher. Paris: Marcel Seheur, [1920]

This book unfolds as a series of vignettes: prisoners building a railway under the vigilant eye of a prison guard; the jugs used to carry the watery beetroot broth fed to the unhappy men (with the ironic title: "Nature morte"); the famished naked bodies contorting to catch the water in a communal shower; a ragtag group of Allies having their picture taken. But whatever their portrayal of ennui and privation, the three creators associated with this book returned home. Those depicted in the final plate remained, their companions, the crows flying in the clear sky and the sun casting the dark shadows of their crosses.

24

OCTOBRE
1914

REIMS

Lib. Lutetia, éd. Bois taillé au canif par Hermann-Paul

THE WAR BETWEEN COVERS

A **NUMBER OF PORTFOLIOS** were issued that deal, exclusively or in part, with the conflict. Their exact uses remain unknown. Smaller than most posters, some may have hung on walls or in windows. Many featured eye-catching color and bold shapes. Whether displayed publicly or viewed privately, each offered a perspective on the struggle.

25

Hermann-Paul. "Octobre 1914 Reims."
Calendrier de la guerre, 1ière année, août 1914-juillet 1915. Paris: Lutetia, 1915

The bombardment of Reims Cathedral began in 1914 and continued through 1917 with one brief respite when the Germans occupied the town for several days. Contemporary French opinion held that the Germans purposely aimed at the cathedral, the traditional site of French coronations. This example of German barbarism became a major propaganda theme. Postcards from 1914 already document the damage. The woodcut by Hermann-Paul depicting October 1914 shows an injured soldier being helped from the exploding rubble by a nurse. The Smiling Angel from the central portal of the facade, a symbol of the cathedral, looks on beatifically.

26

Hermann-Paul. "Décembre 1914 enrôlements."
Calendrier de la guerre, 1ière année, août 1914-juillet 1915. Paris: Lutetia, 1915

Hermann-Paul included the Allies in his scenes as well, and the British were vital to the war effort. The French were fascinated by Caledonian male clothing, and the artist depicted the mobilization of a Scottish soldier dressed in his kilt, his nationalistically appropriate breed of dog waiting faithfully. With the troopship behind him, the soldier bids good-bye to his sweetheart, whose head is bowed in sorrow. Her windblown blue dress is echoed by the birds wheeling in the sky, one above her head facing east toward France.

26

27

Hermann-Paul. "Juin 1915 obus." *Calendrier de la guerre, 1ière année, août 1914-juillet 1915.* Paris: Lutetia, 1915

In these scenes, everyone in France contributes to the war effort. In "Obus" (Cannon Shell) a young boy and a woman work in a factory that is depicted in a vignette over their heads. Lines of completed shells, ready to be rushed to the front, are stacked on shelves behind them receding in a diagonal. The almost empty top shelf signals their ongoing task. Hermann-Paul's strong lines convey the weight of the shell and the determination of the workers.

28

Hermann-Paul. "Juillet 1915 permissionnaires." *Calendrier de la guerre, 1ière année, août 1914-juillet 1915.* Paris: Lutetia, 1915

Echoing the spirit of the scene, this sheet of the portfolio features more color than in "Juin 1915." A soldier on leave and his sweetheart stroll, framed by an arbor of foliage, her face shaded by a pink straw hat. Although they smile and hold hands, the hues, and perhaps their underlying mood, are subdued. A soldier on leave is depicted in another colored woodcut, also published by Lutetia, in an edition of four hundred copies. *La prière du poilu* is by Jean-Carl de Vallée, a painter and printmaker who served in the artillery and died in action in 1917. Presciently, here the mood is despondent as a kneeling woman sobs at the side of the brave praying soldier (see p. 155).

29

Hermann-Paul. Cover. *Calendrier de la guerre, 2ème année, août 1915-juillet 1916.* Paris: Lutetia, 1916

It was probably a broader French optimism about the length of the war that motivated several artists to begin calendars of the conflict. But after the completion of this second portfolio in July 1916, Hermann-Paul, his publisher Lutetia, or both, lost heart, and the enterprise was ended. Like the first portfolio cover, this wrapper is decorated with emblems of military might: airplanes, exploding bombs, and the flags of the Allies. Lutetia issued a great many works related to the war.

30

Hermann-Paul. "Août 1915 Nicolas Nicolaievitch." *Calendrier de la guerre, 2ème année, août 1915-juillet 1916.* Paris: Lutetia, 1916

The sheets of Hermann-Paul's second portfolio establish a chronology of the war through depictions of a series of commanders. These stand proudly in the foreground, while the background alludes to events of the conflict. Grand Duke Nicolas Nicolaievitch, commander in chief of the Russian armies on the eastern front, is resolute, while citizens flee a burning city, carrying their children and their belongings on their backs. An onion-dome church will fall victim to the flames. This may refer to the Sventiany offensive of August 1915, when the German army launched an attack against the Russians, who ultimately triumphed in the battle.

31

Hermann-Paul. "Septembre 1915 Joffre."
Calendrier de la guerre, 2ème année, août 1915-juillet 1916. Paris: Lutetia, 1916

In September 1915 the French general Marshal Joseph Joffre launched a third and final offensive at Artois meant to exploit the superior manpower of the Allies against the Germans. Joffre was previously responsible for the much-praised victory at the first battle of the Marne in 1914, making him, at this point, an extraordinary hero to the French. Behind him soldiers run across the horizon line of a desolate landscape. Explosions fill the air around them.

32

Hermann-Paul. "Janvier 1916 Kitchener."
Calendrier de la guerre, 2ème année, août 1915-juillet 1916. Paris: Lutetia, 1916

January 1916 was a terrible month for the British imperial forces. The final defeat in the eight-month siege of Gallipoli claimed almost half a million lives, the Allies suffering the greatest losses. But Field Marshal Horatio Herbert Kitchener stands proudly, decorated with his numerous honors, in front of the Union Jack. The 1914 recruiting poster featuring Kitchener pointing out of the frame—"Kitchener wants YOU"—served as the model for the 1917 poster of Uncle Sam by James Montgomery Flagg. Kitchener might appear steadfast because conscription was instituted in the United Kingdom on January 27, 1916.

33

Robert Bonfils. Cover sheet. *La manière française*. Paris: Librairie Lutetia, [1916]

The twenty sheets of this portfolio are housed in an elaborate decorated folder. On its cover *La belle France* rides through foliate flowering arches astride a horse, clothed in the *tricolore* and wearing the blue metal Adrian helmet, named for its designer, August-Louis Adrian, and introduced by the French in 1915. The allies later adopted a version of it. Extravagant endpapers enclose the whole; decorated with red, white, and blue round roses, an exploded cocarde, and bearing the words "Vive la France," the portfolio is also tied with tricolor ribbons. On the similar cover sheet, France shelters two children clothed in the Belgian flag.

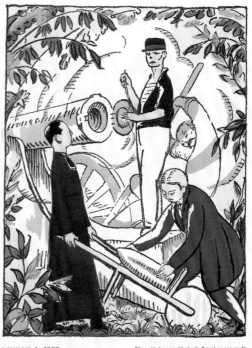

L'UNION SACRÉE.

... Elle sera héroïquement défendue (la France) par tous ses fils, dont rien ne brisera devant l'ennemi l'Union Sacrée, et qui sont aujourd'hui fraternellement assemblés dans une même indignation contre l'agresseur et dans une même foi patriotique.
RAYMOND POINCARÉ, 4 Août 1914.

34

Robert Bonfils. "L'union sacrée." *La manière française*. Paris: Librairie Lutetia, [1916]

Bonfils traced the history of the war, beginning with mobilization. In "L'union sacrée," the "sacred union," a priest, a citizen, and a soldier personify the truce in which the political Left agreed not to oppose the war or call a strike. On this page, all work for the war effort. The bottom of every sheet has a quotation, here from the declaration of war by Raymond Poincaré, president of France: "She will be heroically defended by all her sons; nothing will break their sacred union before the enemy; today they are joined together as brothers in a common indignation against the aggressor, and in a common patriotic faith. 4 August 1914."

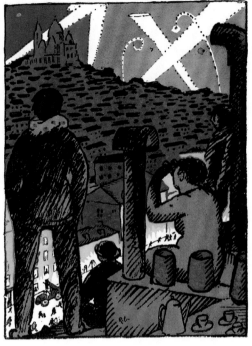

LA RÉCEPTION DES ZEPPELINS

... Les pompiers cornaient la prudence, mais les Parisiens, indifférents au danger, se répandaient dans les rues ou montaient sur les toits pour mieux suivre l'évolution du pirate...

(Le T...).

LES MARRAINES

... Elle est touchante, pendant cette guerre atroce, la sollicitude des femmes françaises pour leur poilu, leur filleul, comme elles l'appellent. Dans la vie confortable qu'elles mènent, elles ne cessent de penser à lui, de le lui dire dans de réconfortantes lettres, lui prouver par l'envoi de précieux colis.

M. B.

35

Robert Bonfils. "La réception des zeppelins." *La manière française*. Paris: Librairie Lutetia, [1916]

Most of the zeppelin raids were on England but Paris was attacked on the night of March 20/21, 1915. A German propaganda card documents their bombing of Calais the month before. Bonfils fully exploited the dramatic diagonals of the searchlights crisscrossing the night sky, silhouetting Sacré-Coeur with their beams. The main subject, however, is the gawkers on the roofs. The text praises the constant vigilance of the firemen while noting the citizens following the depredations of the Germans. Onlookers have even brought refreshments; observe the coffeepot and cups at the lower right.

36

Robert Bonfils. "Les marraines." *La manière française*. Paris: Librairie Lutetia, [1916]

Marraines, or "godmothers," were women pen pals for soldiers in a program encouraged by the French government. Over the course of the portfolio, Bonfils varied the color palette of the sheets of *La manière française*. This nighttime scene creates dramatic shadows. Framed by extraordinary purple polka-dotted curtains, the *marraines* knit socks and write letters to "their *poilu*, their godson," as the text explains. A "precious parcel" is already addressed, ready to send to the front. They work by light shaped by a lampshade decorated with silhouettes. Prominent is a man in a Chinese hat under a tree. Bonfils created a similar scene for the representation of China in the portfolio *Les hymnes alliés*.

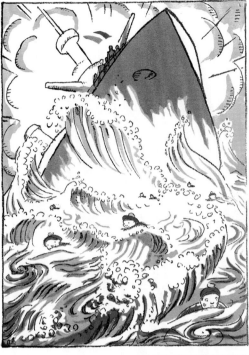

SUR MER.

... On vit alors l'état-major du « Bouvet » debout sur le pont,
avant d'être englouti, saluant le drapeau du cri de : « Vive la
France ! »

(Patris, journal grec).

VERDUN

... Un capitaine d'artillerie m'a raconté l'histoire suivante sur sa batterie : « C'était au plus
fort de l'assaut et leurs canons tiraient coup après coup en toute vitesse. Après 7 ou 800 coups, ils
étaient si chauds qu'il était impossible de continuer le tir avant que les pièces fussent refroidies.
Il n'y avait pas d'eau, excepté dans les bidons des hommes ; les hommes mouraient de faim et de soif ;
ils refusaient à boire une seule goutte, réservant toute leur provision d'eau pour refroidir les pièces. »

(Récit de M. J. Arren, représentant officiel de la presse britannique à Verdun, 5 mars 1916).

37

Robert Bonfils. "Sur mer." *La manière française.*
Paris: Librairie Lutetia, [1916]

On March 18, 1915, the French battleship *Bouvet* was
engaged in an attack on a Turkish fortress in the
Dardanelles when it was struck by shellfire eight
times; the ship then hit a mine and sank. Only about
50 men of 710 were saved. Bonfils depicted the
drowning sailors behaving in an appropriate *manière
française*. As the text reports, the officers stood on the
bridge, saluted the flag and cried, "Vive la France!"

38

Robert Bonfils. "Verdun." *La manière française.*
Paris: Librairie Lutetia, [1916]

The battle of Verdun, fought on the western front by
France and Germany, began on February 21, 1916. When
the report by a British press officer quoted here was
filed on March 5, 1916, it would have seemed beyond
the realm of possibility that the battle would continue
for more than nine months, ending in late December
1916. Bonfils anticipated the French victory: his sol-
diers in blue advance inexorably through lines of
blasted trees. It is estimated that between three-
quarters of a million and one million men died at Verdun,
each side paying a terrible price for the men's bravery.

40

Louis Lefèvre. "Sur le pont." *Rondes glorieuses.* [S.l.: s.n., n.d.]. 1^ière série

The French children's song "Sur le pont d'Avignon" dates to the fifteenth century. Here the site is transposed from the bridge in Avignon to a makeshift one constructed from a plank spanning a trench in a pockmarked battle-field. Two French infantrymen carry munitions across its precarious span while bombs burst in the sky. The left arm of the nearest soldier breaks through the frame of the picture into our own space, rendering the scene especially immediate. The original song contains a reference to the military: in the third verse soldiers are instructed to salute, perhaps one more ironic allusion on the artist's part.

39

Louis Lefèvre. "C'est un fils au kaiser." *Rondes glorieuses.* [S.l.: s.n., n.d.]. 1^ière série

Rondes glorieuses is a web of mysteries and contradictions. Nothing is known of the illustrator beyond his self-description (self-portraits) as a soldier with six stripes (of service) from the 124th Infantry, projectors section. Neither of the two portfolios, totaling twenty sheets, identifies a publisher, place of publication, or date, although their subjects, style, mode of publication—in numbered limited editions of five hundred copies, their loose plates enclosed in a printed cover—and mode of printing with pochoir, all suggest that they were made during or shortly after World War I. It is possible that the lack of publication information was prompted by a desire to evade the censors. The ironic use of nursery songs hardly seems suitable for its stated audience of children. The often chilling iconography also is at odds with the comic style of the illustrations.

42

Louis Lefèvre. "Maman les p'tits bateaux." *Rondes glorieuses.* [S.l.: s.n., n.d.]. 1ière série

Lefèvre once again mercilessly exploited the innocence of a classic French nursery song—this one about boats and the sea—to convey his critique of the war. The well-known nonsense lyrics of the song are: "Mommy, do the little boats that go on water have legs?" "Of course, my big silly. If they had none, they would not move along." As in other sheets in the portfolio, the words have been grimly changed: Do the little boats that go in the trenches have legs? The original absurdity is made literal. A French infantryman must slog through water in the trenches in a makeshift "boat" of a barrel. Throughout the portfolios, the cartoonish nature of the illustrations belies their seriousness.

41

Louis Lefèvre. "Il était un petit navire." *Rondes glorieuses.* [S.l.: s.n., n.d.]. 1ière série

"Il était un petit navire" (There was a little ship) is a traditional children's song whose lyrics about a young shipwrecked sailor about to be cannibalized by other survivors might derive from the infamous wreck in 1816 of the *Medusa*, a French military frigate, immortalized by Théodore Gericault's painting, purchased in 1824 for display in the Louvre. Here, the ship is about to be destroyed by a German torpedo. Interestingly, the song is played and sung by the protagonists of *La grande illusion* (1937) Jean Renoir's classic film about World War I.

43

Louis Lefèvre. "La tour prends garde!" *Rondes glorieuses.* [S.l.: s.n., n.d.]. 1^ière série

"La tour prends garde!" (Tower beware!) is an old French folk song in which children try to break a circle to become king of the tower. In this case, Lefèvre did not alter the original lyrics because they suited his purpose perfectly. Here the tower is, as in the song, threatened with destruction. The plate recalls Hermann-Paul's representation of the bombardment of Reims Cathedral in the October 1914 plate of *Calendrier de la guerre* (1915).

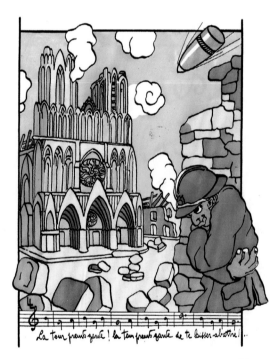

44

Louis Lefèvre. "La Madelon." *Rondes glorieuses.* [S.l.: s.n., n.d.]. 2^ème série

By the time the second series of *Rondes glorieuses* was issued, the soldier on the cover, presumably Lefèvre, had earned a seventh stripe. As before, the sheets primarily feature traditional children's songs that sardonically comment on the war. The lyrics of "Mon bon château" describe the destruction of the "good castle," in Lefèvre's sheet a crude shelter obliterated by a shell. This page highlights a new tune and lyrics by Louis Bousquet and Camille Robert (1914) that became a popular war song, "La Madelon." Here, the object of desire, the comely tavern waitress Madelon, is transformed into a server in the mess. Her principal attraction is the coffee she dispenses.

le cuistot

45

le concert au front

45

45

Lucien Laforge. *Le cuistot. Le concert au front*.
Paris: Librairie Lutetia, [n.d.]

Lutetia published a great many prints related to the
war off the battlefield, including this portfolio of six by
Lucien Laforge. In one scene, sleeves rolled up to reveal
their hairy arms, the *poilus* lounge around watching the
cook—*le cuistot*—prepare a meal. A red dog looks on. In
another, whatever the subject of the revue being per-
formed for a group of soldiers lined up on a bench, they
are clearly enjoying the entertainment in *Le concert au
front*. Before 1918, the participants in concert parties at
the front were fighting men themselves, a compatriot in
drag frequently the star of the show.

46

Lucien Laforge. *L'espion.* Paris: Librairie Lutetia,
[n.d.]

The most famous German spy of World War I was Mata
Hari, whose service allegedly led to the deaths of more
than fifty thousand soldiers. Most secret agents were far
less glamorous—or effective—committing acts of sabo-
tage or revealing troop movements to the enemy. Two of

l'espion

46

Laforge's signature red dogs provide an advance guard as
the prisoner is escorted by two soldiers marching in a
landscape of ruins, smoke, and a blood red sky.

47

48

47

Lucien Laforge. *La marraine.* Paris: Librairie Lutetia, [n.d.]

All of Laforge's prints in this series are distinguished by broad passages of flamboyant color in pochoir. Those critics provoked by the artists they earlier termed *fauves* would have railed at the brilliant yellow, magenta, and bright jade surroundings of the chic French woman entertaining her "godson" soldier. The column between the pair, its capital decorated with hearts, may signal a culmination hinted at, too, by her posture on the edge of her chair facing the soldier with her legs apart. A small white dog sitting at attention seems to look on reprovingly. In *L'assaut,* an unrelated Laforge print, also published by Lutetia, a West African soldier is dismayed by the attentions of a bevy of similarly attractive women.

48

Lucien Laforge. *La croix rouge. Le permissionnaire.* Paris: Librairie Lutetia, [n.d.]

La croix rouge (The Red Cross) shows nurses in white handing out red apples and roses to smiling *tirailleurs* in red caps lying in a row of beds with white sheets. The West African infantry, renowned for their courage and high morale, suffered heavy losses. In *Le permissionnaire* every creature moves toward the open gate to welcome the title soldier home on leave, as he runs with open arms to the son rushing towards his embrace. His wife and baby and even the dog, duck, chicks, and bird join in the reception. Once again Laforge employed an astonishing palette, this time of bright pink, royal blue, purple, vivid yellow, and green.

se trouve à la librairie lutetia 66 boulevard raspail paris

le permissionnaire

48

30 Août 1914.

*Destruction des maisons situées
sur la zone militaire de Paris*

Vu le décret du 2 août 1914 ensemble la loi du 5 août 1914 déclarant l'état de siège;

Vu le décret du 10 août 1914 déclarant les circonscriptions territoriales formant le gouvernement militaire de Paris en état de guerre;

En raison des circonstances urgentes;

Décide :

1° Dans un délai de quatre jours francs à compter du 30 août, les propriétaires, usufruitiers, locataires ou occupants à un titre quelconque de tous immeubles situés dans la zone de servitude des forts détachés anciens et nouveaux devront évacuer et démolir lesdits immeubles;

2° A défaut par les intéressés d'avoir obéi à la présente prescription dans le délai imparti, il sera procédé d'office par l'autorité militaire à la démolition des immeubles et à l'enlèvement des matériaux.

Le Gouverneur militaire de Paris, commandant des armées de Paris,
Signé : GALLIENI.

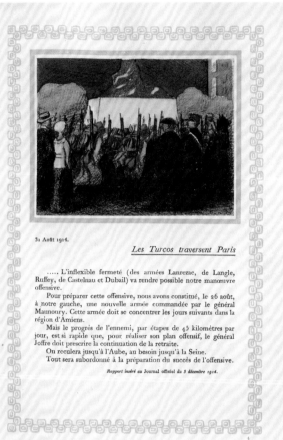

31 Août 1914.

Les Turcos traversent Paris

..... L'inflexible fermeté (des armées Lanrezac, de Langle, Ruffey, de Castelnau et Dubail) va rendre possible notre manœuvre offensive.

Pour préparer cette offensive, nous avons constitué, le 26 août, à notre gauche, une nouvelle armée commandée par le général Maunoury. Cette armée doit se concentrer les jours suivants dans la région d'Amiens.

Mais le progrès de l'ennemi, par étapes de 45 kilomètres par jour, est si rapide que, pour réaliser son plan offensif, le général Joffre doit prescrire la continuation de la retraite.

On reculera jusqu'à l'Aube, au besoin jusqu'à la Seine.

Tout sera subordonné à la préparation du succès de l'offensive.

Rapport inséré au Journal officiel du 5 décembre 1914.

49

André Hellé. "30 août 1914 / 31 août 1914."
Le livre des heures héroïques et douloureuses des années 1914, 1915, 1916, 1917, 1918. Paris, Nancy, Strasbourg: Berger-Levrault, 1919

Admired as an illustrator of great wit, André Hellé executed a history of the Great War in a more sober style. Modeled on a medieval book of hours, it tells the course of the war pictorially and uses a chronology of contemporary documents as the text. The account begins even before the declaration of war on July 25, 1914, with an order for soldiers on leave to rejoin their units. Hellé alternated his attention between the effect of the war on civilians and military actions. On August 30, 1914, a fire burns in daylight as a French home in the military zone is destroyed. The night scene opposite shows citizens observing *tirailleurs algériens* marching through the streets of Paris.

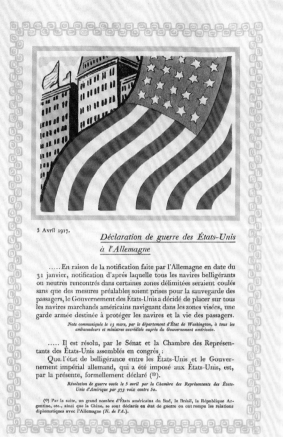

5 Avril 1917. *Déclaration de guerre des États-Unis à l'Allemagne*

.....En raison de la notification faite par l'Allemagne en date du 31 janvier, notification d'après laquelle tous les navires belligérants ou neutres rencontrés dans certaines zones délimitées seraient coulés sans que des mesures préalables soient prises pour la sauvegarde des passagers, le Gouvernement des États-Unis a décidé de placer sur tous les navires marchands américains naviguant dans les zones visées, une garde armée destinée à protéger les navires et la vie des passagers.

Note communiquée le 13 mars, par le département d'État de Washington, à tous les ambassadeurs et ministres accrédités auprès du Gouvernement américain.

..... Il est résolu, par le Sénat et la Chambre des Représentants des États-Unis assemblés en congrès :

Que l'état de belligérance entre les États-Unis et le Gouvernement impérial allemand, qui a été imposé aux États-Unis, est, par la présente, formellement déclaré (※).

Résolution de guerre votée le 5 avril par la Chambre des Représentants des États-Unis d'Amérique par 373 voix contre 50.

(※) Par la suite, un grand nombre d'États américains du Sud, le Brésil, la République Argentine, etc., ainsi que la Chine, se sont déclarés en état de guerre ou ont rompu les relations diplomatiques avec l'Allemagne (N. de l'A.).

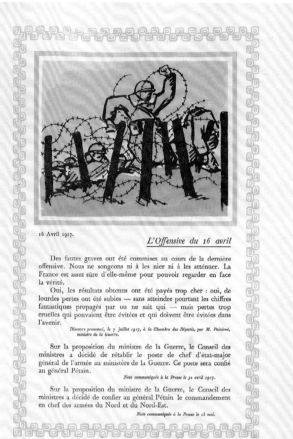

16 Avril 1917. *L'Offensive du 16 avril*

Des fautes graves ont été commises au cours de la dernière offensive. Nous ne songeons ni à les nier ni à les atténuer. La France est assez sûre d'elle-même pour pouvoir regarder en face la vérité.

Oui, les résultats obtenus ont été payés trop cher : oui, de lourdes pertes ont été subies — sans atteindre pourtant les chiffres fantastiques propagés par on ne sait qui — mais pertes trop cruelles qui pouvaient être évitées et qui doivent être évitées dans l'avenir.

Discours prononcé, le 7 juillet 1917, à la Chambre des Députés, par M. Painlevé, ministre de la Guerre.

Sur la proposition du ministre de la Guerre, le Conseil des ministres a décidé de rétablir le poste de chef d'état-major général de l'armée au ministère de la Guerre. Ce poste sera confié au général Pétain.

Note communiquée à la Presse le 30 avril 1917.

Sur la proposition du ministre de la Guerre, le Conseil des ministres a décidé de confier au général Pétain le commandement en chef des armées du Nord et du Nord-Est.

Note communiquée à la Presse le 15 mai.

50

André Hellé. "5 avril 1917/16 avril 1917."
Le livre des heures héroïques et douloureuses des années 1914, 1915, 1916, 1917, 1918. Paris, Nancy, Strasbourg: Berger-Levrault, 1919

In this book of hours Hellé adeptly contrasted the palette and composition of each two-page spread in the book, creating a rhythm of light and dark, happiness and despair, action and calm. The bold design of the American flag inspired many illustrators. For April 5, 1917, Hellé placed the Stars and Stripes against the picture plane, as he illustrated the official entry of the United States into the war, the American government resolution providing the text. On the opposite page, brave *poilus* mount an offensive through a tangle of barbed wire, as the text notes the appointment of General Pétain as commander of the armies of the north and northeast.

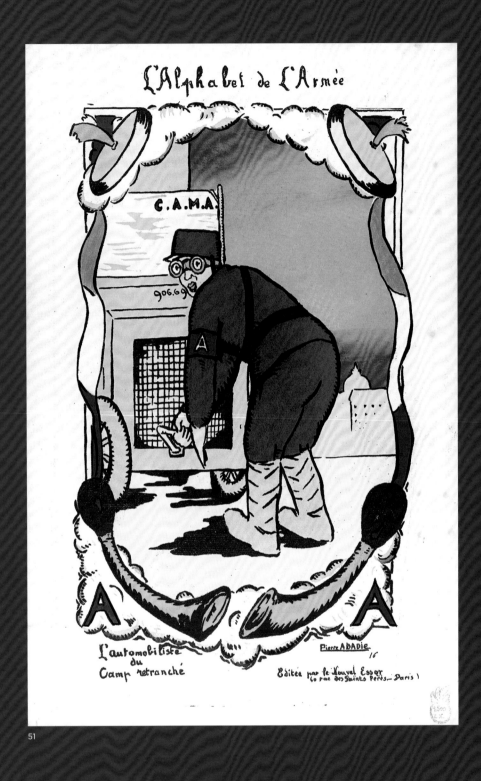

L'Alphabet de L'Armée

C.A.M.A.

906.69

A

A A

L'automobiliste Pierre ABADIE
du 16
Camp retranché Éditée par le Nouvel Essor
 (o rue des Saints Pères — Paris)

THE FRENCH SOLDIER

MILLIONS OF MEN WERE MOBILIZED for the war, and illustrators often focused on an "everyman" to carry the message of their creations. Sometimes this was the *poilu*, a fond but satirical characterization of the foot soldier as a "hairy beast," sometimes the *permissionnaire*, a soldier home on leave, sometimes simply the brave man fighting for France.

51

Pierre Abadie[-Landel]. "C.A.M.A. L'automobiliste du camp retranché." *L'alphabet de l'armée.* Paris: Le Nouvel Essor, 1916

When Pierre Abadie created *L'alphabet de l'armée* he was finishing his studies at the Ecole des Beaux-Arts. Thus, one can assume that he consciously chose this simplified style. These images show workers supporting the war effort as noncombatants. The letter *A* stands for *L'automobiliste*: we see the trench-camp driver cranking up the truck's engine. Abadie incorporated conventions from older prints. For example, two large automobile horns take the place of swags at the bottom. The use of *bokashi* in the sky, the gradation in bright pink instead of Japanese blue, and the point of the dome in the background might allude to Andō Hiroshige's *Thirty-six Views of Mount Fuji.*

52

Pierre Abadie[-Landel]. "Le R.A.T." *L'alphabet de l'armée.* Paris: Le Nouvel Essor, 1916

Just as the exact uses of these vividly hued sheets remain to be identified, the meaning of the abbreviations in Abadie's alphabet is not always apparent today. The word *rat* in the French military was a pejorative term applied to persons in authority. But during World War I "rat" might also mean a base rat, that is, a soldier who stayed at base camp rather than going to the front. What does seem clear is that this *poilu*—a literal illustration of the slang term "hairy beast"—is preventing a civilian from entering a dangerous area. This confrontation has turned the trespasser into a cartoon convention of fear.

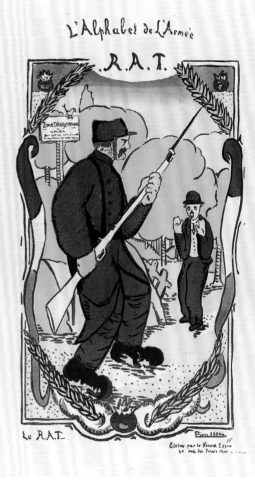

52

54

Guy Arnoux. *La gloire aux soldats français.* Paris: Librairie Lutetia, 1916

Guy Arnoux supported the war effort with illustrations in many different formats, including posters. One poster, constructed of nine panels, traces the exploits of a *poilu*, the whole dignified with captions in French and Latin. This small-format poster glorifies the noble soldier, flanked by two historical predecessors who hold his hands and raise a victory wreath above his head. With Arnoux's *French Soldiers at War*, published the same year, as a guide, it is clear that the figure on the right carries a flag from around 1745, and the other the standard born in triumph at Jemmapes in 1792, when the French liberated what is now Belgium from the Austrians.

53

Pierre Abadie[-Landel]. "Au repos." *Les joies du poilu.* Paris: Le Nouvel Essor, 1917

Two French infantrymen find a moment of repose in a bucolic landscape, one of them serenading cows with his recorder. The bells on the ends of the cows' tails ring in harmony as they march across the paper in a straight line. Like *L'alphabet de l'armée, Les joies du poilu* was published by Le Nouvel Essor. Abadie's style here has become deliberately crude and childlike. Were the six plates in this portfolio meant to satirize the French infantry, to humanize them—as they enjoy swimming, fishing, drinking, opening a parcel, departing for leave, or merely relaxing—or just to provide comic relief?

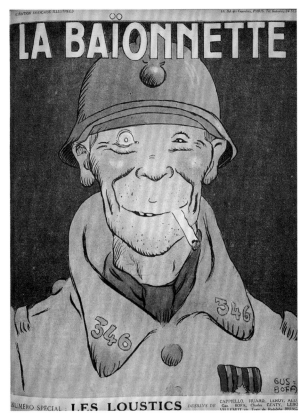

"Les loustics." *La baïonnette*, 23 mars 1916

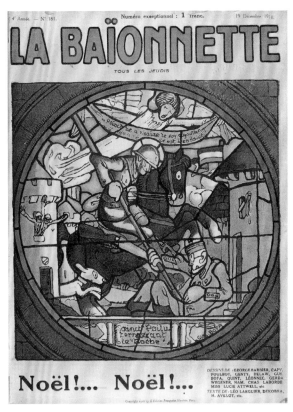

"Les 'Britanniques'." *La baïonnette*, 8 novembre 1917

55

Gus Bofa [Gustave Henri Emile Blanchot]. *La baïonnette*. Paris: L'Edition Française Illustrée

An impressive roster of well-known illustrators worked for *La baïonnette*, among them SEM, Charles Genty, Leonetto Cappiello, Adolphe Willette, Francisque Poulbot. But none contributed more than Gus Bofa. So committed to his art that he is purported to have taken his pen name by age eight, Bofa executed more covers for *La baïonnette* than any other artist, working for it from 1916 to 1920. His strong graphic style and droll humor were ideally suited to the magazine. His first cover, "Les loustics" (The Jokers), showed that the magazine did not idealize the common soldier, a message he repeated in several covers depicting English soldiers.

"Noël!. . . Noël!. . ." *La baïonnette*, 19 décembre 1918

" *Cette troupe magnifique de femmes françaises qui ont voulu être infirmières et qui se sont montrées d'un dévouement, d'une abnégation, d'une générosité que jamais l'imagination la plus fertile n'eût pu formuler.*
(Frédéric Masson).

56

Guy Arnoux. "Infirmière." *Les Françaises*. Paris: Devambez, [n.d.]

Aux Mères et aux Veuves des Soldats morts pour La France
(To the mothers and widows of the soldiers who died for France)

Arnoux's historical survey demonstrates that this conflict was not the first in which women provided support. Popular illustrations during the Great War portrayed women contributing to the war effort in a variety of ways—providing sympathy, moral support, and warm clothing; substituting for men's labor in vital industries, such as the manufacture of munitions; or, as here, serving as nurses. Interestingly, many images of nurses show them, in their white uniforms, with black troops conscripted from French African colonies. Often these soldiers are virtual caricatures, perhaps because of ignorance, or racism. However, Arnoux portrays a soldier with a bandaged foot standing with quiet dignity while the nurse performs her vital tasks.

57

Guy Arnoux. "Ceux de l'Yser." *Les marins*. Paris: Devambez, [n.d.]

World War I as the triumphant zenith of French history appears frequently in illustration, repeatedly in the works of Guy Arnoux. Several different projects by him use variations of this conceit. In his portfolios, the sheets, numbering four or as many as ten, were printed on good-quality paper, colored using the pochoir process, and housed in specially designed enclosures. The steady march of French military achievement is portrayed as a time line culminating in the brave accomplishments of soldiers in the Great War. Strong black outlines, largely unmodulated colors, and powerful compositions characterize Arnoux's creations. On sea and land, the marines demonstrate their military prowess, here at the battle of the Yser in October 1914.

Ceux de l'Yser

58

Guy Arnoux. "1830 marin/1914 fusilier marin." Plate 315. *La guerre documentée*. Paris: Schwarz, [1917]

Different publishers created war propaganda available at different prices. *The War Documented* featured more than three hundred different compositions (the *marins* are shown in plate 315). Printed in inexpensive four-color process color on cheap wood-pulp paper, these particular sheets were, at some point in their history, pinned to a wall. Arnoux used his familiar trope of contrasting historic and contemporary soldiers, but here two figures appear in a single page. The series features pairings of military assignment and rank, for example, a marine from 1830 and his counterpart in 1914. Like his portfolios for Devambez, these compositions are sparingly detailed. The 1914 depiction might show one moment after the scene of the battle of the Yser for Devambez's portfolio *Les marins*.

59

Guy Arnoux. "1825 artilleur/1915 artilleur." Plate 317. *La guerre documentée*. Paris: Schwarz, [1917]

La guerre documentée (The War Documented) contains an explanation of the project: Guy Arnoux, the popular artist of the war, represented the *poilus* side by side with their warrior ancestors, showing them as worthy heirs. Arnoux, in fact, often depicted the soldiers of the Great War as more heroic than their predecessors, coupling a wary-looking grenadier with an incendiary device in 1716 against a 1917 grenadier forcefully throwing a grenade, a 1760 hussard (or *houzard*) at attention in dress uniform against his 1916 counterpart enduring rain on the battlefield, and here, an 1825 artilleryman elegantly lounging against his cannon while the soldier of 1915 stands ready to load the shells.

60

Marc LeClerc. *La passion de notre frère le poilu.* Illus. by Léon Lebègue. Paris: Librairie Des Amateurs, 1918

Originally published in 1916, the poem went through at least fourteen printings that same year. Léon Pichon issued an illustrated edition with woodcuts by Hermann-Paul in 1917. In Lebègue's version, the frontispiece functions as an altarpiece. Two angels from Reims Cathedral welcome the viewer. Opened, the wings depict the warrior saints Joan of Arc and Michael framing a scene of a *poilu* received into heaven by the Trinity and Mary, behind them a range of saints. The interior text and illustrations tell the epic of battle, including the deaths of many. But readers would be comforted that the departed rest in the arms of angels.

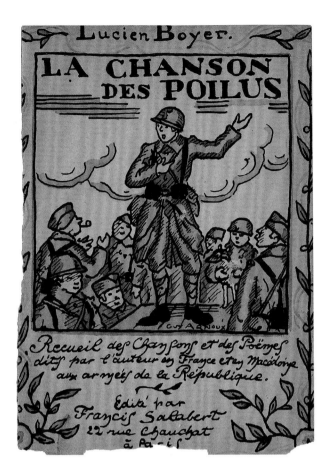

61

Lucien Boyer. *La chanson des poilus*. Cover art by
Guy Arnoux. Illus. by R[oger] de Valerio. Paris:
Francis Salabert, 1918

Guy Arnoux provided the cover for this volume of songs,
poetry, and a play about the war, presumably because
the publisher felt this important topic merited the par-
ticipation of a prominent illustrator with a lighthearted
touch. The numerous interior illustrations depict scenes
from the war in a more realistic mode. After the war Roger
de Valerio became well known for images in a powerful
Art Deco style: more than two thousand covers created
for the music publisher Salabert as well as posters for
Citroën, Chrysler, and Air France.

62

Marcel Astruc. "La retraite. 1914." *Mon cheval mes amis et mon amie.* Illus. by Charles Martin. Paris: La Renaissance du Livre, 1921

The book and its illustrations focus primarily on the amorous exploits of infantrymen during the war, but the conflict regularly intrudes upon their revelry. In "La retraite. 1914." exhaustion and despondency emanate from the bowed bodies of the trudging soldiers. Even the earth and sky seem suffused with blood. Martin used a subdued palette, mostly monochrome, for the scenes of war. His earlier illustrations from *Sous les pots de fleurs* are a point of departure for these depictions but, not surprisingly, they lack the immediacy of the earlier book. Martin and Astruc collaborated before the war but the contrast of subject is telling: an article in April 1914 on hats and umbrellas in the *Gazette du bon ton*.

63

Marcel Astruc. "Tipperary! Tippi." "Le prin-
temps." *Mon cheval mes amis et mon amie.* Illus.
by Charles Martin. Paris: La Renaissance du
Livre, 1921

In contrast to the war tableaux in the book, an incarna-
dine touch appears in every depiction of the home front
or of soldiers with their sweethearts. The very first image
is of a chorus girl singing the popular song "[It's a long
way to] Tipperary," shirt provocatively open showing one
breast and skirt shorter than any respectable Scot would
wear. Even the Union Jack changes its colors to white,
blue, and hot pink. Only near the end of the book, as vic-
tory looms, do the two color palettes come together: a
tree breaks out in magenta blossoms while the cannons
roar behind it.

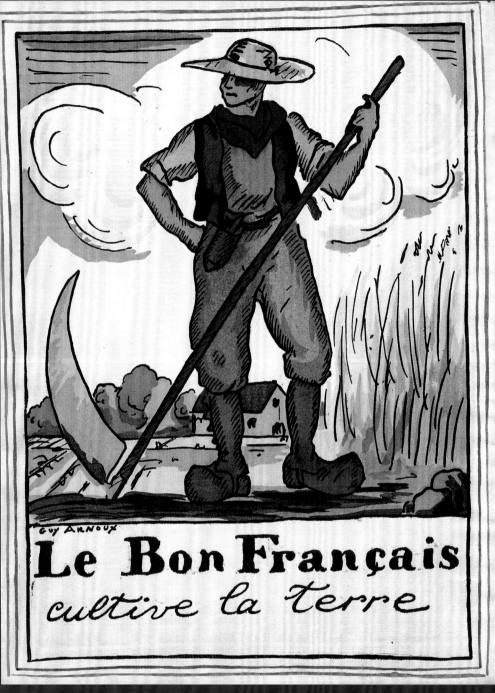

CULTIVATING THE HOME FRONT

T HE WAR AFFECTED EVERYONE IN FRANCE. There were scarcities of food, fuel, and many commodities. Almost everyone knew or was related to one or more of the actual combatants. Official propagandists and illustrator commentators alike sought to sustain civilian morale during the deadly conflict. All those at home were a potential audience for every illustration.

64

Guy Arnoux. *Le bon Français*. Paris: Devambez, [n.d.]

In a series probably published during the war as a spur to civilian support, the five protagonists all contribute in a significant way. Each page resembles one panel in a traditional story printed by Pellerin in Epinal. The farmer cultivates wheat, his scythe a weapon against the enemy. An elderly gentleman purchases national-defense bonds. Another exhorts a woman in a shop to make a purchase, to bolster the economy. A worker in a munitions plant stands heroically holding a shell ready for combat. Of course, all of these support the best of the French, the soldier, also depicted in the portfolio (see p. 4), who bravely defends their country.

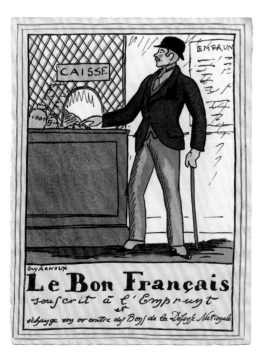

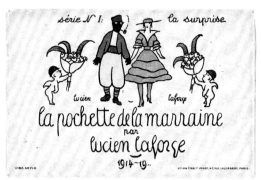

65

Lucien Laforge. *La pochette de la marraine.* Paris: Minot, [1919?]. Série NI: La surprise

The *marraines de guerre*, a program of pen pals known as "godmothers," fostered by the government, gave women a role to play in the war and boosted troop morale. The popular press quickly focused on the possibilities for real or virtual immorality in these relationships. During the war, postcards, cartoons, comic songs, plays, and novels examined this prospect, and some criticized women engaged in frivolity while the war was raging. Laforge, in his miniature postcard narrative of an African soldier's week of leave, might be perceived as one such appraisal. But a similar week of pleasure, entertainment, and indulgence was the dream of many a *poilu*.

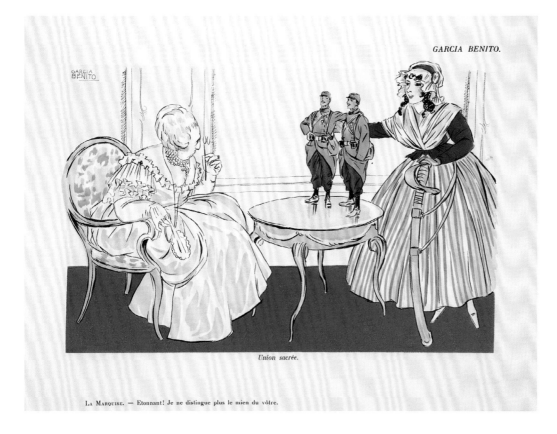

GARCIA BENITO.

GARCIA BENITO

Union sacrée.

LA MARQUISE. — Etonnant! Je ne distingue plus le mien du vôtre.

66

Eduardo García Benito. "Union sacrée." Lucien Laforge. "Les innocents d'Europe." *La Grande Guerre par les artistes, 1914–15.* Preface by Gustave Geffroy. Paris: Les Beaux Livres Pour Tous, 1914–15

Published toward the beginning of the war, *La Grande Guerre* features the work of many artists, in approximately one hundred and fifty illustrations, in a variety of styles. Many are representational and range from battle scenes to allegories. Here, a *marquise* and her maid, the latter in the garb of the French Revolution, compare their two Zouave dolls and conclude they are just the same. Neither class nor politics is a barrier to the recognition of heroism. The left-wing artist Laforge eschewed such anodyne scenes, depicting instead the miseries caused by the madness. The brave Zouave troops also figure in one of the series of prints executed by Benito for Tolmer, also entitled *La Grande Guerre*: more than fifty color woodcuts of the events of 1915 in different theaters of the war. Tolmer issued many such series by various artists.

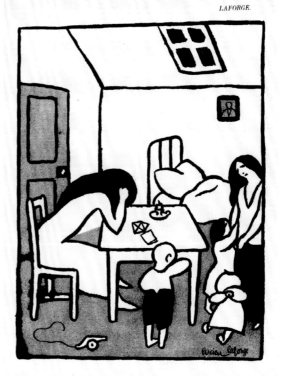

LAFORGE.

Les innocents d'Europe pleurent à cause d'un misérable fou

67

Jean Leprince. *Calendrier*. Paris: L. Arnault, [1918]

The destruction of French homes and lands, scenes of many World War I battles, was a painful topic for illustrators. But, on three of the four pages of Leprince's *Calendrier*, women try to protect La Belle France, willfully pushing the instruments of war to the perimeter of the page. Each wears a striped skirt of blue, white, and red, alluding to the *tricolore*. One woman blocks a tank from entry into a verdant landscape. Another bemoans the invasion of even French planes, and the third poignantly waves the olive branch in front of a house where flames can be seen through each window.

68

Charles Genty. "Les remplaçantes." *La baïonnette*, 25 novembre 1915. Paris: L'Edition Française Illustrée

Presumably many serving in the military enjoyed the barbed satire of *La baïonnette* but the primary audience for the magazine was those who remained on the home front. A number of issues dealt with their lives. "Les remplaçantes" put a spotlight on the substitutes, mostly women, for men away fighting for the cause. Charles Genty, a well-known humorous illustrator who served during the war also worked for such magazines as *Le rire*, *Le rire rouge*, and *Fantasio* and illustrated novels. Other issues of the magazine dealt with such subjects as "Nos gosses" (Our kids), "La vie chère" (The expensive life), and "Les nouveaux riches."

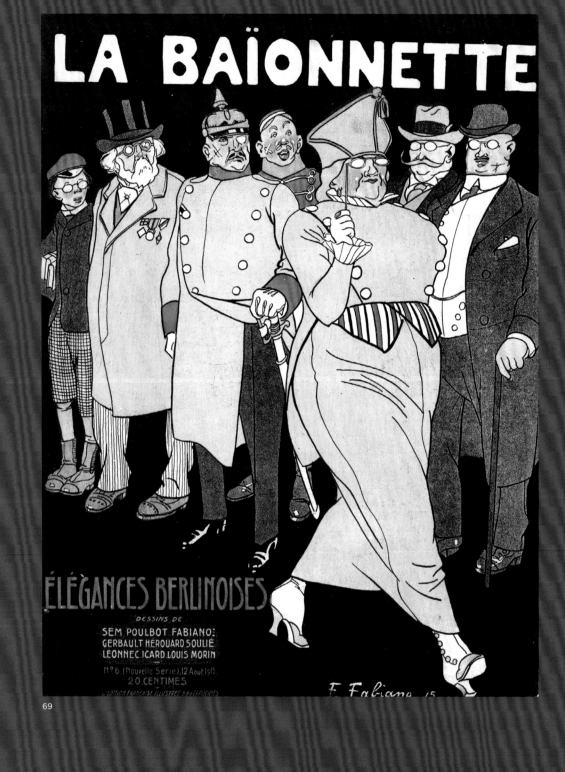

FRENCH FASHION, AN IMPORTANT INDUSTRY, became a strong symbolic tool to assert the power and predominance of Gallic culture and to differentiate the French from their enemies. Fashion illustrators, largely unemployed by this business for the duration of the conflict, turned their talents to supporting the war effort in a variety of venues.

69

Fabien Fabiano [Jules Coup de Fréjac]. "Elégances berlinoises." *La baïonnette*, 12 août 1915. Paris: L'Edition Française Illustrée

Each weekly issue of *La baïonnette* featured a theme, the one for August 12, 1915, being fashion. However, the subject, with images by prominent illustrators in the field, appeared in many issues. In "Elégances berlinoises," Fabiano, who usually featured stylish French models and gamines in alluring poses, shows a cross section of German men, their heads turned by a strolling woman. The joke, repeated in endless variations in the magazine, is that the stout, matronly, and unfashionably dressed woman would not command a glance in Paris, populated with lithe beauties, perfectly *à la mode*.

70

Gerda Wegener. *La baïonnette*. Paris: L'Edition Française Illustrée

Issue six, "Elégances berlinoises," was the first to focus exclusively on fashion, and throughout the years a number of issues were devoted to this topic. But women in every issue were suffused with the modishness of the *mannequin*, not surprisingly since many illustrators had previously worked for fashion magazines. The Danish illustrator Gerda Wegener, who had begun working for *Vogue* in 1912, was a featured contributor. Her cover on national dress offered an opportunity to show off her highly detailed, delicately colored, curvilinear style contrasting fashion through the ages with wartime austerity.

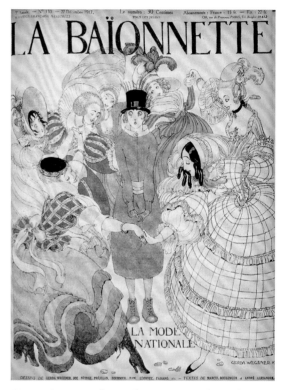

"La mode nationale." *La baïonnette*, 27 décembre 1917

"La guerre et la rue de la Paix." *La baïonnette*, 20 avril 1916

BOUQUET TRICOLORE

LE COMMUNIQUÉ

EN SUIVANT LES OPÉRATIONS

LA MARSEILLAISE

71

Etienne Drian. "Bouquet tricolore." "Le communiqué." "En suivant les opérations." "La Marseillaise." *Gazette du bon ton: Arts, modes & frivolités*. Paris: Lucien Vogel. Année 2 Eté 1915

An editorial in the *Gazette du bon ton* in the summer of 1915 declares that because France has just escaped the greatest peril and is proceeding toward certain victory, the magazine could be published. Most of the illustrations contain no hint of war. On one four-page spread, young women attired by Lanvin, Paquin, Worth, and other celebrated couturiers parade on a balcony by the sea attended by young men in white tie. Apart from Lepape's, the only illustrations to reference the war are a series by Drian. Fashionably dressed women engage in patriotic activities: arranging a tricolor bouquet, reading the war news, following a battle map, or listening to the "Marseillaise."

72

H. Robert Dammy. "Le voila parti pour la guerre." Paris: Librairie Lutetia, 1916

H. Robert Dammy's woodcut refers to the conventions of the fashion plate, at which he excelled as an illustrator for the *Gazette du bon ton*. A young woman dressed in white, and surrounded by red flowers that echo the cocarde, pines for her sweetheart gone to war. Two hearts, their initials, and the date 1914 carved in a tree behind her attest to her abiding love, as do the verses at her feet by "HP." Lutetia published many such patriotic broadsides during the war. Perhaps the woodcut format or other war illustrations mimicking "Epinal" style inspired Dammy to depart from the unfailingly refined and elegant women he created for his fashion compositions.

73

H. Robert Dammy. "Mlle Victoire." Paris: Librairie Lutetia, 1917

A comely and fashionably dressed young woman (note her shoes are the same style as in Georges Lepape's "L'ouragan" illustration from the *Gazette du bon ton*). Mlle Victoire scatters red roses leading a group of *poilus*, the *tricolore* fluttering behind. In the border are the names of battles: La Marne, Verdun, La Somme, L'Yser. Clearly all were deemed victories of the war from 1914 to 1916. In the battle of the Somme alone, which lasted five months in 1916, more than one million men are believed to have died or been wounded, more than half on the Allied side. This print was one of the many messages aimed at keeping soldiers and the home front committed to the cause.

74

André Foy. "Une Russe de guerre." *Fantasio.*
Paris: Félix Juven, 1915

After the outbreak of war, the magazine *Fantasio* heavily
dedicated itself to the conflict. Pre-1914 fashion featured
undress as much as dress but the struggle meant a new
sobriety, although the risqué element remained. André
Foy executed a series in 1915 headlined "Les ama-
zones," a discreet pinup version of the Allies. The fig-
ures included "Une Russe de guerre," as well as "Miss
John Bull," "L'Italie au coeur ardent," and "L'héroïque
Beulemans" (Belgian).

75

Louis Icart. "Le train des permissionnaires."
Fantasio. Paris: Félix Juven, 1917

A common theme of the *permissionnaire* was the farewell
to his family. Here, instead of a baby, a comely young
lady holds up a cupid to be kissed by the soldier depart-
ing from leave, in a work by Louis Icart. The model here
would appear in many of Icart's sensual illustrations in
future years. It seems likely that she is his muse, later
his wife, Fanny Volmers, whom Icart met at the fashion
house of Paquin in 1914.

LE DERNIER CRI

Modes de Printemps : Berlin-Vienne-Constantinople
Composition de Odette CHAMPION.

Pour la Fête Nationale
Dessin de Ed. HALOUZE

76

Odette Champion. "Modes de printemps: Berlin-Vienne-Constantinople." *Fantasio.* Paris: Félix Juven, [1915]

Odette Champion depicted the spring fashions in Berlin, Vienna, and Constantinople. *Le dernier cri* of the Axis would not pass muster in Paris. The physique and style of the breastplated Prussian model are grotesque. Even additions of an upside-down pyramid or a peacock feather cannot make the pickelhaube helmet fashionable. The Viennese designs seem inspired by Gustav Klimt, albeit with a motif of skulls.

77

Edouard Halouze. "Vive la cocarde! Pour la fête nationale." *Fantasio.* Paris: Félix Juven, 1916

The French gamine celebrating Bastille Day contrasts markedly with her German counterpart. From her umbrella to her shoes, the symmetry of Edouard Halouze's model echoes the round rosettes of the tricolor cocarde, symbol of France. Halouze worked for a number of different journals, including *Les feuillets d'art*, and created advertisements for such firms as Mappin & Webb and Van Cleef et Arpels.

78

78

George Barbier. Cover. "En avant!" *La guirlande des mois.* Paris: J. Meynial, 1917

In 1917, the first year of five, the delicate silk cover of *La guirlande des mois* featured an elegant young woman crowning a French infantryman with a laurel wreath beneath a weeping cherry tree. Two doves perch on the topmost branches. It is a trope of love dominating both victory and suffering. Inside, an arresting illustration, "En avant!," shows soldiers hurling grenades through a black night, lit by the showers of sparks and bright yellow lights of explosions.

79

George Barbier. *La guirlande des mois.* Paris: J. Meynial, 1919

Scenes of war and allusions to it pepper the early years of the small volumes of this almanac, for which George Barbier executed the illustrations, covers, and jackets. War returns to the cover of the 1919 volume, where a scene dated 1918 shows a beautifully dressed woman proffering a rose to an American soldier, both of them encased in a bower of the flowers. Although the fleur-de-lys, an iris, is the official flower of France, the rose represents the country in many World War I images, perhaps because its red color and rosette shape allude to the cocarde.

En avant!

78

79

1915
L'OURAGAN

Gazette du Bon Ton. — N° 8-9. Été 1915. — Pl. 1.

80

80

Georges Lepape. "L'ouragan." *Gazette du bon ton: Arts, modes & frivolités*. Paris: Lucien Vogel. Année 2 Été 1915

From the beginning Georges Lepape was one of the most radical and prolific contributors to Lucien Vogel's fashion magazine, *Gazette du bon ton*. His brilliant use of unusual color and essential simplification of form were immediately recognizable. In August 1914 a skirt depicted by Lepape featured a design reminiscent of the cocarde. By the summer of 1915 the landscape, a white billowing dress, even the blue and red circle of the cocarde were being blown apart by the explosions surrounding the woman—a hurricane, the caption declares.

81

Georges Lepape. "L'alerte." "La onzième heure." *Modes et manières d'aujourd'hui*. [Paris: Pierre Corrard, 1921]

Like most fashion magazines, *Modes et manières d'aujourd'hui* ceased publication during World War I. In 1919 they published a portfolio by Lepape tracing the history of the conflict on the home front. The war caused no diminution of French fashion sense. The twelve plates, which begin in August 1914 with the mobilization, portray nursing the wounded, welcoming soldiers on leave, and women and children taking shelter from enemy aircraft. Also pictured here: the happiness of victory at the eleventh hour in 1918, eliciting cheers, waving flags, and sporting of the cocarde, all while wearing elegant attire. The happy ending features dancing and the ecstatic welcome of troops on the Champs-Elysées.

81

81

page 13

THE CHILDREN'S WAR

PERHAPS BECAUSE THE YOUNG would inherit the legacy of victory or defeat, children's literature devoted to the theme of the war was very widespread. The publishing house of Berger-Levrault was especially active. Whether beautifully printed in pochoir or cheaply printed on wood-pulp paper, many works encouraged children to support the righteous cause.

83

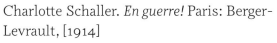

82

Charlotte Schaller. *En guerre!* Paris: Berger-Levrault, [1914]

In *En guerre!* (At war!), the first of two children's books on the war written and illustrated by Schaller and published during the conflict, Boby, his two sisters, and the neighborhood children act out the first months of the hostilities. Our hero, astride his rocking horse, immediately mobilizes all his toy soldiers. Boby admires the bravery and heroism of the Belgians. One illustration, anticipating Surrealism, enacts the battle of Liège. The Belgian army, tiny black figures less than one inch high, wages a futile assault on a pair of Prussian boots that dominate the entire landscape and sky.

83

Charlotte Schaller. *En guerre!* Paris: Berger-Levrault, [1914]

The children celebrate the entry into Alsace with a doll in traditional dress, the flattening of soldier bowling pins enacts the victory at the Marne, and trenches are dug outside of Reims. But their support goes beyond symbolism. Gloves and balaclavas are knitted for the winter and letters to Papa are dispatched to the front. Lavish use of blocks of primary color expresses the optimism of the children, mirroring the general feeling in the early days of the conflict. On the last page the children shout: "Vivent les alliés! Vive la France!"

84

Charlotte Schaller. *Histoire d'un brave petit soldat*. Paris: Berger-Levrault, 1915

Schaller's second book created during the war tells of a little toy soldier living in a beautiful house with other toys and a stuffed dog. Conscripted into the war, he is decorated for valor after killing a German. Subsequent adventures include his monoplane being shot down and his being taken prisoner but escaping. Finally, he triumphantly reenters the nursery, greeted by the cheering toys. While the illustrations lack the power of Schaller's previous book, they still convey a tale that must have been reassuring to children about the dear ones who had departed for the conflict.

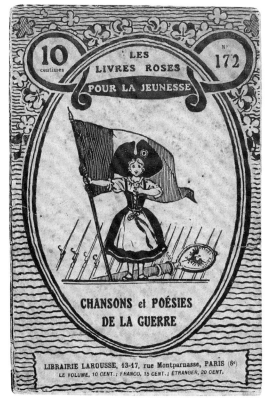

85

85

Chansons et poésies de la guerre. No. 181. Paris: Librairie Larousse, 1916

Issued by Larousse, Les livres roses pour la jeunesse was a series of small-format, inexpensive (ten centimes) collections of illustrated action stories and literature for children. The name of the line derived from the covers' color. By 1915 the books had turned to war: the battles in the skies, our friends the English, the heroes of the ambulances. By 1916 more than thirty titles covered our soldiers in the trenches, the brave Canadians, a heroic family, our prisoners of war, German spies, the Belgian children of war, and two volumes of songs and poetry. Such subjects were published throughout the conflict, encouraging children to empathy and patriotism.

86

Chansons et poésies de la guerre. No. 172. Paris: Librairie Larousse, 1916

86

THE LEIPSIC SOLDIERS

Beware of the " Made in Germany " " of Bimbocherie "

Dᴵᴰ you ever read the tale of a Nutcracker? Dumas, the inimitable, when writing for children was so full of spirit that even now, after seventy years, he interests, amuses and cheers our wounded soldiers for whom such tales are new. Read the story of a Nutcracker hurriedly, then, re-reading it I understood, and it has left on my mind a vague sentiment of doubt, almost of fear. I cannot make out clearly whether the hero Nutcracker, the lovely doll princess he loves so respectfully and his intrepid army of lead soldiers who are determined to

(10)

struggle until death against the hordes of terrible mice, belong to reality or to fiction. In the old apartment we inhabited there were swarms of mice and I half expected the lead soldiers, my lead soldiers to rise in wrath from their wooden boxes and rush out upon the mice if they attacked me, in spite of their queen with her golden crown. Indeed, I carefully removed the lids from their boxes on the night table to enable them to get out more easily.

But my soldiers remembered that they came from Nuremberg and lay quite still. I was lucky, perhaps, that they did not pass over to the enemy as the Saxons did at the battle of Leipsic.

(11)

87

87
André Hellé. *French Toys.* Paris: L'Avenir Féminin, [n.d.]

Intended for an English-speaking audience, primarily in North America, *French Toys* features brief essays by a number of prominent French authors such as Pierre Loti and Henri de Régnier, and was illustrated by the celebrated illustrator André Hellé. The book promoted the French cause in World War I through the metaphor of French playthings. "Children who will see the future for which are dying the sons of France, this book has been written for you." The toys, many of them soldiers, depict the goodness, bravery, and morality of the French. The very large announced print run, 16,050 copies, attests to the publication's ambition.

88
André Hellé. "Batterie/Charge." *Alphabet de la Grande Guerre 1914-1916.* Paris: Berger-Levrault, [1916]

André Hellé's wooden toys of 1911 and his book illustrations, which they populated, certainly inspired later children's books on the war in which toys participated in the conflict. Hellé's alphabet took the conflict out of the playroom, conveying its message in strong simple forms. The sequence begins with *A*—Alsace—and ends with *Z*, for Zouave, who, he assures his young readers, fights with great bravery, and does not exist simply to be the final letter in an alphabet book. In between, such pairings as "Batterie" and "Charge" made the war vivid and, critics asserted, appealing to children. At least one adult found this acceptable fare: in 1916, a fond uncle inscribed this volume to his two nephews.

Léger, souple, précis et rapide, le canon de 75, œuvre des colonels Deport et Sainte-Claire-Deville, a conquis, dès le début de la guerre, une incontestable popularité, grâce à son tir merveilleux. La batterie française de 75 se compose de quatre canons.

88

89

Malgré l'emploi des armes à longue portée, c'est l'attaque à la baïonnette, c'est la lutte corps à corps, homme à homme, qui décide de la victoire. La charge à la baïonnette est le moment suprême du combat.

88

89

André Hellé. *En seconde ligne: Airs militaires des armées françaises.* Paris: Devambez, [n.d.]

André Hellé's many different formats in support of the war effort ranged from illustrations for *La baïonnette* to postcards, like one featuring a child admiring a portrait of her father wearing a protective gas mask. *En seconde ligne* illustrates the bugle calls of the war, with both vignettes and music. Buglers call men to assemble in the morning, they accompany marches in formation and encourage troops—with African soldiers freely mixed into the line—to jog with packs on their backs. Here the bugler signals that all fires are to be put out. In the lower left corner of the page a just-extinguished candle still glows.

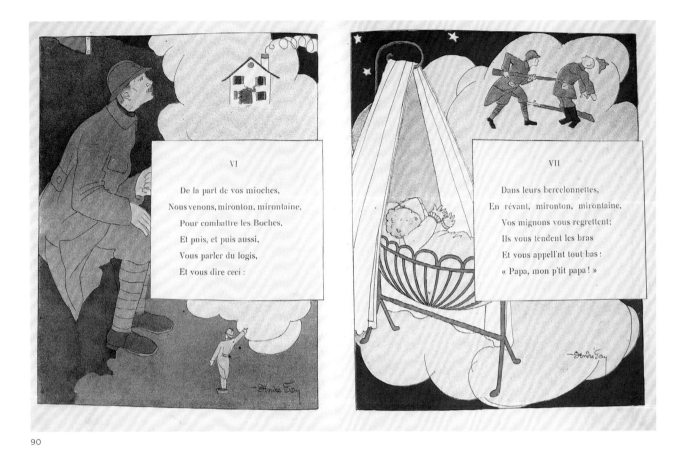

90

90

André Alexandre. *La veillée des p'tits soldats de plomb.* Illus. by André Foy. [France]: La Renaissance du Livre, [n.d.]

The mise-en-scène of this volume takes place in the space of dreams. Sitting in his trench the soldier thinks of home, with its ivy running around the door and the smoke of a warm fire billowing from the chimney. The baby dreams of his father off killing Germans. It is the father who is now in need of succoring—the baby calls him "My little father!" The illustrations, exploiting simple forms and broad passages of color, recall Foy's wartime creations for *Fantasio* and *La baïonnette.* Foy also illustrated a comic children's book during the war, *Bib et Bob et la guerre.*

91

André Alexandre. *La veillée des p'tits soldats de plomb.* Illus. by André Foy. [France]: La Renaissance du Livre, [n.d.]

The book refers to the popular French song "Marlbrough s'en va-t-en guerre" (Marlborough has gone to war), even including the music with new words at the back and repeating its refrain: *mironton mirontaine* (rat-a-tat). In the original song, John Churchill, the 1st duke of Marlborough (1650-1722), has gone to war in Flanders. This text mentions the Flemish locales Woëvre and Ardennes, sites of warfare early in the conflict in 1914. The British hero died in battle, but thanks to the assistance of toy soldiers who come to life at night in the nursery and magically travel to the front, the Germans are defeated, and the father of this baby in his cradle survives.

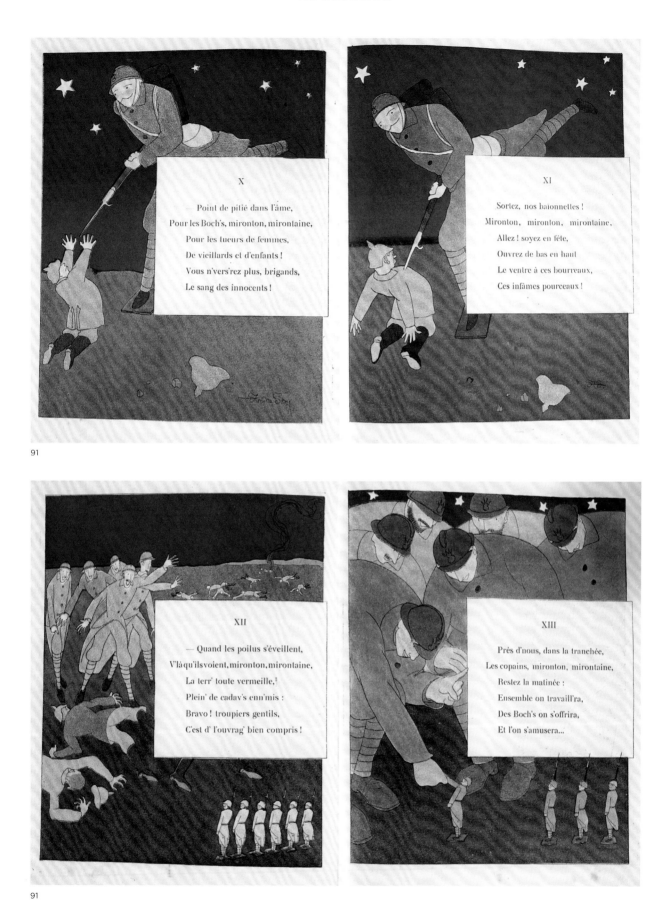

X

— Point de pitié dans l'âme,
Pour les Boch's, mironton, mirontaine,
Pour les tueurs de femmes,
De vieillards et d'enfants !
Vous n'vers'rez plus, brigands,
Le sang des innocents !

XI

Sortez, nos baïonnettes !
Mironton, mironton, mirontaine,
Allez ! soyez en fête,
Ouvrez de bas en haut
Le ventre à ces bourreaux,
Ces infâmes pourceaux !

91

XII

— Quand les poilus s'éveillent,
V'là qu'ils voient, mironton, mirontaine,
La terr' toute vermeille,
Plein' de cadav's enn'mis :
Bravo ! troupiers gentils,
C'est d' l'ouvrag' bien compris !

XIII

Près d'nous, dans la tranchée,
Les copains, mironton, mirontaine,
Restez la matinée :
Ensemble on travaill'ra,
Des Boch's on s'offrira,
Et l'on s'amusera...

91

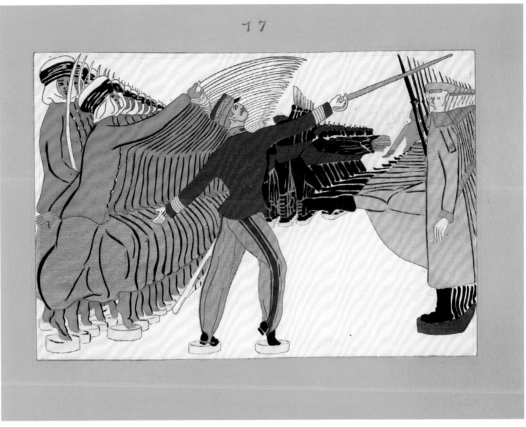

92

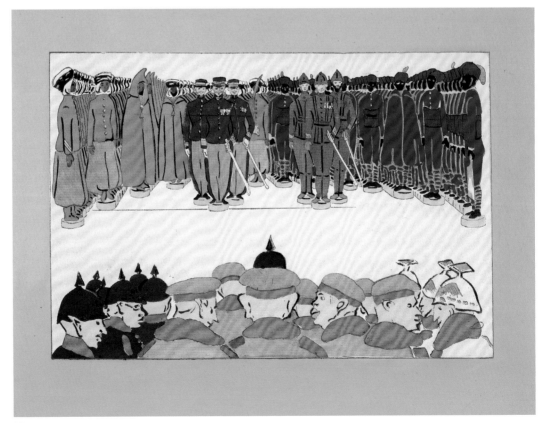

93

92

Val-Rau. *Spahis et tirailleurs: Pour Odile Kastler en l'année de guerre 1916.* Paris: Berger-Levrault, 1916

Through the agency of children and their toys, this book tells of the valor and commitment of the French colonial regiments: the *Spahis*, recruited primarily from Algeria, Tunisia, and Morocco, and the *Tirailleurs*, from Senegal and other French possessions in West, Central, and East Africa. Both groups saw extensive service on the western front. The extraordinary palette and the power of the compositions make this work exceptional. Note in this illustration the rhythm of the curved blades of the *Spahis* led by their French commanding officer, swords raised against the goose-stepping German troops, their purple boots contrasting with the light purple pantaloons of the Algerians.

93

Val-Rau. *Spahis et tirailleurs: Pour Odile Kastler en l'année de guerre 1916.* Paris: Berger-Levrault, 1916

Val-Rau's sense of color and composition is unequaled in children's books on the war. On one page, within pale green pochoir borders the French troops stand with military precision. On one side are ranged rows of toy *Spahis* in their purple and white turbans and bright orange tunics and burnooses, on the other, *Tirailleurs* in smart bright blue uniforms with red feathered hats and sashes. They and their French commanders stand at attention. Below them, against the picture plane, the enemy masses in a confused jumble. Even their fetching hot pink collars and epaulettes cannot mask the bestiality of their faces.

94

J[oseph Porphyre] Pinchon. *Bécassine chez les Turcs.* Paris: Gautier et Langueruau, 1919

The comic strip *Bécassine* first appeared in 1905 in the inaugural issue of *La semaine de Suzette*, a magazine aimed at young girls. The protagonist is a young Breton housemaid. In 1913, book-length adventures appeared and the series was published continually through 1939. In *Bécassine chez les Turcs*, she finds herself in the land of an enemy. The Allied Powers declared war on Turkey, which was part of the Triple Alliance, on November 4, 1914. Pinchon refers to two of her adventures during the war, *Bécassine pendant la guerre* (1916) and *Bécassine chez les alliés* (1917). Edouard Zier drew the later book as well as *Bécassine mobilisée* (1918).

LA PETITE SŒUR D'ADOPTION

Maman a recueilli une petite fille belge.

Nanon est sauvage, mais elle se familiarise avec ses nouveaux amis. Et elle leur raconte son histoire.

Ses parents habitaient une jolie ferme aux environs de Liège. Quand les Allemands sont venus, on est parti.

On a attelé la jument à la charrette, dans laquelle on a empilé du linge et des provisions. Nanon s'est assise sur un ballot, et :
— Hue, Cocote !
C'est ainsi qu'ils sont venus en France.

95

95

Lucie Paul-Margueritte. *Toinette et la guerre.*
Illus. by Henriette Damart. Paris, Nancy:
Berger-Levrault, [1917]

Toinette et la guerre alludes to events of the war as refracted through the lens of the playroom. Perhaps inspired by Charlotte Schaller's illustrations, Riri, the heroine's brother, clothed in military uniform, celebrates the victory of the Marne astride his rocking horse, commanding his toy soldiers with a bugle blast and upraised saber. Damart vividly depicted the past experiences of a Belgian girl taken in by this family. Against a sunset suffused with red, the gigantic figure of a soldier in his pickelhaube hastens the departure of a ragtag group of refugees on the distant horizon.

et les draps qui cachaient ses moustaches, son sabre et ses bottes. Néanmoins, le Petit Chaperon Rouge ne reconnaissait plus sa Grand' Mère La Paix. Comme elle avait changé !

« Grand'Mère, dit le Petit Chaperon Rouge, comme vous avez de grands yeux.

96

96

Charles Moreau-Vauthier. *Histoire du petit chaperon rouge.* Illus. by Guy Arnoux. Paris:
Librairie Lutetia, 1917

"Petit chaperon rouge" (Little Red Riding Hood), first published by the French author Charles Perrault in 1697, has proven to be endlessly adaptable. In this version, published during World War I, it is not difficult to anticipate the identity of the wolf. Even Grandmère's cap does not disguise the point at the top of his helmet (pickelhaube). Ironically, Moreau-Vauthier follows the retelling by the German Brothers Grimm, *Rotkäppchen,* in which a huntsman saves the little girl and her grandmother. As with most of Arnoux's illustrations the style is simplified and powerful.

Paix pourra se rétablir un jour et qu'on la re verra en bonne santé.
Espérons- le...

CH. MOREAU-VAUTHIER.

Fin

96

97

H[enri] Gazan. *Marie-Anne et son oncle Sam.* Paris: G[aston] Boutitie, 1919

Using a format of comic-book cels, interspersed with full-page illustrations, *Marie-Anne et son oncle Sam*, with text in English and French, and brilliantly colored pictures, tells the story of little Marie-Anne, the personification of France, who is stranded in the water, threatened on all sides by sharks and horrific sea creatures such as a giant octopus. To her rescue comes the tall, strapping Uncle Sam, identifiable by his white hair and beard, dressed in an American uniform. He defeats her enemies. The final illustration depicts them going together, facing a brilliant sunrise, "where dwell Friendship and Life . . . from which are banished Hatred and Death."

98

L'oncle Hansi [Jean-Jacques Waltz]. *L'Alsace heureuse.* Paris: H. Floury, 1919

An unabashed promoter of French Alsatian culture, "Hansi," who had worked as a translator during the war, celebrated the return of Alsace to the French after the war in a series of illustrated books. One picture that departed from his usual playful satire is "La belle au bois dormant." Charles Perrault's Sleeping Beauty, wearing the traditional Alsatian headdress, awakes in a bed decorated with the French cock. Above her head Sainte Odile, patron saint of Alsace, and Saint Georges killing the dragon have guarded her long sleep. A brave French soldier is her "prince."

99

Louise-Andrée Roze. *Josette et Jehan de Reims.*
Illus. by Henriette Damart. Paris, Nancy:
Berger-Levrault, [n.d.]

Using bright unmodulated colors and simplified forms
reminiscent of the stained glass depicted in the book's
pages, Damart's illustrations join Roze's text to tell the
story of the great French cathedral of Reims, from the
work of stonemasons carving the Smiling Angel, to the
church's use for the coronation of French kings. The blue-
helmeted soldiers accompanying Charles VII prefigure
the *poilus* retaking the city from the Germans in World
War I. Another image shows blood flowing from the body
of the stone angel, destroyed by the Germans. Finally,
however, whether desecrated or restored, the soul of the
cathedral remains, a living testimony to the triumph of
faith against brutality.

Ainsi que j'en avais fait la promesse à ma grand'mère il y
avait encore un petit Jehan et une petite Josette à Reims en
l'année 1914. Et ceux-là — les miens — devaient réaliser de
leurs yeux d'enfants les horreurs de l'invasion.

A peine avait-on pu se rendre compte que malgré « la
Kultur » dont ils s'enorgueillissent, les Germains du vingtième
siècle dépassent en barbarie leurs plus lointains ancêtres,
qu'après avoir parcouru notre sol à pas de géants ils entraient
dans Reims.

Comme en 1870, le 4 septembre, les troupes allemandes
faisaient résonner, sous le pas deux fois lourd de l'envahisseur,
les rues de notre cité.

55

100

Robert Burnand. *Reims: La cathédrale.* Illus. by Eduardo García Benito. Paris, Nancy, Strasbourg: Berger-Levrault, [1918]

Reims Cathedral, the site of the coronation of French kings, became a symbol of the desecrations of the Germans and a focus of anti-German propaganda. The cathedral was damaged on September 20, 1914, during one of the opening engagements of the war. The Smiling Angel of the facade was often deployed as a symbol of hope. *Reims: La cathédrale* offers children a patriotic history of France through the tale of a young wounded World War I soldier who sees a vision of that angel. Although the cathedral is burning in one scene, the ultimate French victory is prefigured by the triumphant soldier waving an olive branch.

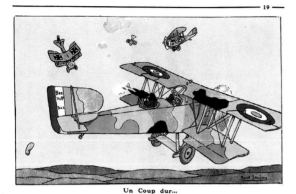

Un Coup dur...

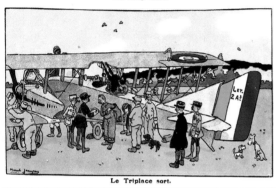

Le Triplace sort.

101

Marcel Jeanjean. *Sous les cocardes: Scènes de l'aviation militaire.* Paris: Hachette, 1919

The heroic pilot of Jeanjean's *Sous les cocardes* represents France. Thus, he flies symbolically under the blue, white, and red of the tricolor circular cocarde. But he literally flies under it as well: it decorates the wings of his plane. World War I was the first in which aircraft were used extensively, mostly for reconnaissance. But in 1914 the French were the first to fire a machine gun from a plane. Children in postwar France must have been thrilled to identify with the exploits of the masters of this new machine and their role in the victory.

102

Simone Bouglé. *Bébés s'en vont en guerre! Une histoire et des images.* Paris, Nancy, Strasbourg: Berger-Levrault, [1918]

Because of the inclusion of liberated Strasbourg as a place of publication, this book was probably printed after the war. Here, children enact the stages of the conflict from mobilization to fighting, being taken prisoner and escaping, and caring for the wounded. They also excel on the home front: they knit and send parcels of necessaries to the *poilus*, grow vegetables, forgo new toys and treats, and contribute money to the national defense. They understand that, although they are small, they can help France. During the war, Bouglé also illustrated Jean Breton's *Noëls de soldats: La fraternité du front.* Paris, Nancy, Strasbourg: Berger-Levrault, 1918.

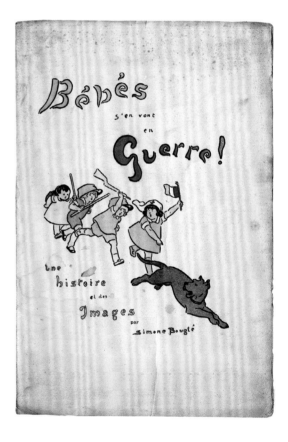

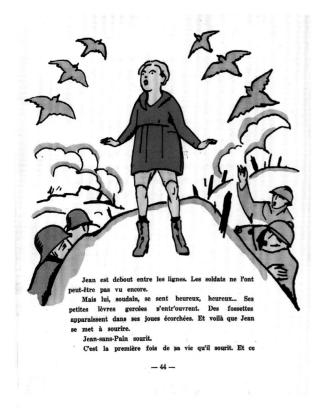

Jean est debout entre les lignes. Les soldats ne l'ont peut-être pas vu encore.

Mais lui, soudain, se sent heureux, heureux... Ses petites lèvres gercées s'entr'ouvrent. Des fossettes apparaissent dans ses joues écorchées. Et voilà que Jean se met à sourire.

Jean-sans-Pain sourit.

C'est la première fois de sa vie qu'il sourit. Et ce

— 44 —

103

Paul Vaillant-Couturier. *Jean sans pain: Histoire pour tous les enfants racontée.* Illus. by [Charles Alexandre] Picart le Doux. Paris: Clarté, 1921

For the French victors, few books of any kind condemned the war, especially after the armistice. The antiwar children's book *Jean sans pain* is an exception. The color illustrations recall Charles Martin's in *Sous les pots de fleurs* in 1917. For example, Picart le Doux depicted bodies in a barren landscape of broken and twisted barbed wire. Jean endures more than hunger. In the cold, his teeth chattering, he sees the degradation of war. A hare that accompanies him answers a query about how long the war will last: miles and miles and years and years.

104

Pierre Chaine. *Mémoires d'un rat.* Illus. by Henry Coudeur. Paris: Payot, 1924

Just as children's books published during the war largely eschewed the death and destruction of the conflict in favor of exhortations to patriotic fervor, those published after the war sometimes provide an ironic view. *Mémoires d'un rat,* published in several illustrated editions, even rehabilitates the scavengers of the dead and dying in the trenches. This rat and his compatriots become pets. Undoubtedly calming the fears of their masters, they help defend the city of Verdun and become heroes of the war. The pastel colors and comic observations of the illustrator of this edition, Henry Coudour, ably support the story.

105

Jeu de la victoire. Paris: Chambrelen, [n.d.]

Pellerin published inexpensive games, printed on a single sheet of paper, such as the *Jeu de l'oie* (The goose game), beginning around 1850. Examples created during the war include Guy Arnoux's *Jeu du pas de l'oie* (The goose-step game; published by Lutetia) and the *Jeu des tranchées* (Game of the trenches; published by Pitault). In the latter, players tried to hit German heads sticking above a trench. This game begins with the invasion of France and ends with the Allies and a triumphant peace. Certain squares, such as "the kaiser," require a penalty move backward. Major events of the war are depicted: the violation of Belgium, the Marne victory, the execution of Edith Cavell, the destruction of Reims Cathedral, the intervention of America, France weighing the scales of German reparations. Sixty-three illustrations narrate the path to victory.

"Français, franchissez la frontière / J'ai mis tous les Boches par terre."
[S.l.]: Dora, [n.d.]

"Même les poupées n'en veulent pas." [S.l.: s. n., n.d.]

Francisque Poulbot. "Un chien, c'est pas un Boche." [S.l.: s. n., 1915]

106
Selection of Postcards

At least twenty thousand different postcards were printed in France during World War I. They were sent to combatants and posted by soldiers back to loved ones. The collecting began almost immediately and some were certainly displayed. Themes included scenes of battle or sometimes just the name of the conflict or the destruction of war, flags and other patriotic symbols, the camps where the men resided, heroes, comic takes on the life of soldiers, the inevitable pretty girls. A subset of almost all these categories featured children. Francisque Poulbot alone created at least one hundred images of his signature waifs during the Great War.

7

THE BATTLE

NO SINGLE IMAGE COULD POSSIBLY convey the horror of the Great War's battlefields. Some illustrators relied on traditional representations, adapting the conventions of nineteenth-century history painting, but substituting contemporary uniforms for the combatants. Others, who had experienced the war firsthand, such as Charles Martin or Fernand Léger, captured the despair of the conflict by more oblique means.

107

Charles Martin. "Le bled en fleur." *Sous les pots de fleurs.* Paris: Jules Meynial, 1917

An established illustrator before the war, Charles Martin served in the infantry. The title of this wartime publication, *Sous les pots de fleurs* (Under the flowerpots), is actually a *contrepèterie*, or spoonerism, for *sous les flots de peur*, beneath the waves of fear. The first full-page illustration, "Le bled en fleur," depicts a wheat field dotted with poppies—the farmland that became battlefields—and a body amid the wheat. Later, poppies came to symbolize endless drops of blood and, because of the popularity of the poem "In Flanders Fields" by the Canadian medical officer John McCrae, to commemorate the war itself.

108

Charles Martin. "Le petit poste." *Sous les pots de fleurs.* Paris: Jules Meynial, 1917

The illustrations in the book cover the period from 1915 to 1917 but are arranged not in chronological but in a powerful visual order. Here we see the scene of "Le cafard" in 1916 from a different perspective. The trench warfare continued. Martin showed us the scorched earth and blasted trees of no-man's-land stretching to the horizon. In France, the early optimism about the war's brief duration had now turned into a pessimism that it would extend to infinity, like the desolation of the landscape.

108

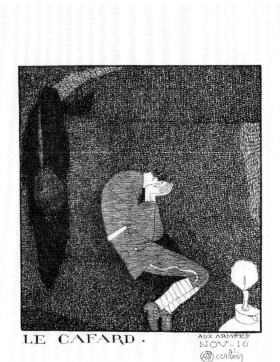

110

Charles Martin. "Les éclats." *Sous les pots de fleurs*. Paris: Jules Meynial, 1917

Martin assimilated the recent avant-garde compositions of Marcel Duchamp and Pablo Picasso to create the movement of air, debris, and bodies in the destruction wreaked by the shells on the battlefield. A lone figure crouches against the blast, his fingers contorted in fear and pain. Martin's masterful use of the expanse of the blank page heightens the dramatic power of the vignette.

109

Charles Martin. "Le cafard." *Sous les pots de fleurs*. Paris: Jules Meynial, 1917

Pierre Mac Orlan's preface notes that the essential characters of the tragedy are the crow, the rat, and the cockroach. In "Le cafard" (The cockroach) the presence of the other two is implied in the oppressive confines of the trenches where a solitary figure sobs in despair. Originally derived from French colonial troops' habit of shooting cockroaches out of boredom, the term *cafard* took on the meaning of extreme depression or a sense of pointlessness. Martin consummately exploited the possibilities of black ink to create the oppressive darkness, both literal and metaphoric.

111

Paul Guignebault. *Pensées et fragments patriotiques.* Paris: Maurice Glomeau, 1916

An established, exhibited artist before the war, Paul Guignebault had already illustrated books, sometimes made in tandem with his teacher, Henri Boutet. Here, he provided a frontispiece of a French soldier, holding the *tricolore* and urging his comrades forward. Perhaps the texts in this pocket-size volume were also meant as an encouragement to those waging battle. Its verses and epigrams feature among others Pascal, Racine, Saint Augustine, Robespierre, Hugo, and Napoleon.

112

Blaise Cendrars. *J'ai tué.* Illus. by Fernand Léger. Paris: A La Belle Edition, 1918

An exhibited artist already engaged in avant-garde movements, Fernand Léger was mobilized at the war's outbreak and spent two years at the front, almost dying as a result of an attack of mustard gas at Verdun. Blaise Cendrars, a Swiss poet who enlisted in the French infantry when war was declared, lost his right hand in battle in 1915. Their experiences came together in *J'ai tué*, the first book illustrated by Léger. Executed in a Cubist style, perfectly suited to capture the chaos and confusion of battle, the book is printed in blue, red, and yellow.

★ Le cadavre d'un homme, de quelque côté de la tranchée qu'il soit sent toujours bon.

★ Les années où la moisson est rouge, sont pour nous des années d'abondance.

★ On n'aura pas la paix tant qu'il en restera deux debout.

2

114

André Lhote. *Sainte Geneviève*. Paris: Librairie Lutetia, [n.d.]

The modernist artist André Lhote's brilliantly colored monumental print, executed for Librairie Lutetia in an edition of five hundred copies, evokes French medieval stained-glass windows in which a saint is frequently shown within a Gothic architectural framework. *Sainte Geneviève* depicts the defense of France. The cityscape of Paris, dominated by the Seine and the Eiffel Tower, is in the background. The country is defended against the German dragon, who disturbs the peace of a garden filled with flowers and populated by lambs. If religion is not enough, an allegorical figure of France, clad in the *tricolore*, aids the patron saint of Paris.

113

Lucien Descaves. *Ronge-maille vainqueur*. Illus. by Lucien Laforge. Paris: Librairie Ollendorff, 1920

By the 1920s a number of avant-garde German artists had created searing indictments of war. For example, the 1924 portfolio of fifty-one prints, "Der Krieg" (War) by Otto Dix portrayed the struggle as a series of scenes from hell. Nothing of such power emerged from France in that period but Lucien Laforge turned his style from witty to crude for his depiction of the triumph of the rats in Descaves's tale. Although the rats declare that years when the harvest is red are for them years of abundance, Laforge wisely eschewed color for his images. The rats have no allegiance, feasting happily on cadavers from both sides of the conflict.

Sainte Geneviève

imagerie André Lhote (édité par la Librairie Lutétia 66 Boulevard Raspail. PARIS)

114

PEACE

NOVEMBER 11, 1918 BROUGHT AN ARMISTICE. Peace would come with the Treaty of Versailles, signed six months later, but it was a peace that attached to bitter memories. France alone had suffered more than six million casualties. Victory and religion could each offer some solace, and illustrators invoked both as they sought to comfort the bereaved.

115

Jean Leprince. *Calendrier.* Paris: L. Arnault, [1918]

Each three-month page of this calendar has a pochoir illustration surmounted by a wish to work for peace related to each season. The calendar, employing the names of months coined during the French Revolution, is strangely prescient: on the first page a woman drops roses on shells and armaments—and the fourteen-point peace program was announced by President Wilson on January 8, 1918. Next, a woman bars the path of a tank— and a major German offensive occurred in April. The third depicts a woman reacting in horror to an aerial bombardment—and the second battle of the Marne took place in July. Finally, a woman waves an olive branch in front of a burning building—and the armistice was signed on November 11.

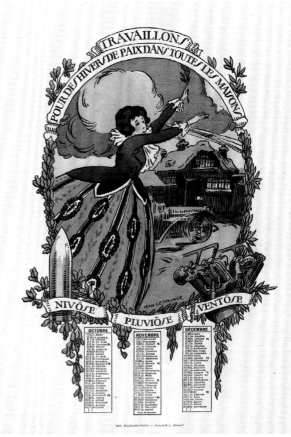

Dans le pays entier reviendra la Paix bienfaisante, et, dominant les toits meurtris de Rei

drale blessée chantera de toutes ses cloches la belle journée et le bonheur de vivre.

116

Robert Burnand. *Reims: La cathédrale.* Illus. by Eduardo García Benito. Paris, Nancy, Strasbourg: Berger-Levrault, [1918]

Reims: La cathédrale depicts many moments in the storied history of the iconic building. In the final scene, after all of its triumphs and vicissitudes, the cathedral and its angel preside over a bucolic paradise of peace. A rainbow frames the cathedral, while the spirit of the angel fills the sky. The landscape is filled with a happy family and a rose-covered home, as well as a bountiful harvest. This scene brings to mind Benito's print *La belle terre*, for the publisher Grasset. There, the arriving heroic American troops even help harvest the wheat.

CROQUIS DE L'AUTEUR

117

Pierre Mac Orlan [Dumarchey]. *La fin: Souvenirs d'un correspondant aux armées en Allemagne*. Illus. by Joseph Hémard. Paris: L'Edition Française Illustrée, 1919

Mac Orlan's memories of his time as a war correspondent in Germany are illustrated with occasional slight sketches in black and white by the author. The cover, however, was executed by one of the most prolific and well-known French illustrators of the first half of the twentieth century, Joseph Hémard, just at the beginning of his most productive period. Hémard is best known for his humorous illustrations, but this cover strikes an appropriately somber note as the prototypical French soldier gazes over the German landscape.

118

Union des aveugles de guerre. Illus. by Pierre Brissaud. Paris: Edition Foetisch, 1926

Both sides deployed chemical weapons in World War I, beginning with the use of tear gas by the French in 1914. The Germans made the most extensive use of chemical agents that killed or caused permanent disabilities, such as blindness. Numerous organizations, or unions, were founded to aid those left sightless by the war. Here, Pierre Brissaud, a famous illustrator who often specialized in fashion, gave his talents to design the program cover for a benefit performance to raise money for blinded soldiers.

CHECKLIST OF THE EXHIBITION

Except for items loaned for the exhibition as noted, all works are held in the Special Collections Research Center, University of Chicago Library. The format of the citations follows the punctuation of the printed original.

PIERRE ABADIE[-LANDEL]

Pierre Abadie[-Landel]. "C.A.M.A. L'automobiliste du camp retranché." *L'alphabet de l'armée.* Paris: Le Nouvel Essor, 1916

On loan from Brown University Library, Anne S. K. Brown Military Collection

Pierre Abadie[-Landel]. "G.V.C. Le garde-voie." *L'alphabet de l'armée.* Paris: Le Nouvel Essor, 1916

On loan from Brown University Library, Anne S. K. Brown Military Collection

Pierre Abadie[-Landel]. "M.A.M. L'ouvrier d'usine." *L'alphabet de l'armée.* Paris: Le Nouvel Essor, 1916

On loan from Brown University Library, Anne S. K. Brown Military Collection

Pierre Abadie[-Landel]. "Le R.A.T." *L'alphabet de l'armée.* Paris: Le Nouvel Essor, 1916

On loan from Brown University Library, Anne S. K. Brown Military Collection

Pierre Abadie[-Landel]. "Le colis." *Les joies du poilu.* Paris: Le Nouvel Essor, 1917

On loan from Richard Cheek

Pierre Abadie[-Landel]. "Le départ pour la permission." *Les joies du poilu.* Paris: Le Nouvel Essor, 1917

On loan from Richard Cheek

Pierre Abadie[-Landel]. "Au repos." *Les joies du poilu.* Paris: Le Nouvel Essor, 1917

On loan from Richard Cheek

GUY ARNOUX

Guy Arnoux. "Sale affaire!" *La baïonnette*, 6 septembre 1917. Paris: L'Edition Française Illustrée

Gift of Neil Harris and Teri J. Edelstein

Roger Boutet de Monvel. *Le bon Anglais.* Illus. by Guy Arnoux. Paris: Chez Devambez, 1914

Guy Arnoux. "Assure la reprise des affaires." *Le bon Français.* Paris: Devambez, [n.d.]

On loan from a private collection

Guy Arnoux. "Se bat pour son pays." *Le bon Français.* Paris: Devambez, [n.d.]

On loan from a private collection

Guy Arnoux. "Cultive la terre." *Le bon Français.* Paris: Devambez, [n.d.]

On loan from a private collection

Guy Arnoux. "Souscrit à l'emprunt." *Le bon Français.* Paris: Devambez, [n.d.]

On loan from a private collection

Guy Arnoux. "Travaille pour nos soldats." *Le bon Français.* Paris: Devambez, [n.d.]

On loan from a private collection

Roger Boutet de Monvel. *Carnet d'un permissionnaire.* Illus. by Guy Arnoux. Paris: Chez Devambez, 1917

Lucien Boyer. *La chanson des poilus.* Cover art by Guy Arnoux. Illus. by R[oger] de Valerio. Paris: Francis Salabert, 1918

Guy Arnoux. "Infirmière." *Les Françaises.* Paris: Devambez, [n.d.]

On loan from a private collection

Guy Arnoux. *La gloire aux soldats français.* Paris: Librairie Lutetia, 1916

Gift of Neil Harris and Teri J. Edelstein

Guy Arnoux. "1825 artilleur/1915 artilleur." Plate 317. *La guerre documentée.* Paris: Schwarz, [1917]

Gift of Neil Harris and Teri J. Edelstein

Guy Arnoux. "1830 marin/1914 fusilier marin." Plate 315. *La guerre documentée.* Paris: Schwarz, [1917]

Gift of Neil Harris and Teri J. Edelstein

Charles Moreau-Vauthier. *Histoire du petit chaperon rouge.* Illus. by Guy Arnoux. Paris: Librairie Lutetia, 1917

On loan from a private collection

Guy Arnoux. "Ceux de l'Yser." *Les marins.* Paris: Devambez, [n.d.]

Gift of Neil Harris and Teri J. Edelstein

Roger Boutet de Monvel. *Nos frères d'Amérique.* Illus. by Guy Arnoux. Paris: Chez Devambez, [1918]

GEORGE BARBIER

George Barbier. *La guirlande des mois*. Paris: J. Meynial, 1917
On loan from a private collection

George Barbier. *La guirlande des mois*. Paris: J. Meynial, 1919
On loan from a private collection

EDUARDO GARCÍA BENITO

"Union sacrée." Illus. by Eduardo García Benito. In *La Grande Guerre par les artistes, 1914–15*. Preface by Gustave Geffroy. Paris: Les Beaux Livres Pour Tous, [1915]
Gift of Neil Harris and Teri J. Edelstein

Robert Burnand. *Reims: La cathédrale*. Illus. by Eduardo García Benito. Paris, Nancy, Strasbourg: Berger-Levrault, [1918]

GUS BOFA [GUSTAVE HENRI EMILE BLANCHOT]

Gus Bofa [Gustave Henri Emile Blanchot]. "Les loustics." *La baïonnette*, 23 mars 1916. Paris: L'Edition Française Illustrée

ROBERT BONFILS

Robert Bonfils. *Le bouquet des alliés*. [S.l.: s.n.], 1915
On loan from Richard Cheek

"Les alliés." Illus. by Robert Bonfils. *Les hymnes alliés*. Paris: Le Nouvel Essor, [1917]
On loan from Brown University Library, Anne S. K. Brown Military Collection

Robert Bonfils. Cover sheet. *La manière française*. Paris: Librairie Lutetia, [1916]
On loan from a private collection

Robert Bonfils. "Les marraines." *La manière française*. Paris: Librairie Lutetia, [1916]
On loan from a private collection

Robert Bonfils. "La réception des zeppelins." *La manière française*. Paris: Librairie Lutetia, [1916]
On loan from a private collection

Robert Bonfils. "Sur mer." *La manière française*. Paris: Librairie Lutetia, [1916]
On loan from a private collection

Robert Bonfils. "L'union sacrée." *La manière française*. Paris: Librairie Lutetia, [1916]
On loan from a private collection

Robert Bonfils. "Verdun." *La manière française*. Paris: Librairie Lutetia, [1916]
On loan from a private collection

[E.] LUCIEN BOUCHER

Mario Meunier. *Images de la vie des prisonniers de guerre*. Illus. by E. L[ucien] Boucher. Paris: Marcel Seheur, [1920]
On loan from a private collection

SIMONE BOUGLÉ

Simone Bouglé. *Bébés s'en vont en guerre! Une histoire et des images*. Paris, Nancy, Strasbourg: Berger-Levrault, [1918]
Gift of Neil Harris and Teri J. Edelstein

PIERRE BRISSAUD

Union des aveugles de guerre. Illus. by Pierre Brissaud. Paris: Edition Foetisch, 1926
Gift of Neil Harris and Teri J. Edelstein

ODETTE CHAMPION

Odette Champion. "Modes de printemps: Berlin-Vienne-Constantinople." *Fantasio*. Paris: Félix Juven, [1915]
Gift of Neil Harris and Teri J. Edelstein

GÉRARD COCHET

"God Save the King." Illus. by Gérard Cochet. *Les hymnes alliés*. Paris: Le Nouvel Essor, [1917]
On loan from Brown University Library, Anne S. K. Brown Military Collection

HENRY COUDEUR

Pierre Chaine. *Mémoires d'un rat*. Illus. by Henry Coudeur. Paris: Payot, 1924
Gift of Neil Harris and Teri J. Edelstein

HENRIETTE DAMART

Louise-Andrée Roze. *Josette et Jehan de Reims*. Illus. by Henriette Damart. Paris, Nancy: Berger-Levrault, [n.d.]
On loan from a private collection

Lucie Paul-Margueritte. *Toinette et la guerre*. Illus. by Henriette Damart. Paris, Nancy: Berger-Levrault, [1917]
On loan from Richard Cheek

H. ROBERT DAMMY

H. Robert Dammy. "Mlle Victoire." Paris: Librairie Lutetia, 1917
On loan from Brown University Library, Anne S. K. Brown Military Collection

H. Robert Dammy. "Le voila parti pour la guerre." Paris: Librairie Lutetia, 1916
On loan from Brown University Library, Anne S. K. Brown Military Collection

VICTOR DESCAVES

"Chant national japonais." Illus. by Victor Descaves. *Les hymnes alliés*. Paris: Le Nouvel Essor, [1917]
On loan from Brown University Library, Anne S. K. Brown Military Collection

ETIENNE DRIAN

Etienne Drian. "Le communiqué." *Gazette du bon ton: Arts, modes & frivolités*. Paris: Lucien Vogel, Année 2 Eté 1915
Gift of Neil Harris and Teri J. Edelstein

Etienne Drian. "La Marseillaise." *Gazette du bon ton: Arts, modes & frivolités*. Paris: Lucien Vogel, Année 2 Eté 1915

Gift of Neil Harris and Teri J. Edelstein

RAOUL DUFY

Raoul Dufy. *Les alliés: Petit panorama des uniformes*. Paris: Iribe & Cie, [1915]

FABIEN FABIANO [JULES COUP DE FRÉJAC]

Fabien Fabiano [Jules Coup de Fréjac]. "Elégances berlinoises." *La baïonnette*, 12 août 1915. Paris: L'Edition Française Illustrée

Gift of Neil Harris and Teri J. Edelstein

ANDRÉ FOY

André Foy. "Une Russe de guerre." *Fantasio*. Paris: Félix Juven, 1915

Gift of Neil Harris and Teri J. Edelstein

André Alexandre. *La veillée des p'tits soldats de plomb*. Illus. by André Foy. [France]: La Renaissance du Livre, [n.d.]

On loan from a private collection

H[ENRI] GAZAN

H[enri] Gazan. *Marie-Anne et son oncle Sam*. Paris: G[aston] Boutitie, 1919

On loan from a private collection

FÉLIX DE GOYON

Félix de Goyon. "Leur peinture: Portrait de Madame la Baronnin Strumpel'-Lise par Gustav Klimt." *La baïonnette*, 31 mai 1917. Paris: L'Edition Française Illustrée

PAUL GUIGNEBAULT

Paul Guignebault. *Pensées et fragments patriotiques*. Paris: Maurice Glomeau, 1916

Gift of Neil Harris and Teri J. Edelstein

EDOUARD HALOUZE

Edouard Halouze. "Vive la cocarde! Pour la fête nationale." *Fantasio*. Paris: Félix Juven, 1916

Gift of Neil Harris and Teri J. Edelstein

ANDRÉ HELLÉ

André Hellé. *Alphabet de la Grande Guerre 1914-1916*. Paris: Berger-Levrault, [1916]

On loan from a private collection

André Hellé. *En seconde ligne: Airs militaires des armées françaises*. Paris: Devambez, [n.d.]

On loan from a private collection

André Hellé. *French Toys*. Paris: L'Avenir Féminin, [n.d.]

On loan from a private collection

André Hellé. *Le livre des heures héroïques et douloureuses des années 1914, 1915, 1916, 1917, 1918*. Paris, Nancy, Strasbourg: Berger-Levrault, 1919

JOSEPH HÉMARD

Joseph Hémard. *Chez les Fritz, notes et croquis de captivité*. Paris: L'Edition Française Illustrée, 1919

Gift of Neil Harris and Teri J. Edelstein

Pierre Mac Orlan [Pierre Dumarchey]. *La fin: Souvenirs d'un correspondant aux armées en Allemagne*. Illus. by Joseph Hémard. Paris: L'Edition Française Illustrée, 1919

Gift of Neil Harris and Teri J. Edelstein

HERMANN-PAUL

Hermann-Paul. "Octobre 1914 Reims." *Calendrier de la guerre, 1ière année, août 1914-juillet 1915*. Paris: Lutetia, 1915

On loan from a private collection

Hermann-Paul. "Décembre 1914 enrôlements." *Calendrier de la guerre, 1ière année, août 1914-juillet 1915*. Paris: Lutetia, 1915

On loan from a private collection

Hermann-Paul. "Juin 1915 obus." *Calendrier de la guerre, 1ière année, août 1914-juillet 1915*. Paris: Lutetia, 1915

On loan from a private collection

Hermann-Paul. "Juillet 1915 permissionnaires." *Calendrier de la guerre, 1ière année, août 1914-juillet 1915*. Paris: Lutetia, 1915

On loan from a private collection

Hermann-Paul. Cover. *Calendrier de la guerre, 2ème année, août 1915-juillet 1916*. Paris: Lutetia, 1916

On loan from a private collection

Hermann-Paul. "Août 1915 Nicolas Nicolaievitch." *Calendrier de la guerre, 2ème année, août 1915-juillet 1916*. Paris: Lutetia, 1916

On loan from a private collection

Hermann-Paul. "Septembre 1915 Joffre." *Calendrier de la guerre, 2ème année, août 1915-juillet 1916*. Paris: Lutetia, 1916

On loan from a private collection

Hermann-Paul. "Janvier 1916 Kitchener." *Calendrier de la guerre, 2ème année, août 1915-juillet 1916*. Paris: Lutetia, 1916

On loan from a private collection

"Hymne américain." Illus. by Hermann-Paul. *Les hymnes alliés*. Paris: Le Nouvel Essor, [1917]

On loan from Brown University Library, Anne S. K. Brown Military Collection

LOUIS ICART

Louis Icart. "Le train des permissionnaires." *Fantasio*. Paris: Félix Juven, 1917

Gift of Neil Harris and Teri J. Edelstein

PAUL IRIBE

Paul Iribe. "Les fossoyeurs de la mer." *La baïonnette*, 22 juin 1916. Paris: L'Edition Française Illustrée

Paul Iribe. "Les gaz asphyxiants." *La baïonnette*, 29 juillet 1915. Paris: L'Edition Française Illustrée

Gift of Neil Harris and Teri J. Edelstein

MARCEL JEANJEAN

Marcel Jeanjean. *Sous les cocardes: Scènes de l'aviation militaire*. Paris: Hachette, 1919

JEAN-EMILE LABOUREUR

Xavier Marcel Boulestin. *Dans les Flandres britanniques*. Illus. by Jean-Emile Laboureur. Paris: Dorbon-aîné, 1916

On loan from a private collection

André Maurois. *Les discours du Docteur O'Grady*. Illus. by Jean-Emile Laboureur. Paris: Société d'Edition, 1929

On loan from a private collection

A.S.C. [Army Service Corps]. *Types de l'armée américaine en France*. Illus. by Jean-Emile Laboureur. Paris: La Belle Edition, 1918

On loan from a private collection

LUCIEN LAFORGE

Lucien Laforge. *Le concert au front*. Paris: Librairie Lutetia, [n.d.]

On loan from a private collection

Lucien Laforge. *L'espion*. Paris: Librairie Lutetia, [n.d.]

On loan from a private collection

Lucien Laforge. *La marraine*. Paris: Librairie Lutetia, [n.d.]

On loan from a private collection

Lucien Laforge. *Le permissionnaire*. Paris: Librairie Lutetia, [n.d.]

On loan from a private collection

Lucien Laforge. *Conte de fées*. Paris: Librairie Lutetia, [n.d.]

On loan from the World War I Printed Media and Art Collection, Kislak Center for Special Collections, Rare Books & Manuscripts, University of Pennsylvania

"Hymne monténégrin." Illus. by Lucien Laforge. *Les hymnes alliés*. Paris: Le Nouvel Essor, [1917]

On loan from Brown University Library, Anne S. K. Brown Military Collection

Lucien Laforge. *La pochette de la marraine*. Paris: Minot, [1919]. Série NI: La surprise

On loan from a private collection

Lucien Descaves. *Ronge-maille vainqueur*. Illus. by Lucien Laforge. Paris: Librairie Ollendorff, 1920

On loan from a private collection

LÉON LEBÈGUE

Marc LeClerc. *La passion de notre frère le poilu*. Illus. by Léon Lebègue. Paris: Librairie Des Amateurs, 1918

Gift of Neil Harris and Teri J. Edelstein

LOUIS LEFÈVRE

Louis Lefèvre. "C'est un fils au kaiser." *Rondes glorieuses*. [S.l.: s.n., n.d.]. 1ière série

On loan from a private collection

Louis Lefèvre. "Il était un petit navire." *Rondes glorieuses*. [S.l.: s.n., n.d.]. 1ière série

On loan from a private collection

Louis Lefèvre. "Maman les p'tits bateaux." *Rondes glorieuses*. [S.l.: s.n., n.d.]. 1ière série

On loan from a private collection

Louis Lefèvre. "Sur le pont." *Rondes glorieuses*. [S.l.: s.n., n.d.]. 1ière série

On loan from a private collection

Louis Lefèvre. "La tour prends garde!" *Rondes glorieuses*. [S.l.: s.n., n.d.]. 1ière série

On loan from a private collection

Louis Lefèvre. "La Madelon." *Rondes glorieuses*. [S.l.: s.n., n.d.]. 2ème série

On loan from a private collection

FERNAND LÉGER

Blaise Cendrars. *J'ai tué*. Illus. by Fernand Léger. Paris: A La Belle Edition, 1918

On loan from the Ryerson and Burnham Libraries, Art Institute of Chicago

GEORGES LEPAPE

Georges Lepape. "L'ouragan." *Gazette du bon ton: Arts, modes & frivolités*. Paris: Lucien Vogel, Année 2 Eté 1915

On loan from the Ryerson and Burnham Libraries, Art Institute of Chicago

Georges Lepape. "La onzième heure." *Modes et manières d'aujourd'hui*. [Paris: Pierre Corrard, 1921]

Gift of Neil Harris and Teri J. Edelstein

JEAN LEPRINCE

Jean Leprince. *Calendrier*. Paris: L. Arnault, [1918]

On loan from a private collection

"Hymne roumain." Illus. by Jean Leprince. *Les hymnes alliés*. Paris: Le Nouvel Essor, [1917]

On loan from Brown University Library, Anne S. K. Brown Military Collection

ANDRÉ LHOTE

André Lhote. *Sainte Geneviève*. Paris: Librairie Lutetia, [n.d.]

On loan from the World War I Printed Media and Art Collection, Kislak Center for Special Collections, Rare Books & Manuscripts, University of Pennsylvania

CHARLES MARTIN

Marcel Astruc. *Mon cheval mes amis et mon amie*. Illus. by Charles Martin. Paris: La Renaissance du Livre, 1921

On loan from a private collection

André Maurois. *Les discours du Docteur O'Grady*. Illus. by Charles Martin. Brussels: Aux Editions du Nord, 1932

On loan from a private collection

André Maurois. *Les silences du Colonel Bramble*. Illus. by Charles Martin. Brussels: Aux Editions du Nord, 1929

On loan from a private collection

Charles Martin. "Le bled en fleur." *Sous les pots de fleurs*. Paris: Jules Meynial, 1917

Gift of Neil Harris and Teri J. Edelstein

Charles Martin. "Le cafard." *Sous les pots de fleurs*. Paris: Jules Meynial, 1917

Gift of Neil Harris and Teri J. Edelstein

Charles Martin. "Les éclats." *Sous les pots de fleurs*. Paris: Jules Meynial, 1917

Gift of Neil Harris and Teri J. Edelstein

Charles Martin. "En attendant . . ." *Sous les pots de fleurs*. Paris: Jules Meynial, 1917

Gift of Neil Harris and Teri J. Edelstein

Charles Martin. "Knock-Out!!!" *Sous les pots de fleurs*. Paris: Jules Meynial, 1917

Gift of Neil Harris and Teri J. Edelstein

Charles Martin. "Le petit poste." *Sous les pots de fleurs*. Paris: Jules Meynial, 1917

Gift of Neil Harris and Teri J. Edelstein

Charles Martin. "La relève." *Sous les pots de fleurs*. Paris: Jules Meynial, 1917

Gift of Neil Harris and Teri J. Edelstein

Charles Martin. "Le tir." *Sous les pots de fleurs*. Paris: Jules Meynial, 1917

Gift of Neil Harris and Teri J. Edelstein

L'ONCLE HANSI [JEAN-JACQUES WALTZ]

L'oncle Hansi [Jean-Jacques Waltz]. *L'Alsace heureuse*. Paris: H. Floury, 1919

[CHARLES ALEXANDRE] PICART LE DOUX

Paul Vaillant-Couturier. *Jean sans pain: Histoire pour tous les enfants racontée*. Illus. by [Charles Alexandre] Picart le Doux. Paris: Clarté, 1921

On loan from a private collection

J[OSEPH PORPHYRE] PINCHON

J[oseph Porphyre] Pinchon. *Béccasine chez les Turcs*. Paris: Gautier et Langueruau, 1919

FRANCISQUE POULBOT

Francisque Poulbot. "Un chien, c'est pas un Boche." [S.l.: s. n., 1915]

CHARLOTTE SCHALLER

Charlotte Schaller. *En guerre!* Paris: Berger-Levrault, [1914]

On loan from a private collection

Charlotte Schaller. *Histoire d'un brave petit soldat*. Paris: Berger-Levrault, 1915

On loan from a private collection

PAULET THÉVENAZ

Les musiques de la guerre. Illus. by Paulet Thévenaz. Paris: Chez Tolmer & Cie., 1915

On loan from a private collection

R[OGER] DE VALERIO

Lucien Boyer. *La chanson des poilus*. Cover art by Guy Arnoux. Illus. by R[oger] de Valerio. Paris: Francis Salabert, 1918

JEAN-CARL DE VALLÉE

Jean-Carl de Vallée. *La prière du poilu*. Paris: Librairie Lutetia, [bet. 1914 and 1917]

Gift of Neil Harris and Teri J. Edelstein

VAL-RAU

Val-Rau. *Spahis et tirailleurs: Pour Odile Kastler en l'année de guerre 1916*. Paris: Berger-Levrault, 1916

WORKS BY UNKNOWN ILLUSTRATORS

Chansons et poésies de la guerre. No. 172. Paris: Librairie Larousse, 1916

Gift of Neil Harris and Teri J. Edelstein

Chansons et poésies de la guerre. No. 181. Paris: Librairie Larousse, 1916

Gift of Neil Harris and Teri J. Edelstein

"Français, franchissez la frontière / J'ai mis tous les Boches par terre." [S.l.]: Dora, [n.d.]

Jeu de la victoire. Paris: Chambrelen, [n.d.]

Gift of Neil Harris and Teri J. Edelstein

"Même les poupées n'en veulent pas." [S.l.: s. n., n.d.]

BIOGRAPHICAL NOTES

A number of the artists represented in the exhibition are so obscure today that their birth and death dates and career accomplishments remain largely untraceable. They include Simone Bouglé, Odette Champion, Paul Ancrenaz, Val-Rau (the pseudonym of Valentine Rau), Louis Lefèvre, and Jean Leprince. Thus they are not described in the pages that follow. For some others, only the most basic data are available. Several of the illustrators for La baïonnette *are also not included.*

PIERRE ABADIE[-LANDEL] (1896-1972)

A student at the Ecole des Beaux-Arts until 1917, Abadie exhibited his paintings at many salons, including the Salon des artistes français. He produced a series of Breton seascapes, along with posters for various balls and galas, some of them held in Montparnasse, the Left Bank Parisian neighborhood whose cheap rents attracted artists and intellectuals in the 1920s. Abadie's participation in the Seiz Breur, a group of artists and artisans, suggests his interest in the folk traditions of Brittany.

GUY ARNOUX (1886-1951)

Born in Paris to a family of army officers, Arnoux was enrolled at the celebrated Lycée Henri IV and pressured to study law. This did not last long, however, as his preference for the artist's life soon became clear. Wounded during the war, not long after he had begun his professional career, a prolific Arnoux would produce almost fifty books, along with posters, menus, theater programs, calendars, pamphlets, advertisements, and decor for ocean liners. Devambez published many of his works, which concentrated on heroic military themes. His cultivation of patriotic sentiments was recognized by appointment, in 1921, as official artist of the French Navy.

GEORGE BARBIER (1882-1932)

Considered by many the quintessential Art Deco artist, Barbier was born in Nantes and moved to Paris, where he was exhibiting his work by 1911. The artists Bernard Boutet de Monvel and Pierre Brissaud were his cousins, and he was closely associated with other great fashion illustrators, such as Paul Iribe, Charles Martin, and

Georges Lepape. His contributions to *Modes et manières d'aujourd'hui* and the *Gazette du bon ton* became legendary. Barbier, who also designed sets, costumes, jewelry, and wallpaper, produced a series of *grand luxe* books in the 1920s, small editions highly prized today, and worked for Hollywood motion pictures as well, notably creating costumes for Rudolph Valentino.

EDUARDO GARCÍA BENITO (1891-1981)

Benito, as he was known, spent his early years in Spain; when he was nineteen his native city of Valladolid gave him a scholarship to study art in Paris. Drawn to the circle of contemporaries like Pablo Picasso, Juan Gris, and Amedeo Modigliani, Benito specialized at first in portraiture and held his first exhibition in 1917. His illustrations were soon appearing in the *Gazette du bon ton*, *La guirlande*, and *Le goût du jour*, among other journals, and he was a frequent contributor to *La baïonnette*. After the war's end he became a frequent cover designer for *Vogue* and *Vanity Fair*, a book illustrator, and caricaturist. He spent much of his life in New York. In his later years he returned to painting and lived out his days in Spain.

GUS BOFA (1885-1968)

Pseudonym of Gustave Blanchot. Bofa was the student of Fernand Cormon and Luc-Olivier Merson, both at the Ecole des Beaux-Arts, and before World War I was actively illustrating for *Le rire* and *Le sourire*. He helped create *La petite semaine*, a children's magazine, with a group of other artists and writers including Joseph Hémard and Roland Dorgelès. After being wounded in action, he returned to Paris to work (extensively) for *La*

baïonnette, and in the 1910s and '20s began his decades-long career as a satirical master of dark humor and a figure of influence and great popularity.

ROBERT BONFILS (1886–1972)
Bonfils studied at the Ecole des Beaux-Arts in Paris, and worked in a variety of graphic media: engraving, lithography, and wood. He executed several other war projects beyond *La manière française* and contributed to the *Gazette du bon ton* in its early years. In 1919, Bonfils joined the faculty at the Ecole Estienne in Paris, a graduate school specializing in the printing arts, and remained there until 1951. A designer of posters, theater sets, upholstery, and bindings, he illustrated dozens of books and was inducted into the Légion d'honneur.

[E.] LUCIEN BOUCHER (1889–1971)
Boucher studied at the Ceramic School in Sèvres. His wartime publications were among his first, for most of his book illustrations appeared in the 1920s and '30s. Boucher also created cartoons for a series of periodicals, and continued to work through the 1950s, designing several theatrical productions. His best-known and most popular efforts were exerted on behalf of Air France, in a series of poster maps created in the years just after World War II.

PIERRE BRISSAUD (1885–1964)
Brissaud was the nephew of two celebrated artists, Maurice Boutet de Monvel and Fernand Cormon, and studied in the latter's atelier, along with other popular illustrators such as Georges Lepape and André Marty. A prolific illustrator for almost half a century, Brissaud enjoyed a wide range of clients, illustrating children's books and classic texts alike, designing catalogues for department stores, and spending time in New York working for *Vogue*.

GÉRARD COCHET (1888–1969)
Cochet was born near Nantes. In Paris, he spent several years studying at the Académie Julian, and had just begun to exhibit when the war broke out. Enlisting in 1914, he was badly wounded in action, losing his right eye and receiving the Croix de guerre. He resumed work in 1917, and soon was producing woodcuts, lithographs, engravings, and etchings. Over the next few decades Cochet worked on dozens of books in these different graphic media, and also decorated various naval offices and museums with his murals. He was named a painter for the French Navy in 1925. Along with all this he created book covers for the Editions Grasset and set designs for the Opéra comique.

HENRIETTE DAMART (1885–1945)
A painter and pastelist, she studied under Odilon Redon and Tony Robert-Fleury and was exhibiting at salons by 1911. The winner of several prizes, Damart produced a few albums for children, of which the most notable were two wartime titles, *Toinette et la guerre* and *Josette et Jehan de Reims*, both published by Berger-Levrault. She was married to Paul-Elie Dubois, a painter who spent time in North Africa, which helped account for some of her own Orientalist portraits.

H. ROBERT DAMMY (ca. 1890–?)
Little is known about Dammy, beyond his extensive work for such fashion magazines as the *Journal des dames et des modes* and Lucien Vogel's *Gazette du bon ton*.

ETIENNE DRIAN (1885–1961)
Pseudonym of Adrian Désiré Estienne. He assumed the name Drian at the Académie Julian in Paris, and was soon working for the *Gazette du bon ton* and other fashion journals, including *Vogue* and *Harper's Bazaar*. Drian designed catalogues for the Paris department store Printemps and worked for the couturier Paul Poiret and for the journal *Femina*. An exhibitor at various salons, Drian was particularly active at the gallery of the publisher Devambez.

RAOUL DUFY (1877–1953)
Dufy was born in Le Havre, studied with Léon Bonnat in Paris, and made his salon debut in 1901. As a painter and graphic artist he moved through Postimpressionism, Fauvism, and Cubism before developing a distinctive style of his own. Dufy's first book illustrations came in 1911, for Guillaume Apollinaire's *Le bestiare*, which remains one of his great achievements. During the 1910s and '20s he went on to create a series of important artist's books for the publishers La Sirène, Ambroise Vollard, Scripta et Picta, and Au Sans Pareil, although his broader reputation today rests on his paintings.

FABIEN FABIANO (1883-1962)

Pseudonym of Jules Coup de Fréjac. Fabiano, descended from several generations of seamen, was born in Brittany and moved to Paris in 1900. He studied at both the Ecole des Beaux-Arts and the Académie Colarossi, and succeeded in getting his drawings and portraits published in newspapers, along with magazines like *Fantasio* and *La vie parisienne*. A commercial artist as well, his fashionable Belle Epoque Parisian women inspired the label *Fabiennettes*.

ANDRÉ FOY (1886-1953)

Foy studied at the Académie Julian in Paris, and produced illustrations for a series of popular journals, including *Le rire*, *La vie parisienne*, and *Le sourire*. He was a frequent contributor to *La baïonnette*. In the 1920s he moved on to creating sets and costumes for the theater and for films, as well as a series of humorous picture postcards. Foy, with colleagues like Gus Bofa, Lucien Boucher, Charles Martin, and Joseph Hémard, among others, helped form the Salon de l'araignée during the 1920s, featuring the work of book and magazine illustrators.

HENRI GAZAN (1887-1960)

A satirical illustrator, Gazan worked for a variety of journals, including *Le rire*, *Le sourire*, *Fantasio*, and *La baïonnette*. Sometimes listed as Henry Gazan, he illustrated at least one children's songbook and a war poster and produced, in the 1930s, posters for the Ministry of Hygiene promoting clean water. *Marie-Anne et son oncle Sam* seems to have been his major published book.

PAUL GUIGNEBAULT (1871-?)

A student of Henri Boutet, whose depictions of Parisian women earned him the sobriquet "le petit maître au corset," Guignebault exhibited at Paris salons from 1902, and went on to illustrate books by Joris-Karl Huysmans, Paul Verlaine, and Francis de Miomandre. He is also claimed as a comic-book pioneer, working for an established publisher of popular images, the Maison Quantin, employer of other well-known illustrators like Job, Caran d'Ache and Benjamin Rabier.

EDOUARD HALOUZE (1895-1958)

Halouze began his exhibiting career as a teenager, and was soon working for such important fashion journals as the *Gazette du bon ton* and, a bit later, *Le goût du jour*. A painter and decorator as well as an illustrator and poster artist, he contributed to several books in the 1920s. These included two elegant pochoir-illustrated almanacs for the years 1921 and 1922 for the publisher Devambez. Jean Saudé featured one of his designs in his influential 1925 treatise on the art of the pochoir.

ANDRÉ HELLÉ (1871-1945)

Hellé was born in Paris, and by 1910 had created some of his striking children's toys. He also achieved celebrity as an illustrator of children's books, published under Alfred Tolmer's imprint shortly before World War I. In 1913, Hellé commenced work on Claude Debussy's *La boîte a joujoux*, a memorable collaboration. Most of Hellé's books appeared during the 1920s and '30s, principally, though not exclusively, for Berger-Levrault. In recent years something of a cult has developed among his admirers, and several of Hellé's books have been reprinted to much acclaim.

JOSEPH HÉMARD (1880-1961)

Hémard was placed in a wallpaper company before moving to Paris as a young man. He sold his first drawings to a humor magazine, *Le pêle-mêle*, and proceeded to publish his droll sketches in journals like *Le rire*, *Fantasio*, *Le sourire*, and *La vie parisienne*. *Chez les Fritz*, notes on his German captivity, came after some cheaply produced fiction and children's books, and one notable edition of a story by Honoré de Balzac, which established his reputation. In the 1920s and '30s Hémard would illustrate dozens of texts, many of them for the publisher René Kieffer, and created satirical volumes of his own, on subjects ranging from grammar and geography to French history and tax law. Among the most prolific and popular French illustrators of his day, he also produced theater sets and designed pottery, fans, and textiles. Many of Hémard's illustrations were stenciled; his style was instantly recognized and occasionally imitated or satirized.

HERMANN-PAUL (1874–1940)

Pseudonym of René Georges Hermann-Paul. Paris born, he trained as a painter at both the Ecole des Arts Décoratifs in Paris and the Académie Julian. Hermann-Paul's prints and caricatures established his reputation by the beginning of the twentieth century. His drawings for *Le courrier français*, starting in 1894, and for *Le rire*, as well as his active support of Alfred Dreyfus, led to involvement with anarchist journals. A satirist of bourgeois values, cynical, abrasive, and even rude in his depictions, Hermann-Paul was an active social commentator for more than three decades, although in his last years his politics moved decisively toward the right.

LOUIS ICART (1888–1950)

Born and raised in Toulouse, Icart moved to Paris in 1907 to study painting and drawing. During World War I he served as a map maker and then as a pilot, while producing drawings for *La baïonnette*, *Le rire,* and other magazines. He traveled to the United States in the 1920s, a decade when his sensuous and sometimes erotic colored etchings, primarily of nude or seminude women, became internationally popular. Icart's popularity extended through the interwar years, and he illustrated a large number of books, for many different publishers.

PAUL IRIBE (1883–1935)

Iribe started out as a compositor for a daily newspaper, *Le temps*. While still a teenager he had his first picture published by *Le rire* in 1901, and was soon working for journals like *L'assiette au beurre*. In 1906 he founded a satirical periodical, *Le témoin*, based on the German satirical journal *Simplicissimus*. There followed publications for a prominent couturier, notably *Les robes de Paul Poiret*, as well as work for the *Gazette du bon ton*. Iribe was soon designing furniture, theatrical costumes, and jewelry. With Jean Cocteau he created in 1914 another journal, *Le mot*, and after World War I he moved to New York and worked for *Vogue*. He spent time in Hollywood, where he became Cecil B. DeMille's artistic director. Returning to Paris in the early 1930s, Iribe carried on a torrid affair with Coco Chanel, and re-created a new version of *Le témoin*, stridently nationalistic and xenophobic.

MARCEL JEANJEAN (1893–1973)

Jeanjean began his illustrating career drawing for a wartime humor magazine, *Le canard poilu*. Serving as an aviator during World War I and eventually becoming official painter for the French Air Force, he produced a number of books on air warfare, of which *Sous les cocardes* of 1919 was the best known. In the 1920s, Jeanjean went on to create a set of children's books built around the adventures (or misadventures) of Fricasson, an anticipation, according to some critics, of Hergé's invention, Tintin.

JEAN-EMILE LABOUREUR (1877–1943)

Born in Nantes, Laboureur came to Paris in 1895 to study at the Sorbonne, turned to art, and made his first appearance at the Salon of 1896. A student of wood engraving with Auguste Lepère, his artist acquaintances at that time included Henri de Toulouse-Lautrec; Marie Laurencin, who would become his student; and Guillaume Apollinaire. Trips abroad took up much of his time before 1911. Returning to Paris he was strongly influenced by Cubism. A series of wartime portfolios followed. He illustrated a long string of more than sixty books, beginning in 1919 with Roger Allard's *L'appartement des jeunes filles*, and was responsible for a large number of individual plates. A master of wood and metal alike, Laboureur designed some eighteen books with English texts, a mark of his interest in and sympathy with British culture.

LUCIEN LAFORGE (1889–1952)

Born Jean Lucien Maurice Laforge in Paris. His mother was a miniaturist and his father first violinist at the Paris Opéra. Laforge had considered a musical career, but enrolled for a time in the Académie Humbert, presenting his paintings for the first time in 1909 at the Salon d'automne. They did not sell well, and Laforge began illustrating children's books, and working for the publisher Larousse. A pacifist and deeply devoted to republican values, he worked for a large number of left-wing journals. While continuing to paint, he produced several more books between 1918 and 1924. After that his published work was principally for magazines, including *La lumière*, *L'humanité*, *Le journal du peuple*, and *Paris-soir*, among a multitude of others.

147

LÉON LEBÈGUE (1863–1944)

Lebègue was born in Orléans, studied with the painter Jean-Léon Gérôme in his atelier, and made his debut at the Salon of 1907. Engraver, lithographer, and painter, he illustrated many books between the 1890s and the 1920s, and worked for *Le courrier français*, *La plume*, and *Le rire,* among other journals. A caricaturist with a good sense of humor, he also produced posters and advertising materials.

FERNAND LÉGER (1881–1955)

Léger was born in Normandy, and trained as an architect in the late 1890s before moving to Paris. After military service he attended the Ecole des Beaux-Arts, but was not granted formal admission. Impressed by Paul Cézanne, and acquainted with contemporaries like Marc Chagall, Robert Delaunay, and Jacques Lipchitz, Léger developed an abstract style. Called to army service in 1914, he was badly wounded during a mustard-gas attack, and during his convalescence introduced machine-like forms into his paintings. Léger's later career flourished, and he achieved an international reputation for his paintings and sculpture, visiting New York and Chicago in the early 1930s in the first of several American trips. His production of illustrated books, which began with *J'ai tué*, would span four decades.

GEORGES LEPAPE (1887–1971)

Paris born, Lepape studied at the Ecole des Beaux-Arts, and soon became friendly with a number of artists and illustrators, including Charles Martin, Georges Braque, and André Marty. In 1910, still in his early twenties, he began a collaboration with Paul Poiret, which led to the celebrated 1911 album *Les choses de Paul Poiret*. Lepape quickly became a featured contributor to the *Gazette du bon ton*. Lepape would work for a series of fashion houses and department stores in the 1920s, design theatrical productions, and illustrate a number of books and *Vogue* covers. Just after the war his plates for a special issue of *Modes et manières* constituted a moving commentary on fashion's relevance to the great effort.

ANDRÉ LHOTE (1885–1962)

Lhote was born in Bordeaux and apprenticed to a furniture maker, apparently in the interest of learning how to sculpt in wood. He soon turned to painting and after moving to Paris in 1906 began participating in various salons. Attracted to Cubism, he exhibited at the Salon de la section d'or, along with Albert Gleizes, Marcel Duchamp, and Jean Metzinger. His service in the army ended in 1917, but he had already produced watercolors and several allegorical prints in a style very different than that of his signature accomplishments. In later years Lhote spent a good deal of time teaching, writing, and editing.

CHARLES MARTIN (1884–1934)

Martin was born in Paris and studied at the Académie Julian and the Ecole des Beaux-Arts between 1908 and 1910. His fellow students at the Ecole included his cousin Pierre Brissaud and other famed illustrators, like Georges Lepape and Paul Iribe. Martin quickly became a prominent contributor to such fashion journals as the *Gazette du bon ton*, *Modes et manières d'aujourd'hui*, and the *Journal des dames et des modes*. *Le sourire*, and *La vie parisienne* also carried his elegant but often satirical illustrations. Martin's style, for some of this period, was distinguished by its Cubist features. A designer of costumes for the ballet and theater, during the 1920s and '30s he also produced a series of illustrated books and portfolios.

L'ONCLE HANSI (1873–1951)

Pseudonym of Jean-Jacques Waltz. Hansi was born in Colmar, in Alsace, soon after it was annexed by Germany. Working as a postcard illustrator and textile artist, around 1909 he began to produce satirical illustrations lampooning the German occupiers and promoting Alsatian history. The French public soon lionized "l'oncle Hansi," but the Germans put him on trial in Leipzig for treason. This cause célèbre, which came on the eve of the war, led to his imprisonment. After escaping, Hansi continued to work as an illustrator, drawing on the folklore of his native province and continuing to poke fun at German soldiers, professors, and tourists. Decades later, the Nazi government of Germany sought to imprison him again, and he fled France for the safety of Switzerland.

CHARLES ALEXANDRE PICART LE DOUX (1881–1959)

Both a painter and an engraver and famous for his nudes, Picart le Doux illustrated dozens of books from the 1920s to the '50s. These included works by

Balzac, François Villon, Pierre de Ronsard, Charles Baudelaire, and Georges Duhamel. His son, Jean Picart Le Doux, was also an illustrator, and a famed designer of tapestries.

J[OSEPH PORPHYRE] PINCHON (1871–1953)

Born in Amiens, Pinchon studied at the celebrated Atelier Cormon and the Ecole des Beaux-Arts in Paris. He was exhibiting at salons as early as 1902, and designing costumes for the Paris Opéra. However, his fame was based on his lively renditions of Bécassine, which began to appear in 1905 in a children's journal, *La semaine de Suzette*. Nearly one hundred of these tales, featuring a young country girl in Breton costume, were published in that journal before 1913, when Pinchon's first album appeared, its authorship now assumed by Caumery (the pseudonym of Maurice Languerreau). Bécassine enjoyed enormous popularity, two dozen albums appearing through the late 1930s. Pinchon also turned to comic-strip art, his illustrations featuring the characters Frimousset and Grassouillet. These were published by Ferenczi and written by Jaboune (the pseudonym of Jean Nohain).

FRANCISQUE POULBOT (1879–1946)

Poulbot was born in Saint-Denis, near Paris, and by the turn of the century, despite a lack of formal training, was successfully submitting his drawings to various journals. He served briefly in the army during World War I, and after leaving the front began a series of posters and postcards, most of them depicting Parisian street children. Many of his drawings of military actions, which were published in *Le journal*, also became postcards.

CHARLOTTE SCHALLER (1880–?)

Born in Bern, Switzerland, Schaller moved to Paris, married a Frenchman, and began exhibiting at various salons around 1910. A designer of fabrics and embroideries, she contributed to *La baïonnette* and produced other children's books besides the two wartime efforts, *En guerre!* and *Histoire d'un brave petit soldat*. This last book was published in at least two different printings early in the war, the second time with Schaller adding her husband's surname, Mouillot, to the title page.

SEM (1863–1934)

Pseudonym for Georges Goursat. A prolific and sometimes feared caricaturist of the Belle Epoque era, and a noted portraitist, SEM also illustrated several wartime works, among them *Un Pekin sur le front* in 1917.

PAULET THÉVENAZ (1891–1921)

Thévenaz, something of a cult figure, was born in Geneva and moved to Paris for his studies. An admirer of Igor Stravinsky and Jean Cocteau, whose portraits he sketched, Thévenaz wrote about the relationships linking dance, music, sculpture, and painting, earning him the label of "rhythmician." For a time he was involved with the program developed by Jacques Dalcroze, also Swiss, popularizing rhythmic gymnastics. As the citizen of a neutral state, Thévenaz avoided military duty, but he produced at least one colorful wartime album for the publisher Tolmer. In 1917 he moved to New York, where, among other things, he taught at the Dalcroze School and executed portraits and murals for wealthy clients. He died young, and suddenly, of peritonitis caused by a ruptured appendix.

ROGER DE VALERIO (1886–1951)

Pseudonym of Roger Laviron. Born in Lille, Valerio studied architecture in Paris, and then went to work as art director for the newspaper *Le matin*. In the 1910s and '20s he specialized in sheet-music covers, and then emerged as a major poster designer, working for the house of Devambez. Clients included beer and champagne companies, as well as the annual Paris Air Show.

GERDA WEGENER (1886–1940)

Born in Denmark, Wegener studied at the Royal Art Academy in Copenhagen, and moved to Paris in 1912. She soon was publishing in magazines like *Fantasio* and *La vie parisienne*, and, during the war, for *La baïonnette*. She also exhibited her paintings in Denmark. Aside from her distinctively mannered style and considerable productivity, Wegener gained notoriety because her first husband, Einar Wegener (later Lili Elbe), underwent one of the first male-to-female surgeries, in 1930.

SELECTED BIBLIOGRAPHY

Anzalone, John. "Hermann-Paul et la guerre sur bois." *Bulletin du bibliophile* (2009, no. 1): 142-62.

Auclert, Jean-Pierre. *La Grand Guerre des crayons: Les noirs dessins de la propagande en 1914-18.* Paris: Robert Laffont, 1918.

Audoin-Rouzeau, Stéphane. *La guerre des enfants, 1914-1918.* Paris: Armand Colin, 1993, 2004.

Audoin-Rouzeau, Stéphane, and Jean-Jacques Becker, eds. *Encyclopédie de la Grande Guerre 1914: Histoire et culture.* Paris: Bayard, 2004.

Audouin-Rouzeau, Stéphane, et al. *La guerre des animaux.* Péronne, Somme: L'Historial de la Grande Guerre, 2007.

Babou, Henry. *Jacques Touchet.* Les artistes du livre. Paris: Henry Babou, 1932.

Bachollet, Raymond, et al. *Paul Iribe.* Paris: Denoël, 1982.

Bass, Jacquelynn, and Richard S. Field. *The Artistic Revival of the Woodcut in France, 1850-1900.* Ann Arbor: University of Michigan Museum of Art, 1984.

Beaupré, Nicolas, et al. *Xavier Josso: Un artiste combattant dans la Grande Guerre.* Paris: Somogy, 2013.

Bénézit, E[mmanuel]. *Dictionnaire critique et documentaire des peintres, sculpteurs, dessinateurs & graveurs de tous les temps et de tous les pays: English Dictionary of Artists.* 14 vols. Paris: Grund, 2006.

Bibliothèque Forney. *Exposition Tolmer: 60 ans de création graphique dans l'Île Saint-Louis.* Paris: Bibliothèque Forney, 1986.

Cate, Phillip Dennis, ed. *The Graphic Arts and French Society, 1871-1914.* New Brunswick: Rutgers University Press, 1988.

Cerisier, Alban, and Jacques Desse. *De la jeunesse chez Gallimard: 90 ans de livres pour enfants: Un Catalogue.* Paris: Gallimard, 2008.

Chevrel, Claudine, et al. *Poulbot affichiste: Francisque Poulbot, 1879-1946.* Paris: 2007.

Clément-Janin [Hilaire Noël Sébastien]. *Essai sur la bibliophilie contemporaine de 1900-1928.* 2 vols. Paris: René Kieffer, 1931-32.

———. "Les estampes et la guerre." *Gazette des beaux-arts* 13 (1917): 75-94, 361-83, 483-508.

———. *Les estampes, images et affiches de la guerre.* Paris: Gazette des beaux-arts, 1919.

Cork, Richard. *A Bitter Truth: Avant-garde Art and the Great War.* New Haven: Yale University Press, 1994.

Cotsen Children's Library. *A Catalogue of the Cotsen Children's Library: The Twentieth Century.* 2 vols. Princeton: Cotsen Children's Library, 2000, 2003.

Dagen, Philippe. *Le silence des peintres: Les artistes face à la Grande Guerre.* Paris: Fayard, 1996.

Davis, Mary E. *Classic Chic: Music, Fashion, and Modernism.* Berkeley: University of California Press, 2008.

Doche, Jean-Pierre. *Poulbot et le livre.* Paris: L'Apart, 2011.

Douglas, Allen. *War, Memory, and the Politics of Humor: The Canard Enchaîné and World War I.* Berkeley: University of California Press: 2002.

Dulac, Jean. *Pierre Brissaud.* Les artistes du livre. Paris: Henry Babou, 1929.

Edouard-Joseph, René. *Dictionnaire biographique des artistes contemporains, 1910-1930.* 3 vols. Paris: Art & Edition, 1930-34.

Epinal tricolore: L'imagerie Raoul Dufy, 1914-1918. Epinal: Musée Départemental de l'Art Ancien et Contemporain, 2011.

Ferro, Marc. "Cultural Life in France, 1914-1918." In Aviel Roshwald and Richard Stites, eds. *European Culture in the Great War: The Arts, Entertainment, and Propaganda, 1914-1918.* Cambridge, U.K., and New York: Cambridge University Press, 1999, 295-307.

Findlay, James A., ed. *The Game of War: Books, Toys, and Propaganda from the Mitchell Wolfson, Jr. Study Centre.* Fort Lauderdale: Bienes Center for the Literary Arts, 2006.

Fourment, Alain. *Histoire de la presse des jeunes et des enfants, 1768-1988.* Paris: Editions Ecole, 1987.

Gallatin, Albert E. *Art and the Great War.* New York: Dutton, 1919.

Geiger, Raymond. *Hermann-Paul.* Les artistes du livre. Paris: Henry Babou, 1929.

Ginisty, Paul. *Les artistes morts pour la patrie.* Paris: Félix Alcan, 1916.

Goddard, Stephen H. *Ubu's Almanac: Alfred Jarry and the Graphic Arts.* Lawrence, Kans.: Spencer Museum of Art, 1997.

Golan, Romy. *Modernity & Nostalgia: Art and Politics in France between the Wars.* New Haven: Yale University Press, 1995.

Gourévitch, Jean-Paul. *Images d'enfance: Quatre siècles d'illustration du livre pour enfants.* [Paris]: Editions Alternatives, 1994.

Grayzel, Susan R. "Mothers, Marraines, and Prostitutes: Morale and Morality in First World War France." *International History Review* 19, no. 1 (Feb. 1997): 66-82.

La guerre de 1914-1918 par quelques artistes. Paris: Musée des arts décoratifs, 1940.

Hémard, Joseph. *Joseph Hémard: Autobiographie par lui-même.* Les artistes du livre. Paris: Henry Babou, 1928.

Herman, Paul, and Georges Léonnec. *Léonnec: Illustrateur de La vie parisienne.* Grenoble: Glénat, 1990.

Higonnet, Margaret R. "Picturing Trauma in the Great War." In Elizabeth Goodenough and Andrea Immel, eds. *Under Fire: Childhood in the Shadow of War.* Detroit: Wayne State University Press, 2008, 115-28.

Higonnet, Margaret R., ed. *Lines of Fire: Women Writers of World War I.* New York: Plume, 1991.

Huss, Marie-Monique. "Pronatalism and the Popular Ideology of the Child in Wartime France: The Evidence of the Picture Postcard." In Richard Wall and Jay Winter, eds. *The Upheaval of War: Family, Work and Welfare in Europe, 1914-1918.* Cambridge, U.K., and New York: Cambridge University Press, 1988.

Illustrateurs des modes et manières en 1925. Paris: Galerie du Luxembourg, 1972.

IVAM Centre Julio González. *Infancia y arte moderno.* Valencia: s.n., 1999.

Johnson, Eric J. "Under Ideological Fire: Illustrated Wartime Propaganda for Children." In Goodenough and Immel, *Under Fire*, 59-75.

Jones, Barbara, and Bill Howell. *Popular Arts of the First World War.* London: Littlehampton, 1972.

Jude, Patrick, et al. *Mathurin Méheut, 1914-1918: Des ennemis si proches.* Paris: Ouest-France, 2001.

Kahn, Elizabeth Louise. "Art from the Front." *Art History* 8, no. 2 (June 1985): 192-208.

———. *The Neglected Majority: "Les camoufleurs," Art History, and World War I.* Lanham, Md.: University Press of America, 1984.

Kinchin, Juliet, and Aidan O'Connor. *Century of the Child: Growing by Design, 1900-2000.* New York: Museum of Modern Art, 2012.

Laboureur, Sylvain. *Jean-Emile Laboureur: Livres illustrés.* Neuchâtel: Ides et Calendes, 2000.

Lemmens, Albert, and Serge Stomells. *Russian Artists and the Children's Book, 1890-1992.* Nijmegen: LS, 2009.

Lepape, Claude, and Thierry Defert. *From the Ballets Russes to Vogue: The Art of Georges Lepape*. New York: Vendome Press, 1984.

Lévèque, Françoise, and Serge Plantureux. *Dictionnaire des illustrateurs de livres d'enfants russes*. Paris: Bibliothèques de la Ville de Paris, 1997.

Levitch, Mark. *Panthéon de la Guerre: Reconfiguring a Panorama of the Great War*. Columbia, Mo.: University of Missouri Press; Kansas City, Mo.: National World War I Museum, 2006.

———. "Young Blood: Parisian Schoolgirls' Transformation of France's Great War Poster Aesthetic." In Pearl James, ed. *Picture This: World War I Posters and Visual Culture*. Lincoln: University of Nebraska Press, 2009, 145-71.

Malineau, Jean-Hugues. *Images drolatiques d'André Hellé: Le petit monde d'André Hellé*. Paris: Michel Lagarde, 2012.

Martin, Henri-Jean, et al. *Histoire de l'édition française. Vol. 4: Le livre concurrencé 1900-1950*. Paris: Promodis, 1986.

Martorelli, Barbara, ed. *George Barbier: La nascita del déco*. Venice: Marsilio, Musei Civici Veneziani, 2008.

Meissner, Günter. *Allgemeines Künstlerlexikon: Die bildenden Künstler aller Zeiten und Völker*. 77 vols. Munich: K. G. Saur, 2005-9; Berlin: de Gruyter, 2010.

Meyer, Jacques. *La vie quotidienne des soldats pendant la guerre*. Paris: Hachette, 1967.

Morin, Claude. *La Grande Guerre des images: La propagande par la carte postale, 1914-1918*. Turquant: L'Apart Editions, 2012.

Mornand, Pierre. *Trente artistes du livre*. Paris: Marval, 1945.

———. *Vingt-deux artistes du livre*. Paris: Le Courrier Graphique, 1948.

Olivier-Messonnier, Laurence. *Guerre et littérature de jeunesse (1913-1919): Analyse des dérives patriotiques dans les périodiques pour enfants*. Paris: L'Harmattan, [2012].

Osterwalder, Marcus. *Dictionnaire des illustrateurs 1800-1914*. Neuchâtel: Ides et Calendes, 1989.

———. *Dictionnaire des illustrateurs 1890-1945*. Neuchâtel: Ides et Calendes, 1992.

———. *Dictionnaire des illustrateurs 1905-1965*. Neuchâtel: Ides et Calendes, 2001.

Parmegiani, Claude-Anne. *Les petits Français illustrés, 1860-1940*. Paris: Cercle de la Librairie, 1989.

Paul Poiret: Couturier & parfumeur. Paris: Somogy, 2013.

Paul Thévenaz: A Record of His Life and Art, Together with an Essay on Style by the Artist. [New York]: privately printed, 1922.

Peixotto, Ernest. "Special Service for Artists in War Time." *Scribner's Magazine* 62 (July 1917): 1-10.

Pichon, Léon. *The New Book-illustration in France*. London: Studio, 1924.

Piffault, Olivier, ed. *Il était une fois …les contes de fées*. Paris: Bibliothèque Nationale de France, 2001.

———. *Babar, Harry Potter et Cie: Livres d'enfants d'hier et d'aujourd'hui*. Paris: Bibliothèque Nationale de France, 2009.

Pignot, Manon. *La guerre des crayons: Quand les petits Parisiens dessinaient la Grande Guerre*. Paris: Parigramme, 2004.

Pignot, Manon, et al., *Les enfants dans la Grande Guerre*. Péronne, Somme: L'Historial de la Grande Guerre: 2003.

Pollaud-Dulian, Emmanuel. *Charles Martin, Féerie pour une grande guerre*. Paris: Michel Lagarde, 2014.

———. *Gus Bofa: L'enchanteur désenchanté*. [Paris]: Editions Cornélius, 2013.

———. *Le Salon de l'araignée 1920-1930*. Paris: Michel Lagarde, 2013.

Porter, David J., and John Anzalone. "Clouds in the Sky: The *Sports et Divertissements* of Erik Satie and Charles Martin." *Bulletin du bibliophile* (2001, no. 2): 343-72.

Ragon, Michel. *Le dessin d'humour: Histoire de la caricature et du dessin humoristique en France*. Paris: Editions du Seuil, 1992.

———. *Les maîtres du dessin satirique en France de 1830 à nos jours*. Paris: Pierre Horay, 1972.

Ray, Gordon N. "The Art Deco Book in France." In Dorothy L. Vander Meulen, ed. *Studies in Bibliography* 55 (2002): 1-131.

———. *The Art of the French Illustrated Book, 1700-1914*. 2 vols. New York: Pierpont Morgan Library, and Ithaca: Cornell University Press, 1982.

Renonciat, Annie. *Livre mon ami: Lectures enfantines, 1914-1954*. Paris: Agence Culturelle de Paris, 1991.

Robinson, Julian. *The Brilliance of Art Deco*. New York: Bartley & Jensen, [n.d.].

Sadion, Martine. *Images d'Epinal*. Paris: Editions de La Martinière, 2013.

San Millan, François. *Lucien Laforge à l'index*. Paris: La Nouvelle Araignée, 2008.

Schug, Albert, ed. *Die Bilderwelt im Kinderbuch: Kinder- und Jugendbücher aus fünf Jahrhunderten*. Köln: Josef-Haubrich-Kunsthalle, 1988.

Seroux, Lucien. *Anthologie de la connerie militariste d'expression française*. 4 vols. Toulouse: AAEL, 2003-8.

Sherman, Daniel J. *The Construction of Memory in Interwar France*. Chicago: University of Chicago Press, 1999.

———. "Objects of Memory: History and Narrative in French War Museums." *French Historical Studies* 19 (spring 1995): 49-74.

Silver, Kenneth E. *Esprit de corps: The Art of the Parisian Avant-Garde and the First World War, 1914-1925*. Princeton: Princeton University Press, 1989.

———. "Jean Cocteau and the *Image d'Epinal*: An Essay on Realism and Naiveté." In Arthur King Peters, ed. *Jean Cocteau and the French Scene*. New York: Abbeville, 1984.

Thomas, Martine, et al. *Le dessin de presse à l'époque impressioniste, 1863-1908*. [Paris]: Democratic Books, 2010.

Toys of the Avant-garde. Málaga: Museo Picasso, 2010.

Troy, Nancy J. *Couture Culture: A Study in Modern Art and Fashion*. Cambridge, Mass.: MIT Press, 2003.

———. *Modernism and the Decorative Arts in France: Art Nouveau to Le Corbusier*. New Haven: Yale University Press, 1991.

Unno, Hiroshi. *Fashion Illustration and Graphic Design: George Barbier: Master of Art Deco*. Tokyo: Pie Books, 2011.

Valotaire, Marcel. *Charles Martin*. Les artistes du livre. Paris: Henry Babou, 1928.

———. *J.E. Laboureur*. Les artistes du livre. Paris: Henry Babou, 1929.

Watkins, Glenn. *Proof through the Night: Music and the Great War*. Berkeley: University of California Press, 2003.

Winter, Jay. *Sites of Memory, Sites of Mourning: The Great War in European Cultural History*. Cambridge, U.K., and New York: Cambridge University Press, 1995.

Winter, Jay, and Jean-Louis Robert, eds. *Capital Cities at War: Paris, London, Berlin 1914-1919*. Cambridge, U.K., and New York: Cambridge University Press, 2007, vol. 2.

SUPPORTERS AND IMAGE CREDITS

Support for this publication was provided by the Smart Family Foundation, Inc.; the University of Chicago Library Society; the France Chicago Center of the University of Chicago; the Gladys Krieble Delmas Foundation; Martha Fleischman; the Institut Français in Paris and the Cultural Service at the Consulate of France in Chicago; and an anonymous donor.

PHOTOGRAPHY CREDITS

IMAGE REPRODUCTION PERMISSIONS

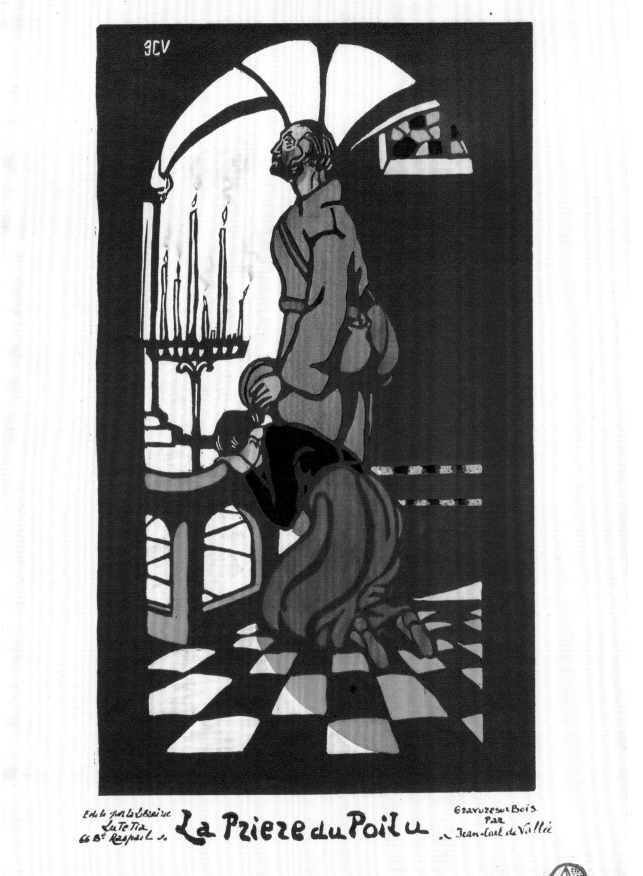

La Priere du Poilu

Edité par la Librairie
Lutetia
66 B^d Raspail ..

Gravures sur Bois.
Par
Jean-Carl de Vallée

2,000 copies of this publication were printed in conjunction with an exhibition held in the Special Collections Research Center Exhibition Gallery, University of Chicago Library, October 13, 2014-January 2, 2015.

A Web version of the exhibition is available at www.lib.uchicago.edu/e/webexhibits/enguerre.

This exhibition has received the designation of the commemoration of the centenary of the Great War.

For permission to quote or reproduce from this publication contact:

Special Collections Research Center
University of Chicago Library
1100 East 57th Street
Chicago, IL 60637
www.lib.uchicago.edu/e/scrc

ISBN: 978-0-943056-42-5

Design and production: Joan Sommers and Amanda Freymann, Glue + Paper Workshop LLC, Chicago
Managing Editor: Patti Gibbons
Photography: Michael Kenny
Color Separations: Professional Graphics, Rockford, IL
Printing and Binding: Asia One, Hong Kong

All translations are by the contributors.

Distributed by the University of Chicago Press
www.press.uchicago.edu

Cover: Adapted from Hermann-Paul. Cover. *Calendrier de la guerre, 2ème année, août 1915-juillet 1916*. Paris: Lutetia, 1916. On loan from a private collection

Back cover: Charlotte Schaller. *En guerre!* Paris: Berger-Levrault, [1914]. On loan from a private collection

Frontispiece: Charles Martin. "Knock-Out!!!" *Sous les pots de fleurs*. Paris: Jules Meynial, 1917. Gift of Neil Harris and Teri J. Edelstein

Page 4: Guy Arnoux. "Se bat pour son pays." *Le bon Français*. Paris: Devambez, [n.d.]. On loan from a private collection

Page 8: Louis Lefèvre. "Sur le pont." *Rondes glorieuses*. [S.l.: s.n., n.d.]. 1ière série. On loan from a private collection

Page 155: Jean-Carl de Vallée. *La prière du poilu*. Paris: Librairie Lutetia, [bet. 1914 and 1917]. Gift of Neil Harris and Teri J. Edelstein (See Entry 28)

Endpapers: Robert Bonfils. *La manière française*. Paris: Librairie Lutetia, [1916]. On loan from a private collection